Naive Art

Text: Nathalia Brodskaia and Viorel Rau
Translation: Mike Darton (main text), Nick Cowling and
Marie-Noëlle Dumaz (biographies)

Layout:
Baseline Co Ltd
127-129A Nguyen Hue Blvd
Fiditourist, 3rd Floor
District 1, Hô Chi Minh
Vietnam

ISBN: 978-1-85995-674-8

Printed in China

Naive Art

- Contents -

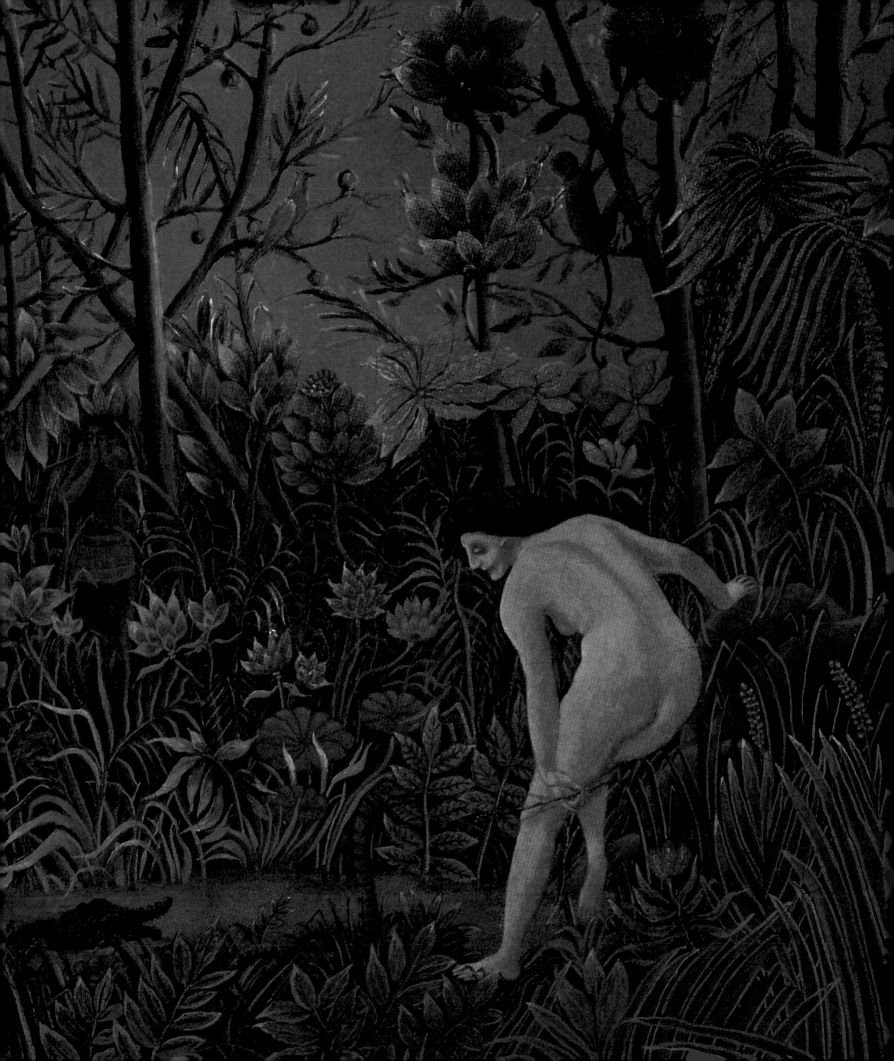

I. Birth of Naive Art

When Was Naive Art Born?

There are two possible ways of defining when naive art originated. One is to reckon that it happened when naive art was first accepted as an artistic mode of status equal with every other artistic mode. That would date its birth to the first years of the twentieth century. The other is to apprehend naive art as no more or less than that, and to look back into human prehistory and to a time when all art was of a type that might now be considered naive – tens of thousands of years ago, when the first rock drawings were etched and when the first cave-pictures of bears and other animals were scratched out. If we accept this second definition, we are inevitably confronted with the very intriguing question, so who was that first naive artist?

Many thousands of years ago, then, in the dawn of human awareness, there lived a hunter. One day it came to him to scratch on a flattish rock surface the contours of a deer or a goat in the act of running away. A single, economical line was enough to render the exquisite form of the graceful creature and the agile swiftness of its flight. The hunter's experience was not that of an artist, simply that of a hunter who had observed his 'model' all his life. It is impossible at this distance in time to know why he made his drawing. Perhaps it was an attempt to say something important to his family group; perhaps it was meant as a divine symbol, a charm intended to bring success in the hunt. Whatever – but from the point of view of an art historian, such an artistic form of expression testifies at the very least to the awakening of individual creative energy and the need, after its accumulation through the process of encounters with the lore of nature, to find an outlet for it.

This first-ever artist really did exist. He must have existed. And he must therefore have been truly 'naive' in what he depicted because he was living at a time when no system of pictorial representation had been invented. Only thereafter did such a system gradually begin to take shape and develop. And only when such a system is in place can there be anything like a 'professional' artist. It is very unlikely, for example, that the paintings on the walls of the Altamira or Lascaux caves were creations of unskilled artists. The precision in depiction of the characteristic features of bison, especially their massive agility, the use of chiaroscuro, the overall beauty of the paintings with their subtleties of coloration – all these surely reveal the brilliant craftsmanship of the professional artist. So what about the 'naive' artist, that hunter who did not become professional? He probably carried on with his pictorial experimentation, using whatever materials came to hand; the people around him did not perceive him as an artist, and his efforts were pretty well ignored.

Any set system of pictorial representation – indeed, any systematic art mode – automatically becomes a standard against which to judge those who through inability or recalcitrance do not adhere to it. The nations of Europe have carefully preserved as many masterpieces of classical antiquity as they have been able to, and have scrupulously also consigned to history the names of the classical artists, architects, sculptors and designers. What chance was there, then, for some lesser mortal of the Athens of the fifth century B.C.E.

Henri Rousseau, also called
the Douanier Rousseau,
The Charm, 1909.
Oil on canvas, 45.5 x 37.5 cm.
Museum Charlotte Zander,
Bönnigheim.

who tried to paint a picture, that he might still be remembered today when most of the ancient frescos have not survived and time has not preserved for us the easel-paintings of those legendary masters whose names have been immortalised through the written word? The name of the Henri Rousseau of classical Athens has been lost forever – but he undoubtedly existed.

The Golden Section, the 'canon' of the (ideal proportions of the) human form as used by Polyclitus, the notion of 'harmony' based on mathematics to lend perfection to art – all of these derived from one island of ancient civilisation adrift in a veritable sea of 'savage' peoples: that of the Greeks. The Greeks encountered this tide of savagery everywhere they went. The stone statues of women executed by the Scythians in the area north of the Black Sea, for example, they regarded as barbarian 'primitive' art and its sculptors as 'naive' artists oblivious to the laws of harmony.

As early as during the third century B.C.E. the influence of the 'barbarians' began to penetrate into Roman art, which at that time was largely derivative of Greek models. The Romans believed not only that they were the only truly civilised nation in the world but that it was their mission to civilize others out of their uncultured ways, to bring their primitive art forms closer to the rigorous standards of the classical art of the Empire. All the same, Roman sculptors felt free to interpret form in a 'barbaric' way, for instance by creating a sculpture so simple that it looked primitive and leaving the surface uneven and only lightly polished. The result was ironically that the 'correct' classical art lacked that very impressiveness that was characteristic of the years before in the third century B.C.E.

Having overthrown Rome's domination of most of Europe, the 'barbarians' dispensed with the classical system of art. It was as if the 'canon' so notably realised by Polyclitus had never existed. Now art learned to frighten people, to induce a state of awe and trepidation by its expressiveness. Capitals in the medieval Romanesque cathedrals swarmed with strange creatures with short legs, tiny bodies and huge heads. Who carved them? Very few of the creators' names are known. Undoubtedly, however, they were excellent artisans, virtuosi in working with stone. They were also true artists, or their work would not emanate such tremendous power. These artists came from that parallel world that had always existed, the world of what Europeans called 'primitive' art.

'Naive' art, and the artists who created it, became well known in Europe at the beginning of the twentieth century. Who were these artists, and what was their background? To find out, we have to turn back the clock and look at the history of art at that time.

It is interesting that for much of the intervening century, the naive artists themselves seem to have attracted rather less attention than those people responsible for 'discovering' them or publicising them. Yet that is not unusual. After all, the naive artists might never have come into the light of public scrutiny at all if it had not been for the fascination that other young European artists of the avant-garde movement had for their work - avant-garde artists whose own work has now, at the turn of the millennium, also passed into art history. In this way we should not consider viewing works by, say, Henri Rousseau, Niko Pirosmani, Ivan Generalić, André Bauchant or Louis Vivin without reference at the same time to the ideas and styles of such recognised masters as Pablo Picasso, Henri Matisse, Joan Miró, Max Ernst and Mikhail Larionov.

But of course, to make that reference itself presents problems. Who was influenced by whom, in what way, and what was the result? The work of the naive artists poses so many

Anonymous,
Antelopes and Men.
Kamberg region, Africa.

Aristide Caillaud,
The Mad Man, 1942.
81 x 43 cm.
Musée d'Art moderne
de la Ville de Paris, Paris.

Anonymous,
Masculine Idol, 3000-2000 B.C.E.
Wood, h: 9.3 cm.
Musée d'Archéologie nationale,
Château de Saint-Germain-en-Laye,
Saint-Germain-en-Laye.

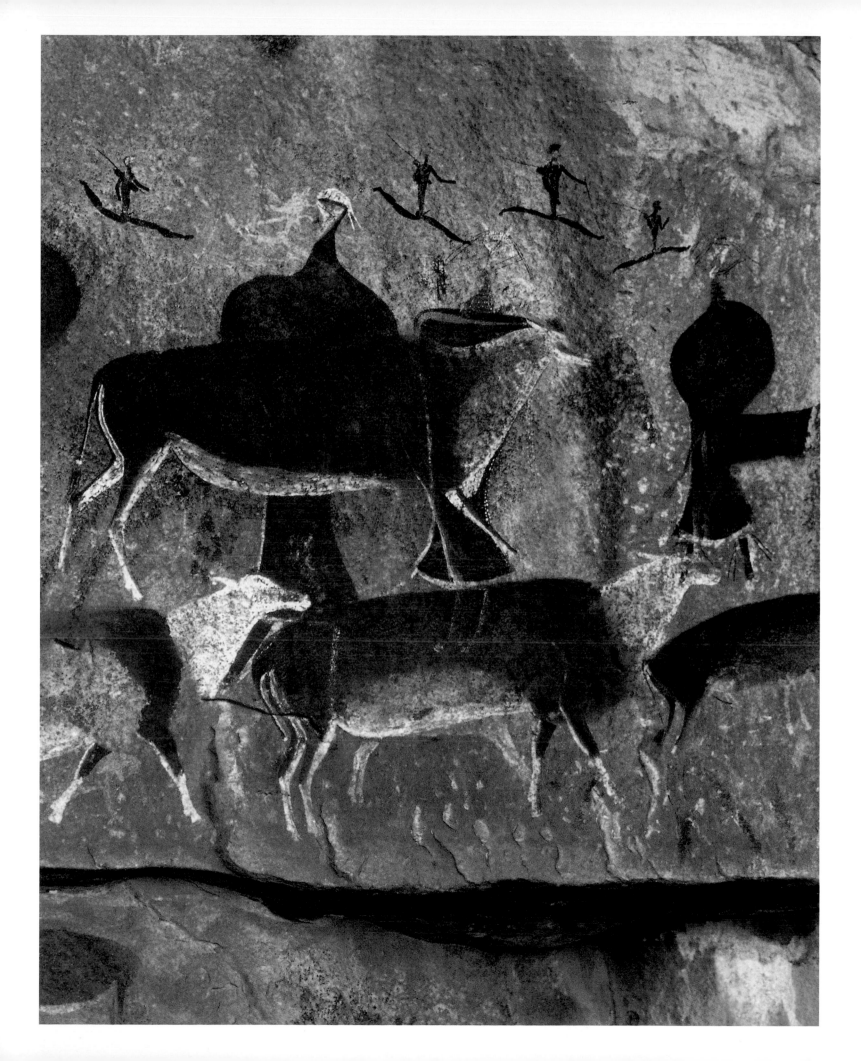

questions of this kind that experts will undoubtedly still be trying to unravel the answers for a good time yet. The main necessity is to establish for each of the naive artists precisely who or what the main source of their inspiration was. This has then to be located within a framework expressing the artist's relationship to the 'classic' academic ('official') art of the period. Difficult as it is to make headway in such research, matters are further complicated by the fact that such questions may themselves have more than one answer – and that each answer may be subject to different interpretation by different experts anyway.

It gets worse. All the time the works of previously unknown naive artists are coming to light, some of them from the early days of naive art, some of them relatively contemporary. Their art may add to our understanding of the phenomenon of naive art or may change it altogether. For this reason alone it would simply not be feasible to come to an appreciation of naive art that was tightly-defined, complete and static.

In this study, therefore, we will contemplate only those outstanding – yet outstandingly diverse – examples of naive art that really do constitute pointers towards a genuine style, a genuine direction in pictorial representation, albeit one that is currently little known. Think of this book, if you like, as a preliminary sketch for a picture that will be completed by future generations.

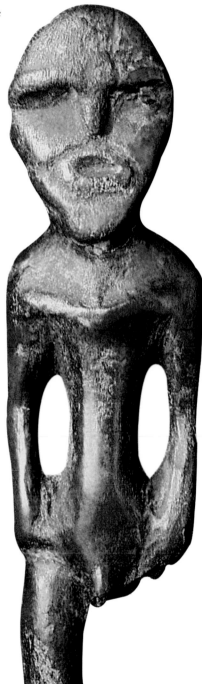

It is difficult – perhaps even impossible – to quantify the influence of Henri Rousseau, Niko Pirosmani and Ivan Generalić on professional 'modern' artists and the artworks they produce. The reason is obvious: the three of them belonged to no one specific school and, indeed, worked to no specific system of art. It is for this reason that genuine scholars of naive art are somewhat thin on the ground. After all, it is hard to find any basic element, any consistent factor, that unites their art and enables it to be studied as a discrete phenomenon.

The problems begin even in finding a proper name for this kind of art. No single term is descriptive enough. It is all very well consulting dictionaries – they are not much use in this situation. A dictionary definition of a 'primitive' in relation to art, for example, might be "An artist or sculptor of the period before the Renaissance". This definition is actually not unusual in dictionaries today – but it was first written in the nineteenth century and is now badly out of date because the concept of 'primitive' art has expanded to include the art of non-European cultures in addition to the art of naive artists worldwide. In incorporating such a massive diversity of elements, the term has thus taken on a broadness that renders it, as a definition, all too indefinite. The description 'primitive' is simply no longer precise enough to apply to the works of untaught artists.

The word 'naive', which implies naturalness, innocence, unaffectedness, inexperience, trustfulness, artlessness and ingenuousness, has the kind of descriptively emotive ring to it that clearly reflects the spirit of such artists. But as a technical term it is open to confusion. Like Louis Aragon, we could say that "It is naive to consider this painting naive."[1]

Many other descriptive expressions have been suggested to fill the gap. Wilhelm Uhde called the 1928 exhibition in Paris Les Artists du Sacré-Coeur, apparently intending to emphasise not so much a location as the unspoiled, pure nature of the artists' dispositions.

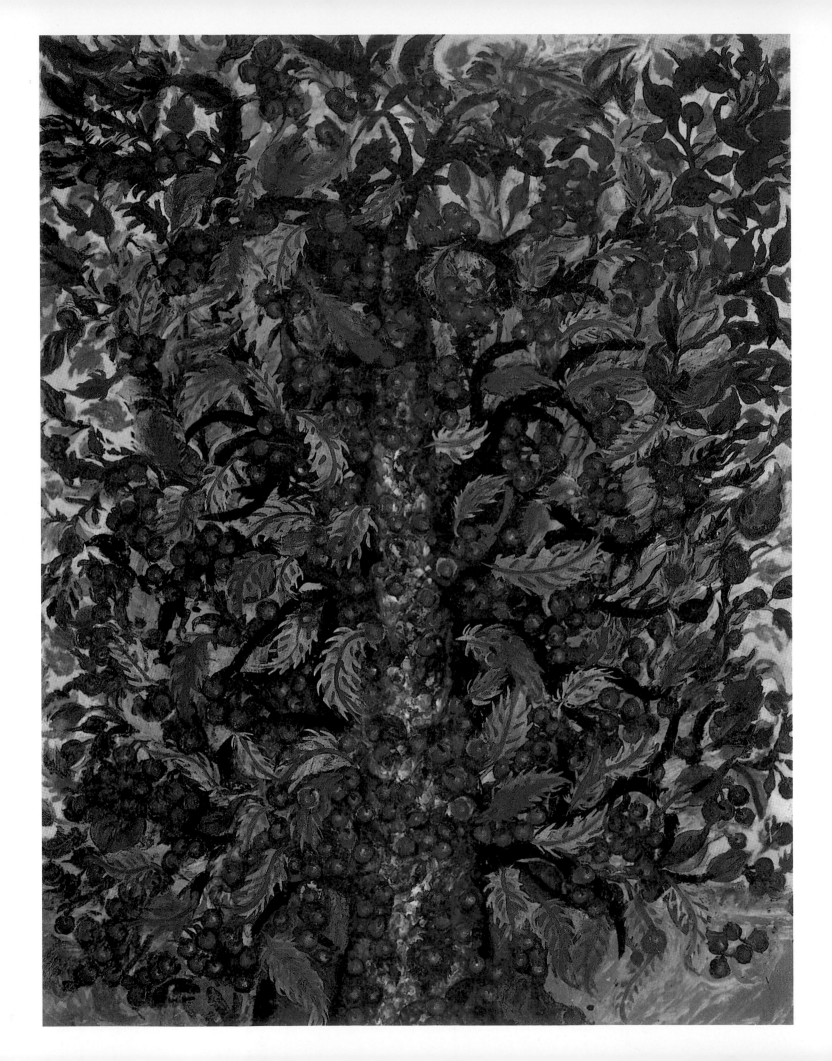

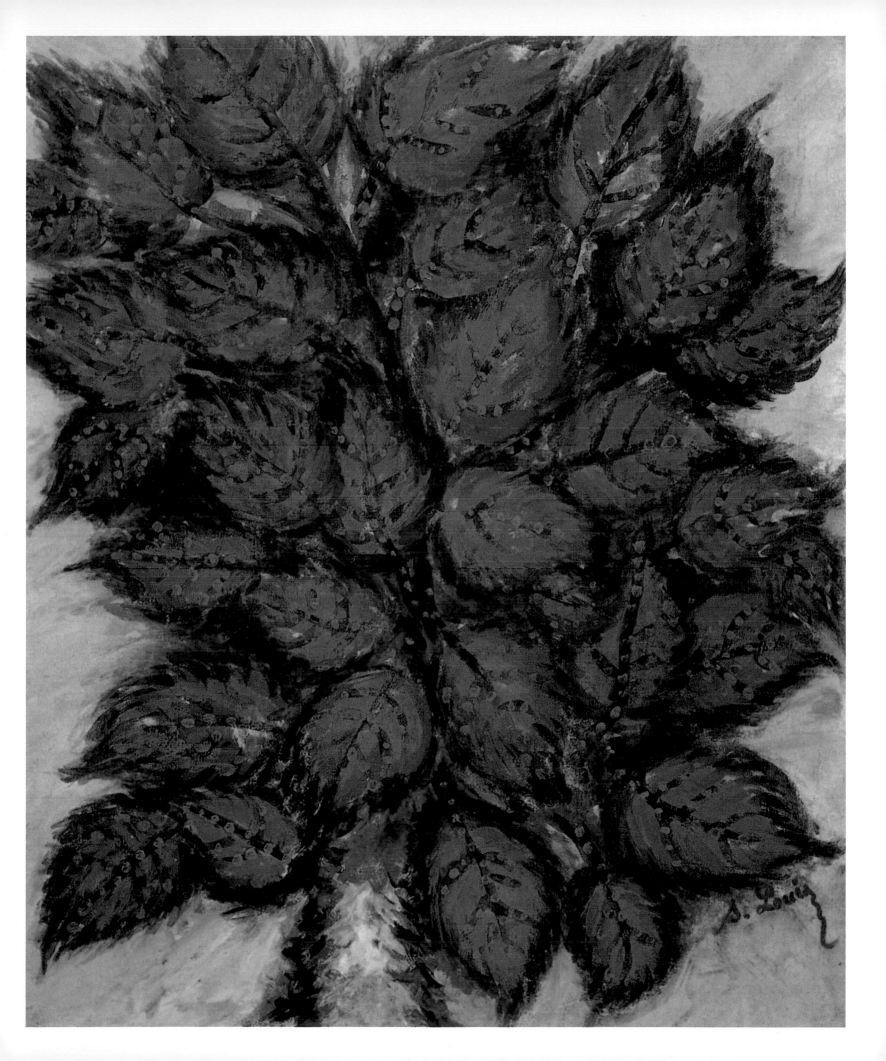

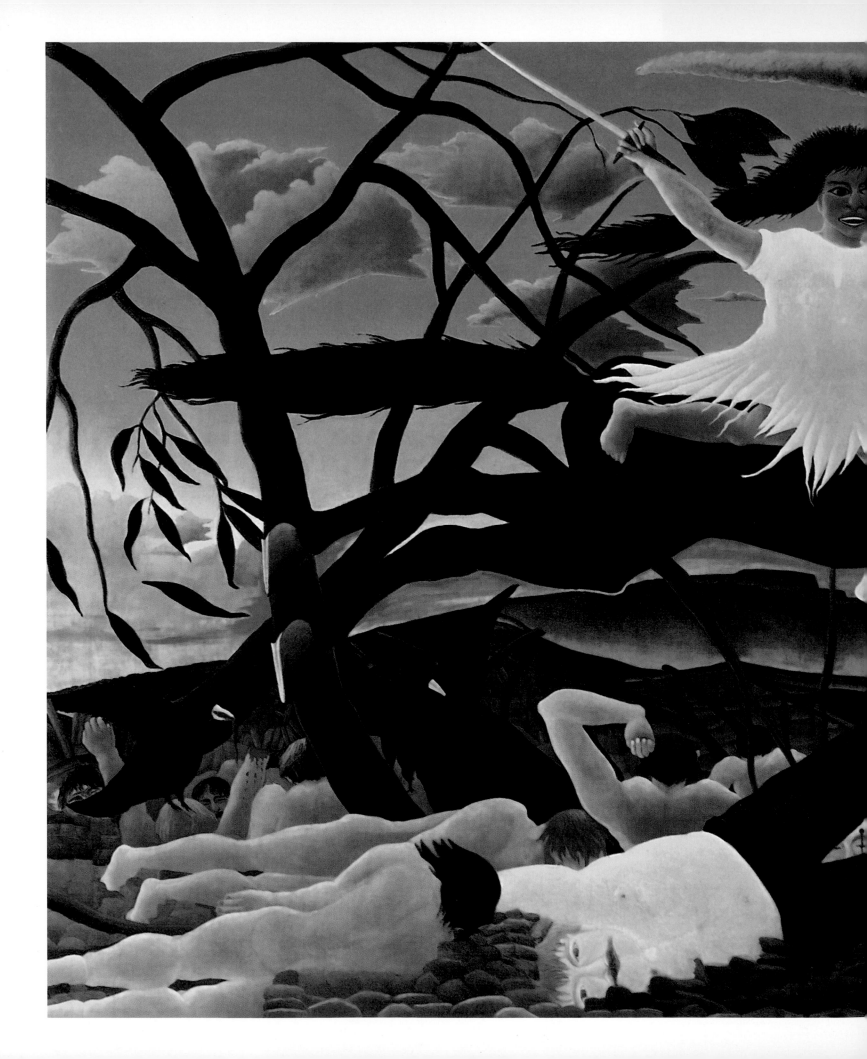

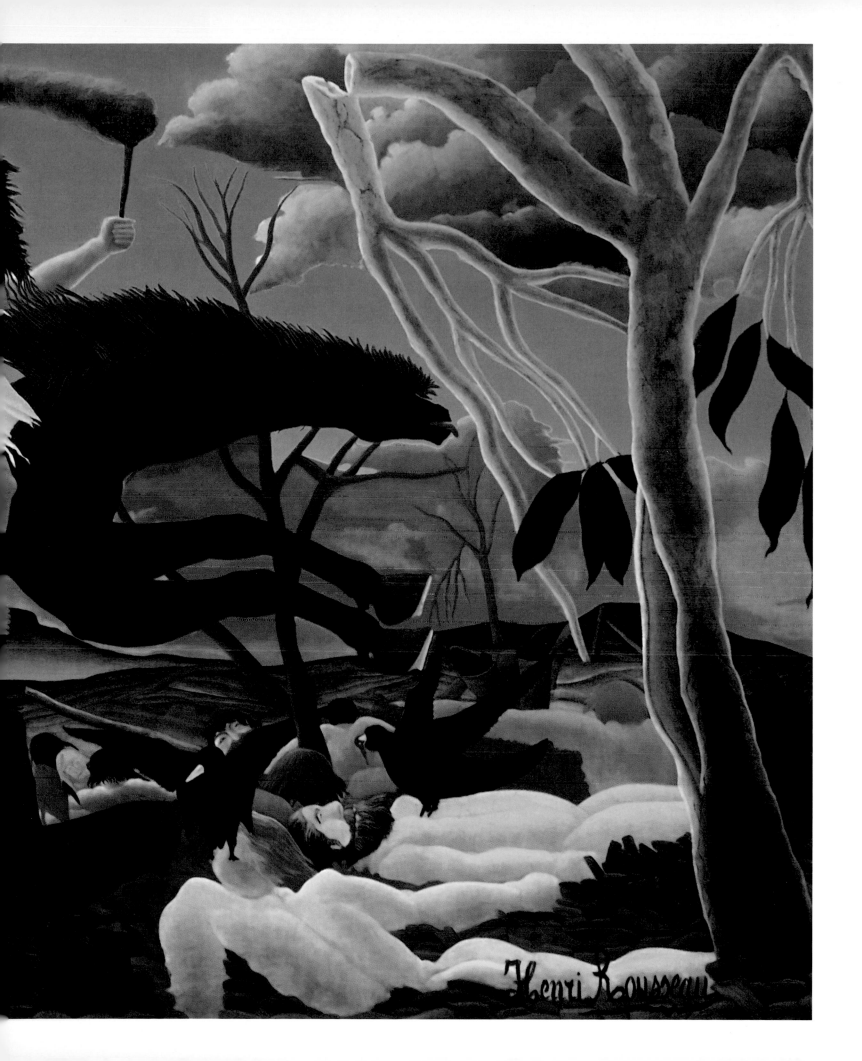

Séraphine Louis, also called
Séraphine de Senlis,
The Cherries.
Oil on canvas, 117 x 89 cm.
Museum Charlotte Zander,
Bönnigheim.

Séraphine Louis, also called
Séraphine de Senlis,
Flowers.
Oil on canvas, 65.5 x 54.5 cm.
Museum Charlotte Zander,
Bönnigheim.

Henri Rousseau, also called
the Douanier Rousseau,
War or *The Ride of Discord*, 1894.
Oil on canvas, 114 x 195 cm.
Musée d'Orsay, Paris.

Henri Rousseau, also called
the Douanier Rousseau,
The Sleeping Gypsy, 1897.
Oil on canvas, 129.5 x 200.7 cm.
The Museum of Modern Art,
New York.

Another proposal was to call them 'instinctive artists' in reference to the intuitive aspects of their method. Yet another was 'neo-primitives' as a sort of reference to the idea of nineteenth-century-style 'primitive' art while yet distinguishing them from it. A different faction picked up on Gustave Coquiot's observation in praise of Henri Rousseau's work and decided they should be known as 'Sunday artists'.

Of all the various terms on offer, it was naive that won out. This is the word that is used in the titles of books and in the names of a growing number of museums. Presumably, it is the combination of moral and aesthetic factors in the work of naive artists that seems appropriate in the description. Gerd Claussnitzer alternatively believes that the term is meant pejoratively, as a nineteenth-century comment by the realist school on a visibly clumsy and unskilled style of painting.[2] For all that, to an unsophisticated reader or viewer the term 'naive artist' does bring to mind an image of the artist as a very human sort of person.

Every student of art feels a natural compulsion to try to classify the naive artists, to categorise them on the basis of some feature or features they have in common. The trouble with this is that the naive artists – as noted above – belong to no specific school of art and work to no specific system of expression. Which is precisely why professional artists are so attracted to their work. Summing up his long life, Maurice de Vlaminck wrote: "I seem initially to have followed Fauvism, and then to have followed in Cézanne's footsteps. Whatever – I do not mind. . . as long as first of all I remained Vlaminck."[3]

Naive artists have been independent of other forms of art from the very beginning. It is their essential quality. Paradoxically, it is their independence that determines their similarity. They tend to use the same sort of themes and subjects; they tend to have much the same sort of outlook on life in general, which translates into much the same sort of painting style. And this similarity primarily stems from the instinctual nature of their creative process. But this apart, almost all naive artists are or have been to some extent associated with one or other non-professional field of art. The most popular field of art for naive artists to date has been folk art.

Modern Art in Quest of New Material

The rebellion of Romanticism against classicism, and the resultant general enthusiasm for artworks that broke the classical mould, set the scene for the events that took place on the threshold between the nineteenth and twentieth centuries. Classical painting styles became obsolete: even its die-hard champions realised that classicism was in crisis. Historical and genre painting as featured in the Paris salons had taken to treating Leonardo's dictum that 'art should be a mirror-image of reality' as an excuse for mere vulgarity in a way that the great Italian master had certainly never envisaged. Admiration for the ancient world had turned from slavish devotion to the works of Plutarch to the prurient sentimentality embodied in such works as Jean-Léon Gérôme's *The Auction of a Female Slave.* Similarly, the burgeoning interest in the attractions of the mysterious East had resulted in no more than a host of portrayals of nude beauties in tile-lined pools.

At the same time, the quest for natural depiction, for reality of presentation, had stimulated the development of photography – which at one stage was a bitter rival of painting. After all, André Malraux quite rightly said that the one and only preoccupation of photography should

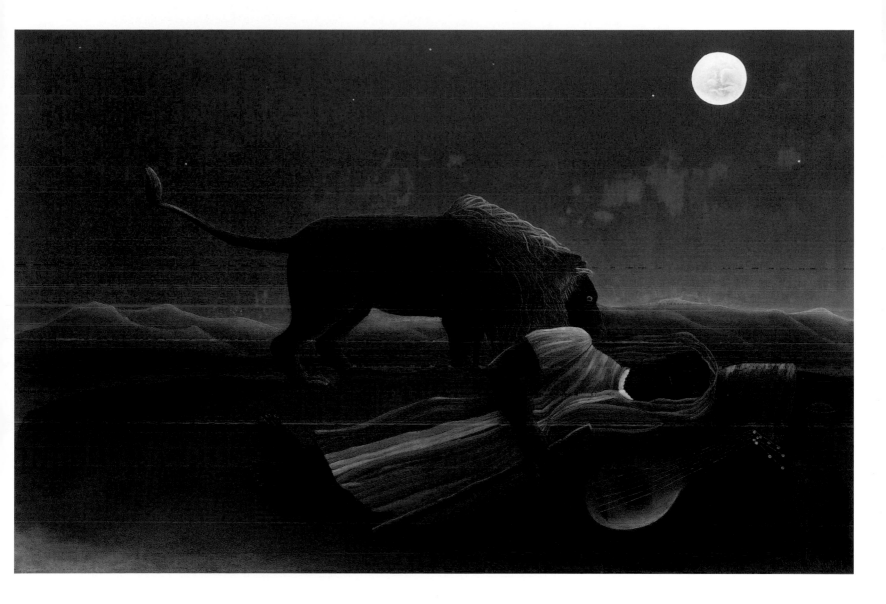

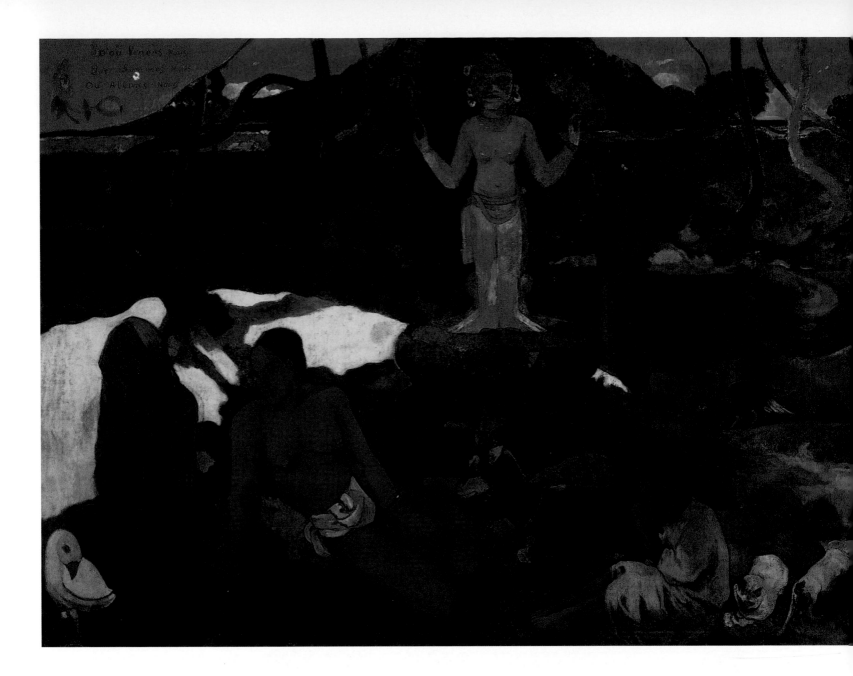

be to imitate art. In an endeavour somehow to outdo photography on its own terms, painters resorted to copying three-dimensional nature in minutely refined detail, using myriad brushstrokes. This was in itself nothing less than an acknowledgement of painting's incapacity and defeat. And such was the end of the Academy's domination, which had lasted since the seventeenth century. The most liberated of the artists of the Romantic era no longer bothered much with reality of presentation: photography, by reproducing reality as an instant of three-dimensional history caught forever, caused the final departure from it.

The famous words of Maurice Denis, written when he was only twenty years old in 1890, take on a special significance in this respect. 'Remember that a picture – before becoming a war-horse or a nude woman or a scene from a story – is essentially a flat surface covered with colours assembled in a particular order.'[4] It was the masters of the very early Renaissance years, already known customarily as 'primitives' in nineteenth-century Europe, whose work could be used to provide guidance in understanding the role of the flat surface as the basis for

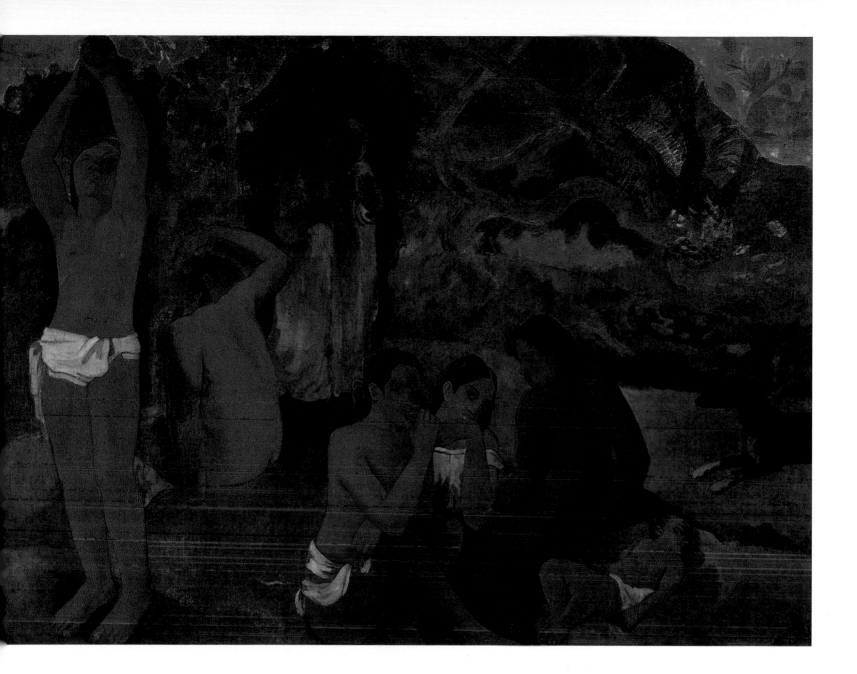

colour. And this heritage had the potential to lead to that new Renaissance which the future Impressionists dreamt of in their youth.

What the noted German philosopher Oswald Spengler called *Der Untergang des Abendlandes*, 'the decline of the West' (which was the title of his book), was also a powerful factor that increased the divide between artists who chose to look back to the system of the classical ancients and artists who had no truck with such criteria. Political Eurocentrism collapsed under the pressure of a complex multitude of pressures, and did so at precisely this time – the threshold between the two centuries. Yet by then European artists had already for some time been on the look-out to learn new things from other parts of the world. So, for instance, in their research into the 'mysterious East', the Romantic youth of the 1890s were also examining Japanese and Chinese art as part of a search for different approaches to the 'flat surface' about which Maurice Denis had written. Closer to home, Islamic art – 'primitive' in the most accomplished sense of the word – rose to considerable

Paul Gauguin,
Where Do We Come From?
Where Are We Going?, 1897-1898.
Oil on canvas, 139.1 x 374.6 cm.
The Museum of Fine Arts, Boston.

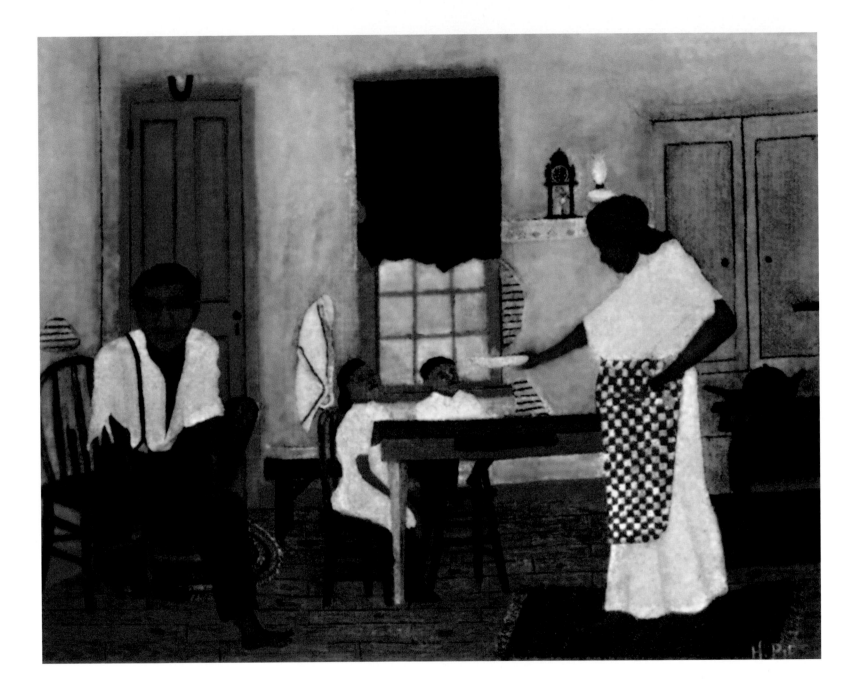

Horace Pippin,
Sunday Morning Breakfast, 1943.
Oil on canvas.
Private collection.

Paul Gauguin,
Eiaha Ohipa (Tahitians in a Bedroom),
1896.
Oil on canvas, 65 x 75 cm.
The Pushkin Museum of Fine Arts,
Moscow.

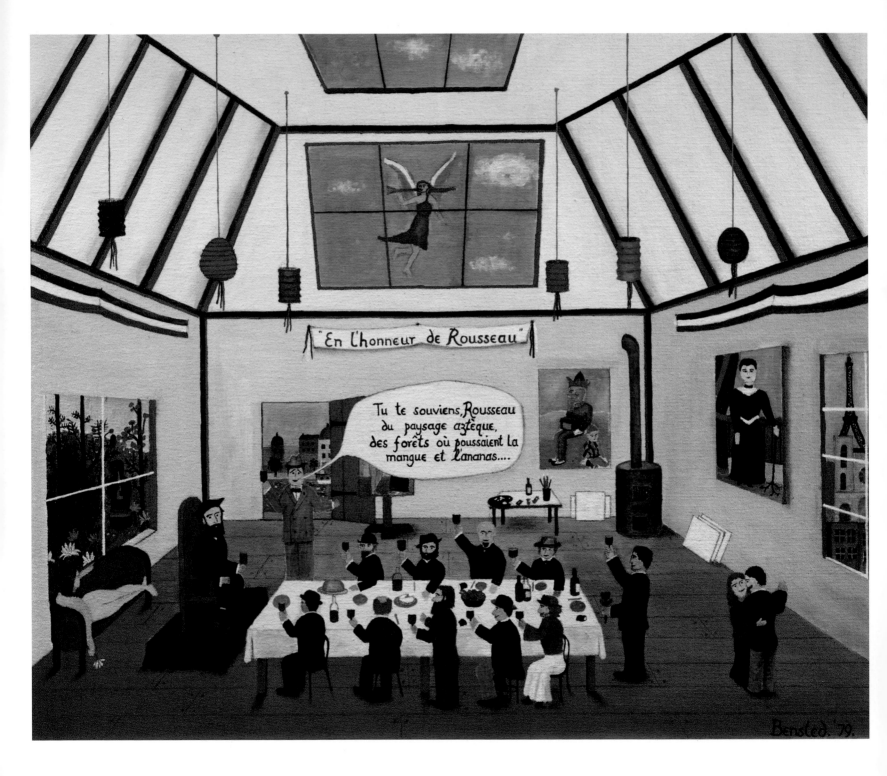

popularity during the first decade of the twentieth century, which increased following large exhibitions in Paris and in Germany.

The biggest boost to the new form of Romantic art came in the form of a massive influx of works from the 'primitive' world – some from Central and South America, but most from Africa – that poured into Europe at the turn of the twentieth century, chiefly through colonial agents. Until this time, the only conceivable description of works of art from these areas was as 'primitive'. The marvellous gold artefacts fashioned by native Peruvians and Mexicans, which flooded Europe following the discovery and colonisation of their lands, were regarded simply as precious metal to be melted down and reworked. Museums did keep and display items from Africa and the Pacific, but little interest was shown in obtaining them.

However, by the end of the nineteenth century, the territories of the world open to European exploration and trade had expanded so dramatically that far-off countries became objects not only of curiosity but also of study. A new science – anthropology – was born. In 1882 an anthropological museum opened in Paris. An Exhibition of Central America took place in Madrid in 1893. And in 1898 the French discovered a rich source of tribal art in their West African colony of Benin (called Dahomey from 1899 to 1975).

So it was that although the first Exhibition of African Art was mounted in Paris only in 1919, young artists had by then already been familiar with African artefacts for quite a while. According to one art-dealer, some of the Parisian artists had fair-sized personal collections from black Africa and Oceania. It is more than possible that the German Expressionist painter Karl Schmidt-Rottluff developed an interest in collecting such items even earlier. His fellow Expressionist Ernst Kirchner claimed that he had 'discovered' black African sculpture back in 1904, in the anthropological museum.

One event in particular marked a significant stage in the interface between European and African art, in that it presaged the rejuvenation of the former by the latter. The story was later narrated by the artist Maurice de Vlaminck and his friends.

Vlaminck was travelling back from doing some sketches up in Argenteuil, to the north-west of Paris, when he decided to stop at a bistro. There, he was surprised to espy – between the racked bottles of Pernod – wooden statuettes and masks, all of which had been brought from Africa by the bistro-proprietor's son. Vlaminck purchased the lot there and then. Once he had got home he showed them to his studio-companion André Derain, who was so impressed that in turn he persuaded his friend to sell them all on to him. Presumably, Derain next took them over to Matisse's studio to show him and the same thing happened yet again, because Picasso was amazed to be shown them when he was invited to dinner specially by Matisse. The story was concluded by Max Jacob, who recounted how he discovered Picasso the next morning poring over a stack of sketch-papers, on each one of which was an increasingly simplified head of a woman.

Vlaminck perceived what was the most valuable point of things 'primitive'. 'Black African art manages by the simplest of means to convey an impression of stateliness but also stillness.'[5] Nonetheless, having passed through the hands of Vlaminck, Derain and Matisse – all of them great artists – African sculpture directly affected only Pablo Picasso. Vlaminck dated this story to 1905, although most likely it actually happened a bit later. In any case, all the artists involved were by then in a mood to accept primitive art as a complete and entire phenomenon, not simply as a mass of individual and multifarious items.

John Bensted,
The Rousseau Banquet.
Oil on canvas, 50.7 x 60 cm.
Private collection.

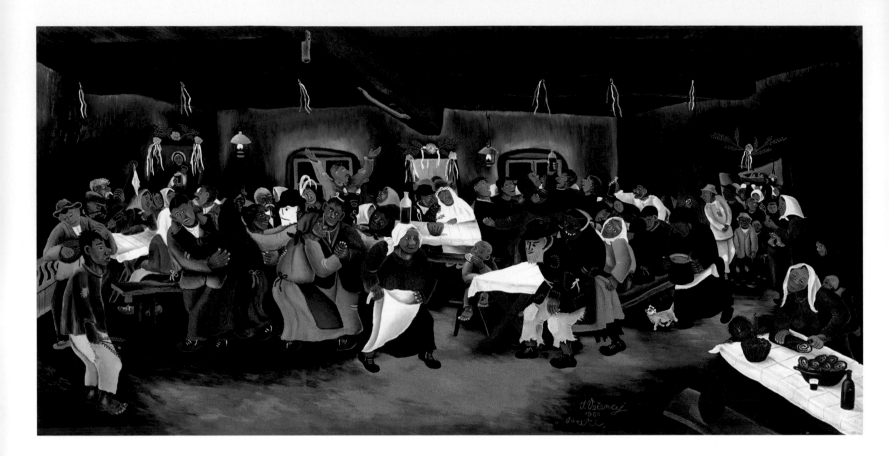

Most significantly, Picasso gradually worked out how to reveal the primal nature of objects thanks to the expressivity of African sculpture. It was this discovery that provided the impetus for him to go on to develop Cubism.

However primitive the sense of form presented by black African sculpture might seem to the European eye, it represented an aesthetic school that was centuries old and a tradition of craftsmanship inherited from remote ancestors. That a system exists means that it is possible to study it, to learn from it and to work to it. This is why the influence of African carving on European art has been so marked during the twentieth century.

Today, then, the art courses of many educational establishments focus on the interrelationship between twentieth-century painting and black African art, together with the influence of the art forms of native North America, Oceania and Arabic/Islamic Africa on European and North American artists from Gauguin up to the Surrealists. As art expert Jean Laude has said, the 'discovery' of black African art by Europeans 'seems to be an integral part of the general process of renewing sources; it is certainly a contributory factor'. [6] It was at the peak of this wave of enthusiasm, at the very moment of 'the decline of the West', that the naive artists emerged. There was no need to go searching for them in Africa or in Oceania.

Discovery – the Banquet in Rousseau's Honour

Ivan Vecenaj,
Dinner of the Night.
Gallery of Modern Art, Zagreb.

Impressionism actually had more of an effect upon art in general than it initially seemed to. The rebellion against the 'tyranny' of the old and traditional system of Classicism that it

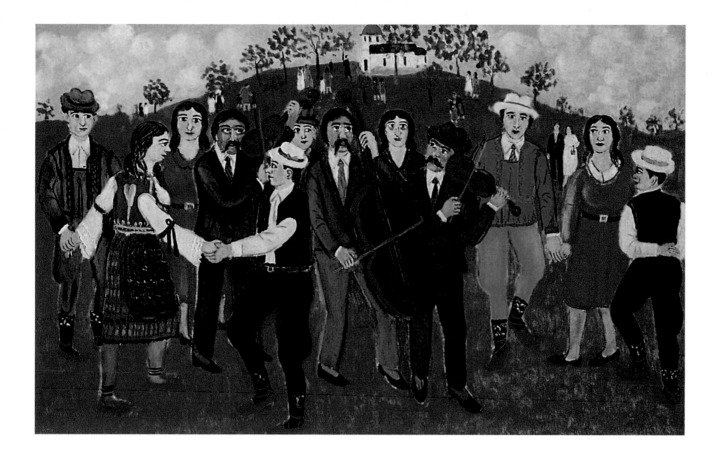

fomented – the establishing of the principle of freedom in content, form, style and context – led to a broadening of the whole concept of 'art' itself.

Towards the end of the Impressionist 'period' – so much so that they are forever labelled Post-Impressionist – Paul Gauguin and Vincent Van Gogh joined the Impressionists' ranks. What they lacked in training they made up for in hard work. Indeed, only in the very early pictures of Gauguin is any deficiency of skill evident. And when Van Gogh arrived in Paris in 1886, no one expressed any doubts as to his worthiness to take his place among the international clique of artists in the community in Montmartre which by that time had existed there for nigh on a century. Perhaps inevitably, the pair did not, however, find acceptance in the salon dedicated to the most classical forms of contemporary art. They were nonetheless able to exhibit their works to the public, especially since Parisian art-dealers – marchands – were opening more and more galleries. In 1884 the Salon des indépendants was launched. This had no selection committee and was set up specifically to put on show the works of those artists who painted for a living but were yet unable or unwilling to meet the requirements of the official salons. Of course there were many such artists – and of course among the overwhelming multiplicity of their mostly talentless works it was not always easy to identify those pictures that were exceptional in merit.

Henri Rousseau served as a customs officer at the Gate of Vanves in Paris. In his free time he painted, sometimes on commission for his neighbours and sometimes in exchange for food. Year after year from 1886 to 1910 he brought his work to the Salon des indépendants for display, and year after year his work was exhibited with everybody else's despite its total lack of professional worth. Nevertheless he was proud to be numbered among the city's artists, and

Janko Brašić,
Dance in Circle next to the Church.
Private collection.

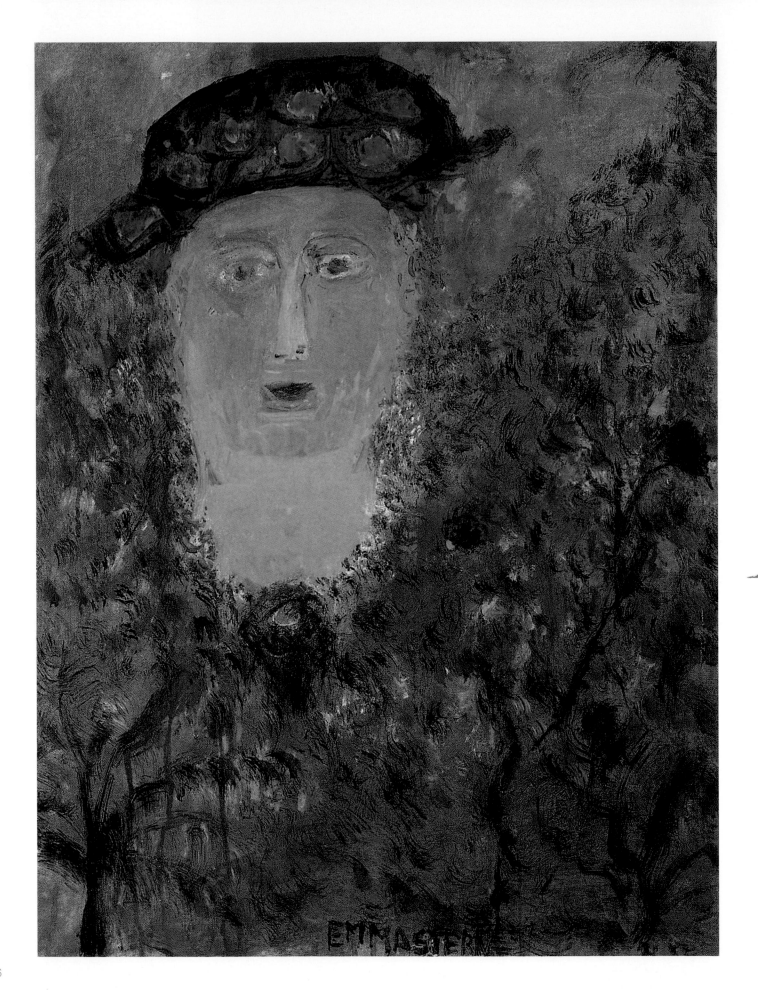

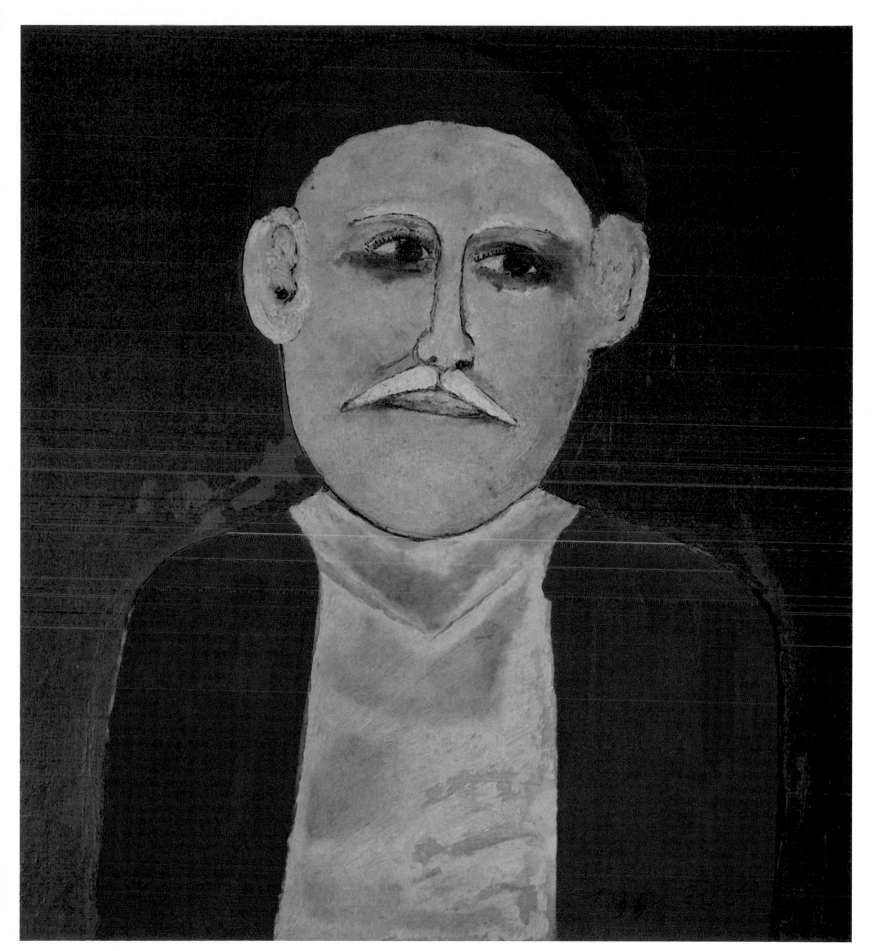

thoroughly enjoyed the right they all had to see their works shown to the public like the more accepted artists in the better salons.

Rousseau was among the first in his generation to perceive the dawn of a new era in art in which it was possible to grasp the notion of freedom – freedom to aspire to be described as an artist irrespective of a specific style of painting or the possession or lack of professional qualifications. His famous picture (now in the National Gallery, Prague), dated 1890 and entitled *Myself, Portrait-Landscape.* rather than the comparatively feeble self-portrait, reflected that selfsame ebullient self-confidence that was a characteristic of his, and established the image of the amateur artist taking his place in the ranks of the professionals. "His most characteristic feature is that he sports a bushy beard and has for some considerable time remained a member of the Society of the Indépendants in the belief that a creative personality whose ideas soar high above the rest should be granted the right to equally unlimited freedom of self-expression",[7] was what Rousseau wrote about himself in his autobiographical notes.

It just so happened that Pablo Picasso visited a M. Soulier's bric-a-brac shop in the Rue des Martyrs on a fairly regular basis: sometimes he managed to sell one of his pictures to M. Soulier. On one such occasion Picasso noticed a strange painting. It could have been mistaken for a pastiche on the type of ceremonial portraits produced by James Tissot or Charles-Emile-Auguste (Carolus-Duran) had it not been for its extraordinary air of seriousness. The face of a rather unattractive woman was depicted with unusually precise detail given to its individual features, yet with a sense of profound respect for the sitter. Somehow the female figure – clothed in an austere costume involving complex folds and creases and surrounded by an amazing panoply of pansies in pots on a balcony, observing a prominent bird flying across a clouded sky, and holding a large twig in one hand – looked for all the world like a photographer's model as posed by an amateur photographer, but still was hauntingly realistic and arresting. The artist was Henri Rousseau. The price was five francs. Picasso bought it and hung it in his studio.

In point of fact, it was not only Picasso who was interested in Rousseau's work at this time. The art-dealer Ambroise Vollard had already purchased some of Rousseau's paintings, and the young artists Sonja and Robert Delaunay were friends of his, as was Wilhelm Uhde, the German art critic who organised Rousseau's first solo exhibition in 1908 (on the premises of a Parisian furniture-dealer). But it was Picasso who, with his friends, decided in that same year to hold a party in Rousseau's honour. It took place in Picasso's studio in the Rue Ravignan at a house called the Bateau-Lavoir. Some thirty people turned up, many of them naturally Picasso's friends and neighbours, but others present included the critic Maurice Raynal and the Americans Leo and Gertrude Stein.

Decades later, during the 1960s, by which time the 'Rousseau banquet' had become something of a legend in itself, one of the guests – the naive artist Manuel Blasco Alarcon, who was Picasso's cousin – painted a picture of the event from memory. Henri Rousseau was depicted standing on a podium in front of one of his own works, and holding a violin. Seated around a table meanwhile were various guests whom Alarcon portrayed in the style of Picasso's Gertrude Stein and Henri Rousseau's Apollinaire and Marie Laurencin.

At the banquet all those years previously, the elderly ex-Douanier Rousseau (then aged sixty-four, having retired from his customs post at the age of forty-one in order to concentrate on art) found himself surrounded mainly by vivacious young people intent on having a good time but in a cultural sort of way. Poems were being recited even as supper was being eaten. There was dancing to the music of George Braque on the accordian and Rousseau on the

Emma Stern,
Self-Portrait, 1964.
Oil on canvas, 61 x 46 cm.
Clemens-Sels-Museum, Neuss.

Sava Sekulić,
Portrait of a Man with Moustache.
Mixed media on cardboard,
45 x 48 cm.
Galerie Charlotte, Munich.

Marie Laurencin,
The Italian, 1925.
Oil on canvas.
Former collection of Albert Flamert.

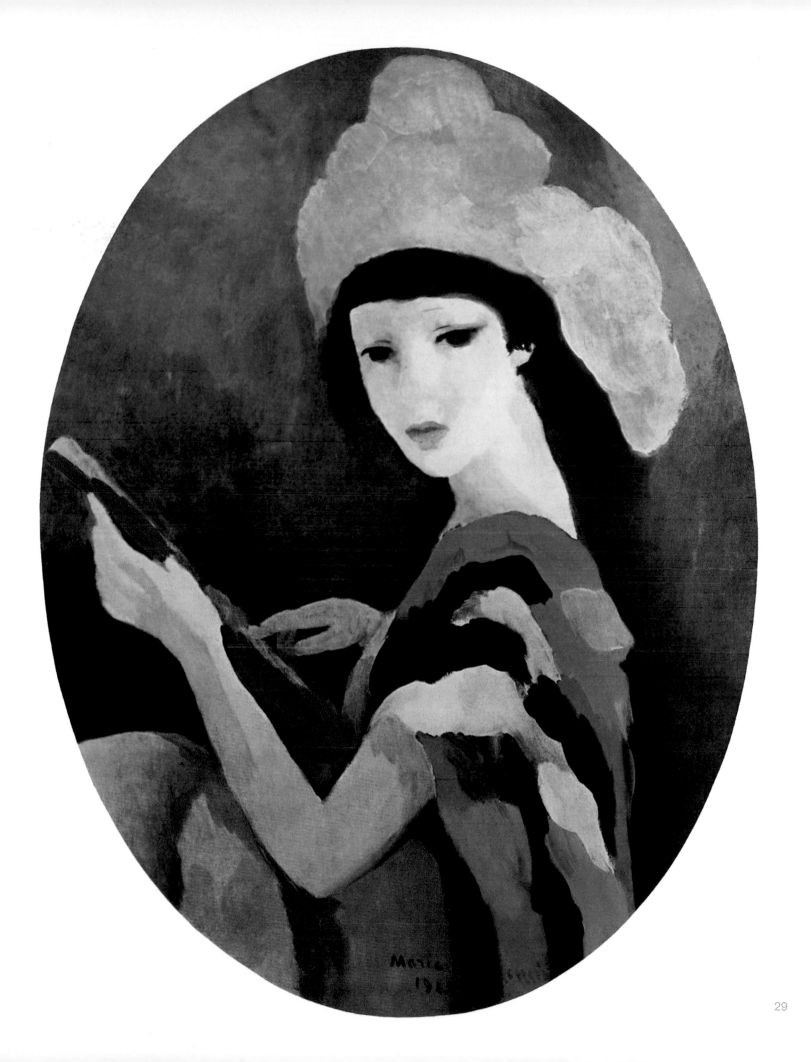

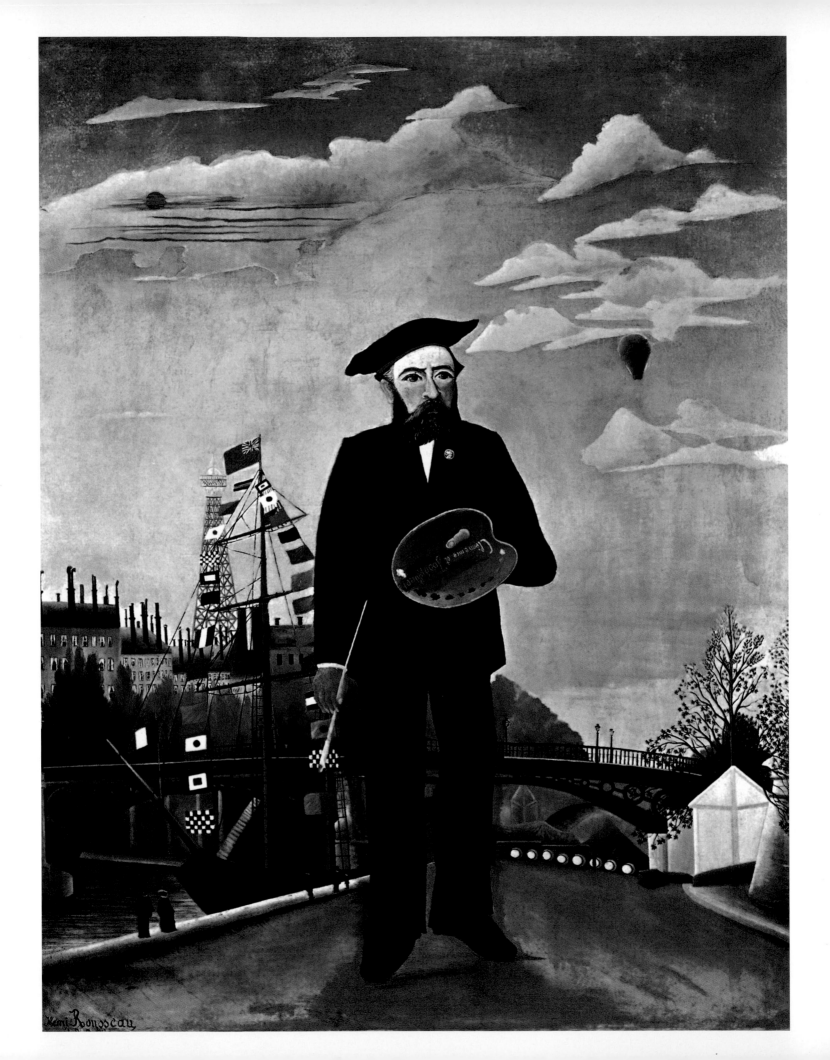

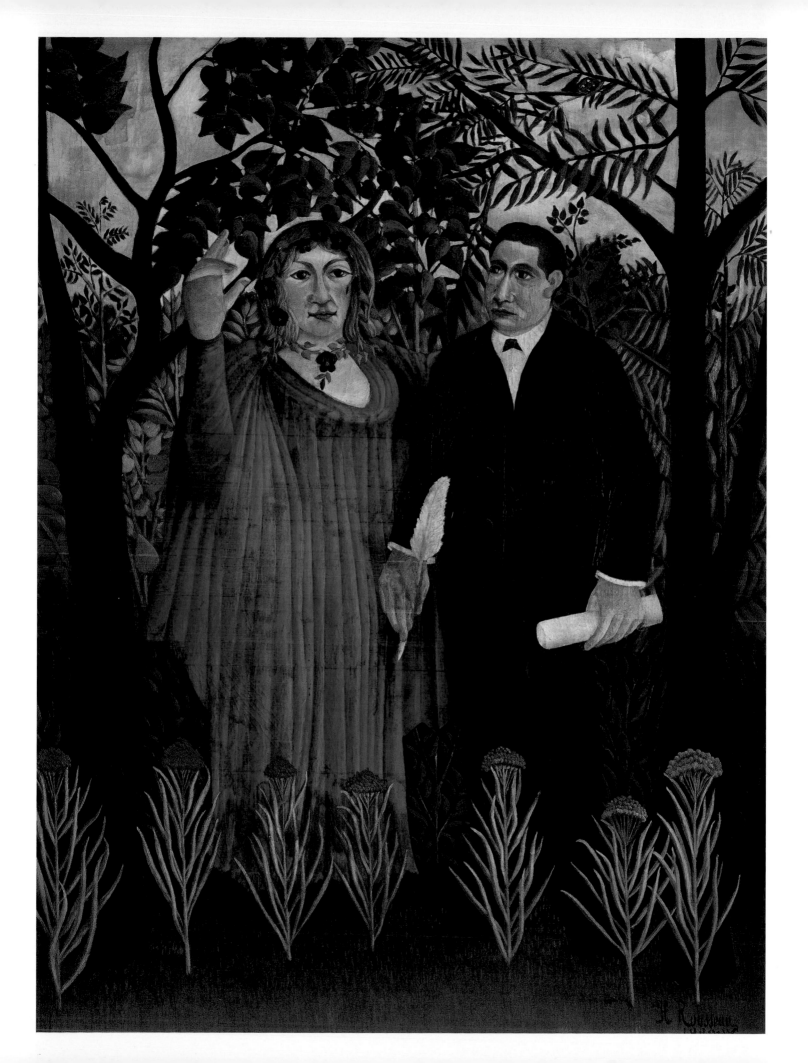

Henri Rousseau, also called
the Douanier Rousseau,
Myself, Portrait-Landscape, 1890.
Oil on canvas, 143 x 110 cm.
Národní Galerie, Prague.

Henri Rousseau, also called
the Douanier Rousseau,
*Guillaume Apollinaire
and Marie Laurencin*, 1909.
Oil on canvas, 200 x 389 cm.
The State Hermitage Museum,
St Petersburg.

Henri Rousseau, also called
the Douanier Rousseau,
Horse Attacked by a Jaguar, 1910.
Oil on canvas, 89 x 116 cm.
The Pushkin Museum of Fine Arts,
Moscow.

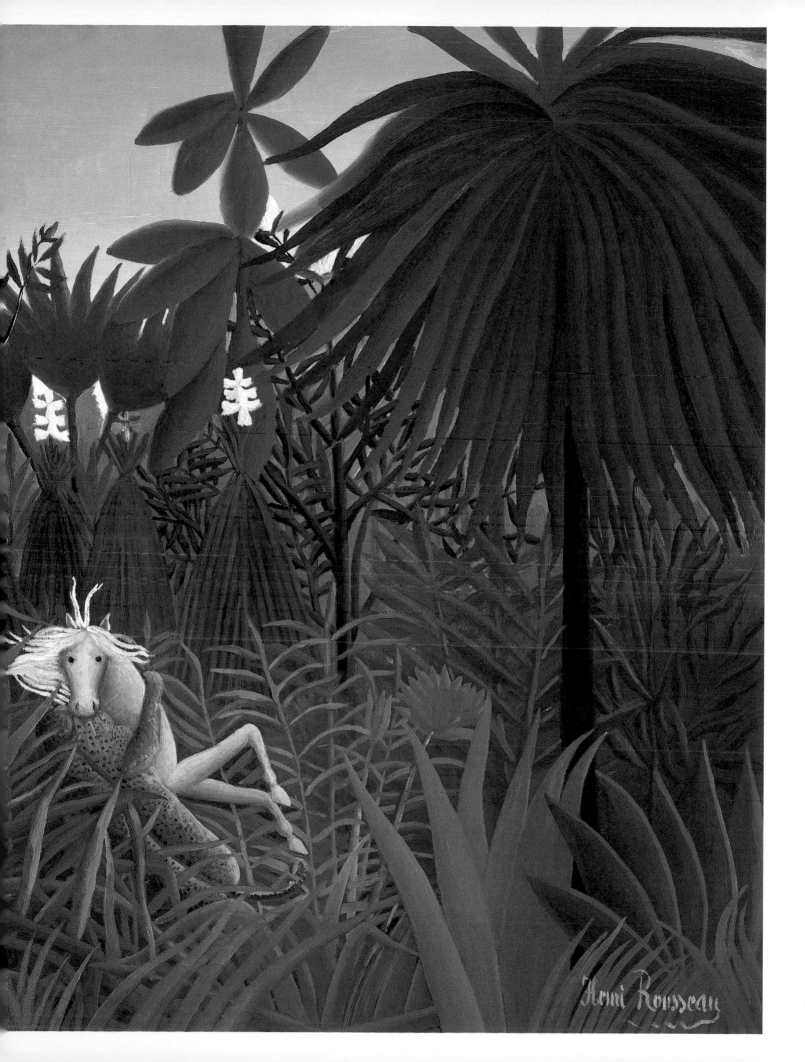

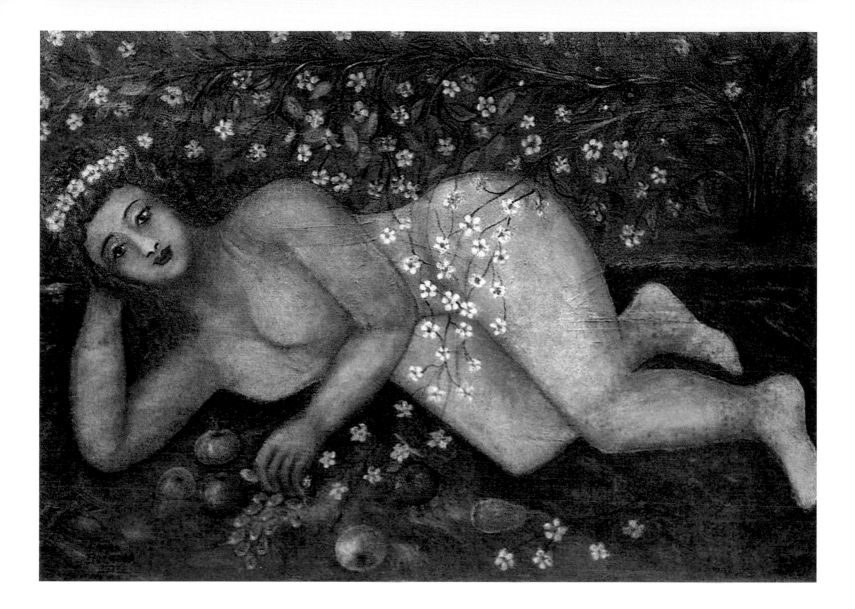

violin – in fact, Rousseau played a waltz that he had composed himself. The party was still going strong at dawn the next day when Rousseau, emotional and more than half-asleep, was finally put into a fiacre to take him home. (When he got out of the fiacre, he left in it all the copies of the poems written for him by Apollinaire and given to him solicitously as a celebratory present.) Even after he had departed, the young people carried straight on with the revels. Only later in the memories of the people who had been there did this 'banquet' stand out in their minds as a truly remarkable occasion. Only then did individual anecdotes about what happened there take on the aspect of the mythical and the magical. Quite a few were to remember a drunken Marie Laurencin falling over on to a selection of scones and pastries. Others indelibly recalled Rousseau's declaration to Picasso that "We two are the greatest artists of our time – you in the Egyptian genre and me in the modern!"[8]

This statement, arrogant as it might have seemed at the time to those who heard it, was by no means as ridiculous as some of those present might have supposed. As the story of the 'Rousseau banquet' spread around the city of Paris and beyond, the people who had been there began in their minds to edit what they had seen and heard in order to present their own versions when asked. Six years later, in 1914, Maurice Raynal narrated his recollections of it in Apollinaire's magazine *Soirées de Paris*. Later still, Fernanda Olivier and Gertrude Stein wrote it up in their respective

Ivan Rabuzin,
Flower on the Hill, 1988.
Watercolour on paper, 76 x 56 cm.
Rabuzin Collection, Ključ.

Elena A. Volkova,
Young Girl from Sibera.
Private collection.

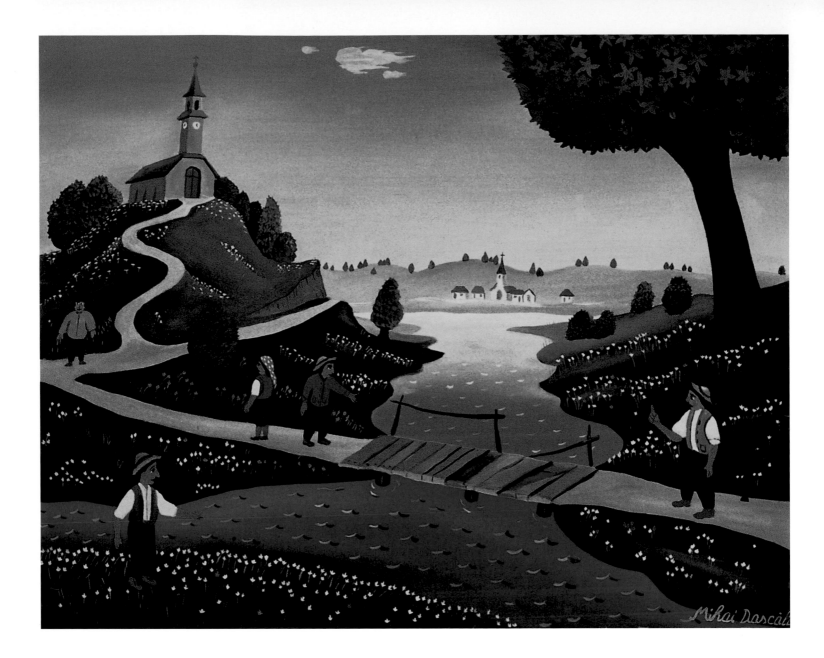

Mihai Dascalu,
The Broken Bridge.
Oil on canvas, 50 x 70 cm.
Private collection.

memoirs. In his *Souvenirs sans fin*, André Salmon went to considerable pains to point out that the 'banquet' was in no way intended as a practical joke at Rousseau's expense, and that – despite suggestions to the contrary – the party was meant utterly sincerely as a celebration of Rousseau's art. Why else, he insisted, would intellectuals like Picasso, Apollinaire and he himself, André Salmon, have gone to the trouble of setting up the banquet in the first place? This was too much for the French artist and sculptor André Derain who publicly riposted to Salmon, "What is this? A victory for con-artistry?" [9] Later, he was sorry for his outburst, particularly in view of the fact that he rather admired Rousseau's work, and only quarrelled with Maurice de Vlaminck, one of his best friends, when Vlaminck was unwise enough to suggest in an interview with a journalist that Derain was dismissive of Rousseau's work.

Only a few years later, and there was actually a squabble about who had 'discovered' Rousseau. The critic Gustave Coquiot in a book entitled *Les Indépendants* expressed his exasperation at hearing people say that it had been Wilhelm Uhde who had introduced Rousseau and his work to the world. How was it, he asked indignantly, that some German fellow could claim in 1908 to present for the first time to the Parisian public a Parisian

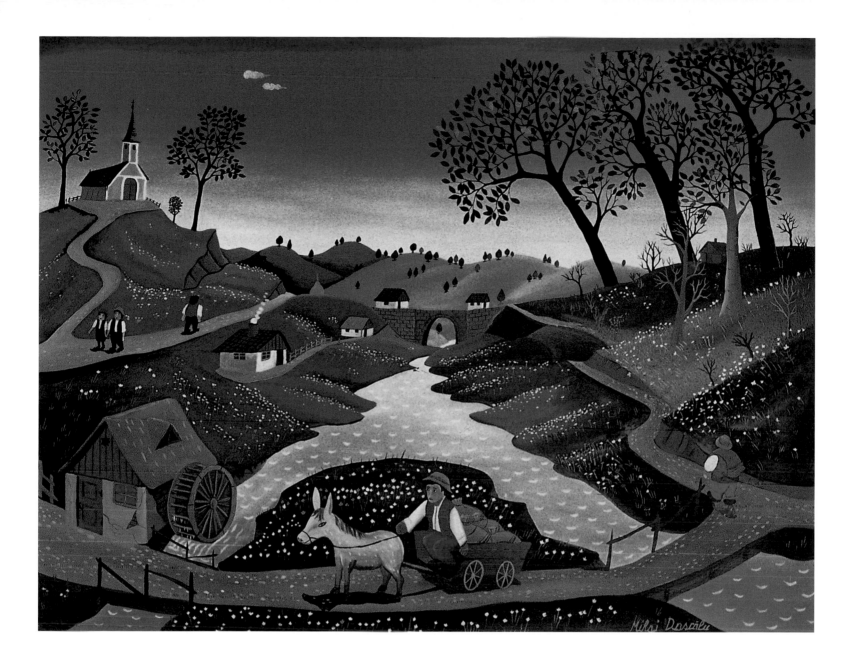

artist whose work had been on show in Paris to those who wanted to see it ever since 1885 or earlier? [10]

Writing enthusiastically about Rousseau's paintings, and praising his unique style, Coquiot went on to make an interesting comment. "There must be many an amateur artist in France – Sunday painters who for the rest of the week may be working men, tradesmen or businessmen. I once gave the artist Vlaminck a painting called *Dance of the Bayadère*, produced by a wine merchant from Narbonne. It was a rather pretentious canvas in the style of Rousseau. But the point is that on another occasion the same merchant painted a picture he called *Place de l'Opéra* which did indeed show the Opera in all its intricate detail. Now that is surely amazing!" [11]

These words of Coquiot mark a new line in the spectrum that is the history of naive art. Discussion and appreciation of Rousseau's works inevitably led to discussion and (sometimes) appreciation of the works of others in similar vein. Accordingly, some perhaps not so talented but undoubtedly original artists were noticed and even encouraged to come forward. A chain of 'discoveries' ensued. 'Primitive' and 'naive' art was suddenly all around – to the extent that professional artists were becoming heavily involved.

Mihai Dascalu,
Close to the Windmill.
Oil on canvas, 80 x 100 cm.
Private collection.

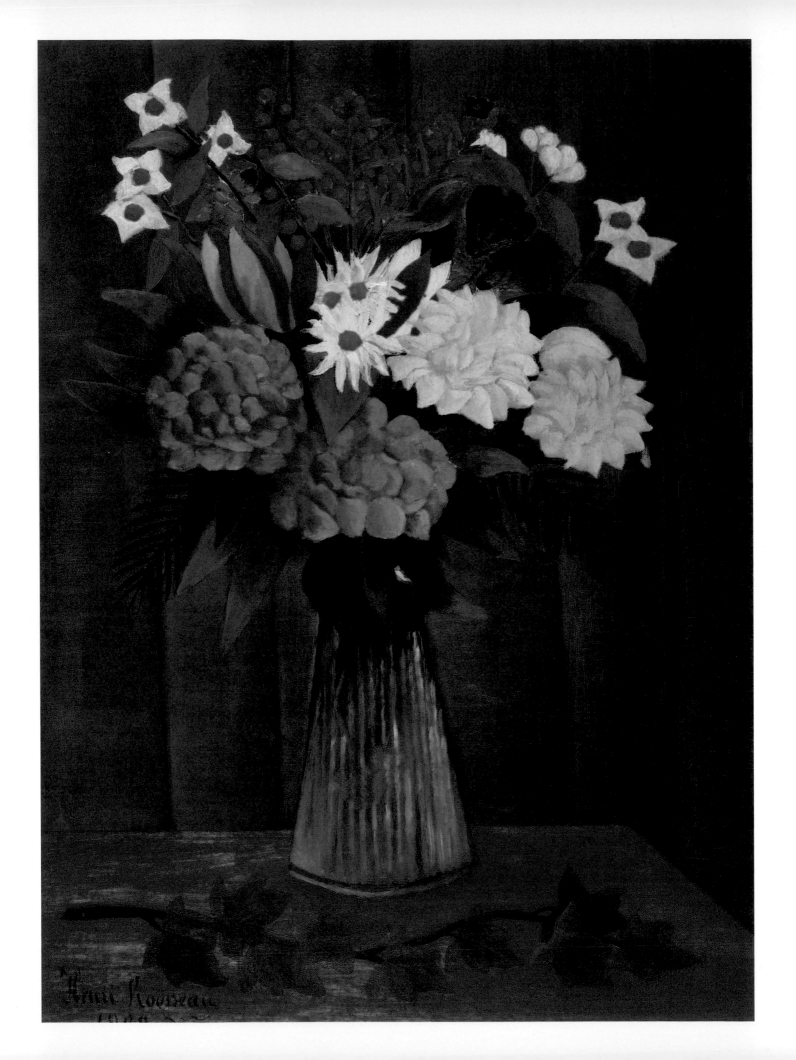

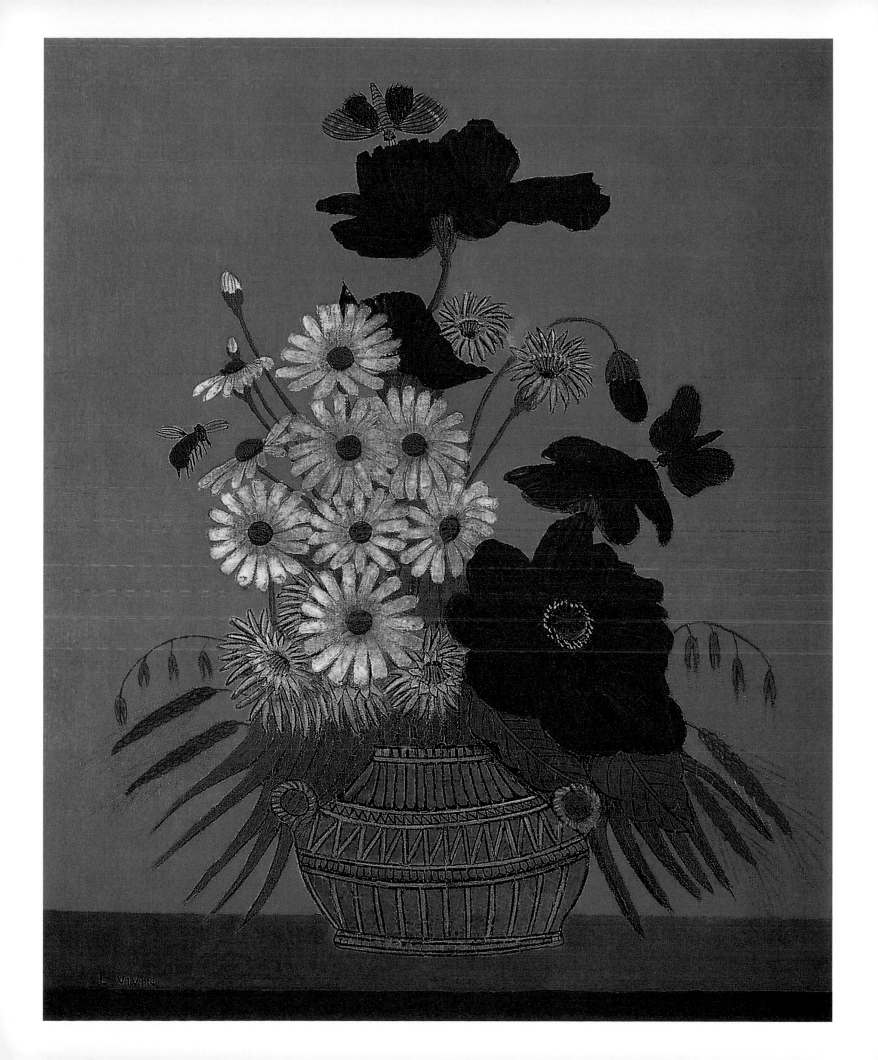

Henri Rousseau, also called
the Douanier Rousseau,
Bouquet of Flowers, 1909.
Oil on canvas, 46.5 x 33.5 cm.
Albright Knox Art Gallery, Buffalo.

Louis Vivin,
Still-Life with Butterflies and Flowers.
Oil on canvas, 61 x 50 cm.
Museum Charlotte Zander,
Bönnigheim.

Alfred Wallis,
The Blue Ship, c. 1934.
Oil on wood panel,
43.8 x 55.9 cm.
Tate Britain, London.

II. Back to the Sources:
From the Primitives to Modern Art

Primitive Art and Modern Art: Miró's Case

In 1919 Pablo Picasso bought himself a picture by the young Catalan artist Joan Miró. Called *Self-Portrait*, the picture was painted in a way that gave no hint at all that its originator had spent many years studying art. Instead, it resembled the diligent yet clumsy handiwork of an unskilful village artist. And that was what so captivated Picasso. *Self-Portrait* marked the beginning of a friendship between the two men.

Based in Paris, Miró went on to enjoy the company of other artistic and cultural luminaries, notably Max Ernst and André Masson, the poets Pierre Reverdy, Max Jacob and Tristan Tzara, and the critic Maurice Raynal. The artists of the contemporary Paris school were particularly intrigued by Miró's work, believing that they saw in it the rudiments of a new, lively style that might do much to reinvigorate what they had come to think of as the depressingly indolent state of European art.

This, after all, was only a decade or so after the end of the nineteenth century – a time when artists, in despair at the superficiality and falseness of civilised society, had turned their eyes more towards primitive communities of 'natives' and 'savages'. Paul Gauguin, for one, left France altogether in order to try to experience oneness with nature among the people of the Pacific islands, thousands of miles from the soaring cities of his homeland. His intention was to immerse himself in the life and culture of Tahiti in such a way as to reinvent his own artistic style, firmly believing that in their roughly-carved stone idols the Tahitian sculptors were able somehow to express what was beyond the capacities of the more polished art of European studios.

By the time Joan Miró arrived in Paris, however, the young Catalan had already found sources of inspiration much closer to home.

During this period, most of his holidays from school were spent with his maternal grandparents in Palma de Mallorca, the capital of Majorca. Now on the cliffs of Majorca there remain a number of prehistoric paintings and drawings which, in their skilful use of the expressive dynamism of empty space, succeed not only in communicating a distinctive perception of the world but in conveying – through strength of form – the very human sense of pride in power. Joan Miró visited Majorca repeatedly through his life. And it would seem likely that each time he did so, it was consciously or unconsciously to reaffirm his attraction for such large simple forms, for such clean lines and for such natural texture of material.

There were, however, additional sources of inspiration for these facets of Miró's art. "I'll tell you what interests me more than anything else, he said. It is the linear form of a tree or a roofing-tile – it is gazing at one leaf after another, one twig after another, one clump of grass after another…"[12] Just as probable that was aroused his passion for paints.

Ilja Bosilj-Basicevic,
The Baptism of Christ.
Oil on wood, 89 x 69 cm.
Clemens-Sels-Museum, Neuss.

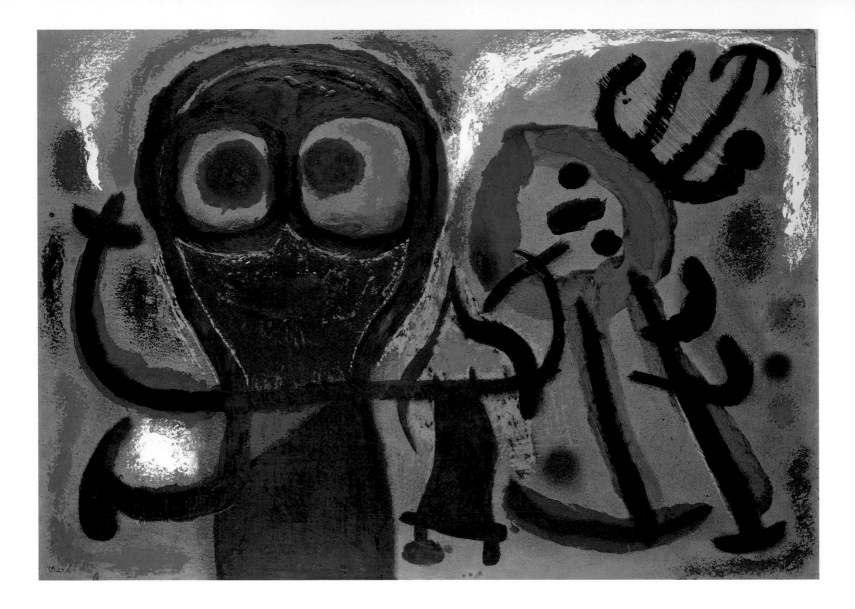

From Medieval to Naive Artists: A Similar Approach?

'Primitive' art may on first consideration seem to bear little relevance to a review of naive art. But there is a connection. It was the energy of this primitive stratum of art which nurtured every naive artist of the twentieth century. More significantly, the naive artists were rescued from their obscurity on the crest of a wave of enthusiasm for all things 'primitive' and all things 'wrong' which had no ties to any specific geographical or chronological framework. The first stirrings of the swell that was to produce that wave of interest had come centuries earlier, during the Age of Romance.

The Renaissance in Europe relied on a scientific system of pictorial representation that remained the sole criterion of the professional artist until the twentieth century. "A mirror that has a flat surface nonetheless contains a true [three-dimensional] picture on this surface. A perfect picture executed on the surface of some flat material should resemble the image in the mirror. Painters, you must therefore think of the mirror's image as your teacher, your guide to chiaroscuro and your mentor for the correct sizing of each object in the picture",

Joan Miró,
Person and Bird, 1963.
Oil on cardboard, 75 x 105 cm.
Private collection.

Joan Miró,
Person and Bird Facing the Sun, 1963.
Oil on cardboard, 106.6 x 73.6 cm.
Private collection.

Viorel Cristea,
The Gathering.
Oil on cardboard, 30 x 40 cm.
Private collection.

„A înflorit Iorgovanu La Ghelad"

Viorel

Ana Kiss,
The Harvest.
Oil on canvas, 42 x 48 cm.
Private collection.

wrote Leonardo da Vinci. [13] So rejecting everything that had to do with the realm of sensitivity and intuitive insight, the Renaissance artist revered scientific measurement and precision to such an extent that painting was thoroughly enmeshed in a network of mathematical calculations. Art had indeed become a science.

To the Renaissance artist, all other forms of artistic endeavour – prehistoric art, the art of the early inhabitants of Africa and Oceania, the art of the Oriental peoples, even the homely crafts of rustic fellow Europeans – remained outside the limits of what was true art. The whole body of artistic enterprise that had accumulated during the Middle Ages (with all its cathedrals and religious masterpieces) was similarly not to be regarded as true art. No heed was paid to the fact that the medieval artists genuinely did work to a system – their own contemporary system. The logic went that they were 'primitive' because, principally, they did not profess the religion of perspective. Duccio di Buoninsegna, Cimabue and Giotto – great masters of the thirteenth and fourteenth centuries – were all 'primitives' because their paintings did not present a scientifically-proportioned mirror-image of reality.

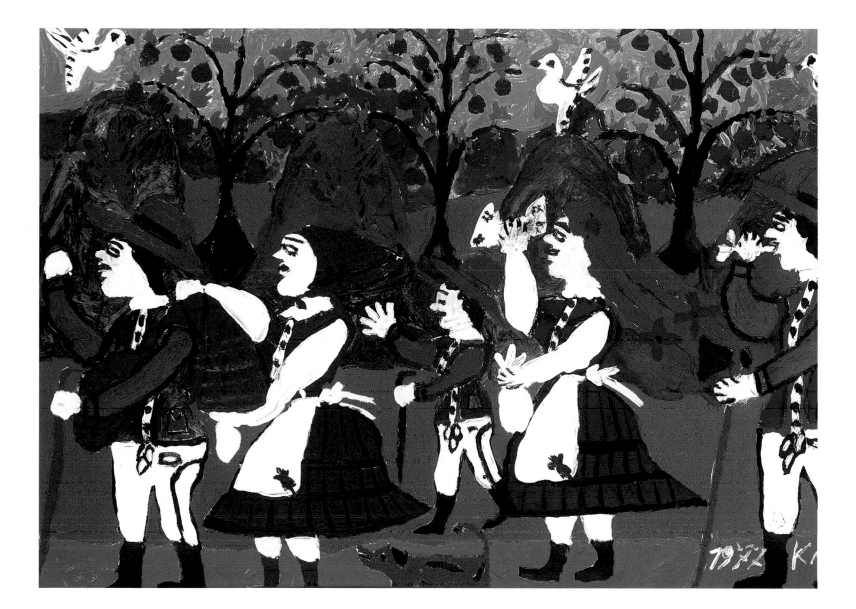

The Age of Romance marked the beginning of reconciliation with the 'primitives', the first steps on a return journey. It was not an end in itself for the young Romantic artists. They rejected the traditional classical subjects of paintings, based on Plutarch's *Lives*, demanding that art become more closely related to reality and contemporary life. The critic Auguste Jal wrote in 1824, "I have been a citizen of Athens, of Carthage and of Latium. Today, what I want is France." [14] All very well, of course, but France would not be France today without the France of yesterday: the past is an intrinsic part of the present.

It was in 1831 that Victor Hugo astounded the world with his presentation in a novel of a Paris completely different from the city of his contemporaries. The book in which he brought it all to life is in English called *The Hunchback of Notre-Dame* (although the French title is the slightly more prosaic *Notre-Dame de Paris*), and the Paris he portrayed – specifically the area of Paris known as Notre-Dame – was one that few nineteenth-century Parisians had thought seriously about. "However beautiful the modern Paris might seem to you", wrote Hugo to his readers, "replace it with the Paris of the fifteenth century. Reproduce it in your imagination.

Ana Kiss,
Saying Farewell.
Oil on cardboard, 42 x 53 cm.
Private collection.

Look at the world anew through an extraordinary forest of spires, turrets and steeples…"[15] At that time it was a city of two levels, Romanesque and Gothic.[16] This was the first occasion in recorded history that a notable commentator was viewing the changes in architecture wrought by the Renaissance as a crime perpetrated on its original, true appearance. The Renaissance era turned out to be intolerant. Not satisfied with creating, it wanted to overturn things.[17] With the fervour of a true Romantic, Hugo railed at previous generations for allowing the grandly mysterious, majestic area of the city to become the travesty of an eyesore it now was. "Such maiming and dismembering, such wholesale changes to the very nature of a building, such perverse 'restoration' work – these are the kinds of things done by the followers of Vitruvius and Vignola [writers of the standard textbooks on systematic order in classical architecture]!" he thundered. [18]

Not content with pouring scorn on the 'new order', Hugo was fulsome in his praise for the 'primitives'. "This is how magnificent art created by men who cared nothing about what other people thought was destroyed by academics and theorists and line-drawers," he said scathingly, [19] then going on to describe the 'magnificent art'. "It is like a huge symphony in stone, a vast work of creative endeavour on the part of humankind . . . It is the miraculous result of the combined forces of an entire age, a result by which the energy of a worker influenced by the genius of art bursts forth from every stone, assuming hundreds of forms."[20] The 'worker' he was talking about was a 'naive' artist.

The impact Hugo's words made on others of his generation was tremendous. Many immediately determined to defend and protect national treasures that had till then been altogether excluded from the lists and catalogues of artistic works. The architect Eugène Viollet-le-Duc devoted his life thereafter to the accurate restoration of Gothic cathedrals to their original appearance. The writer and playwright Prosper Mérimée, who in his other professional life was Inspector of Historic Monuments, was likewise energetic in seeing to the protection and conservation of medieval works of art, notably mille-fleurs tapestries. Thanks to him the Musée de Cluny in Paris came into possession of the magnificent *Lady and the Unicorn* series of tapestries now famous the world over. And from then on, museums and collections in France began deliberately to acquire and display the works of the previously-ignored 'primitives'.

In due course, an exhibition of medieval French art was staged in Paris in 1904. It brought the world of the 'primitives' to the next generation of artists – to Picasso and Matisse, to Vlaminck and Derain, to the very people who were a few years later themselves to introduce Henri Rousseau to the artistic community.

Naive Art Sources: From Popular Tradition to Photography

Naive Artists and Folk Art

Anuta Tite,
The Preparation of the Bride.
Oil on cardboard, 50 x 60 cm.
Private collection.

A naive artist creates singular and inimitable works of art. This is because, for the most part, the naive artist is not a professional artist but has a quite separate occupation by which he or she earns a living, in which he or she relies on a totally different set of skills

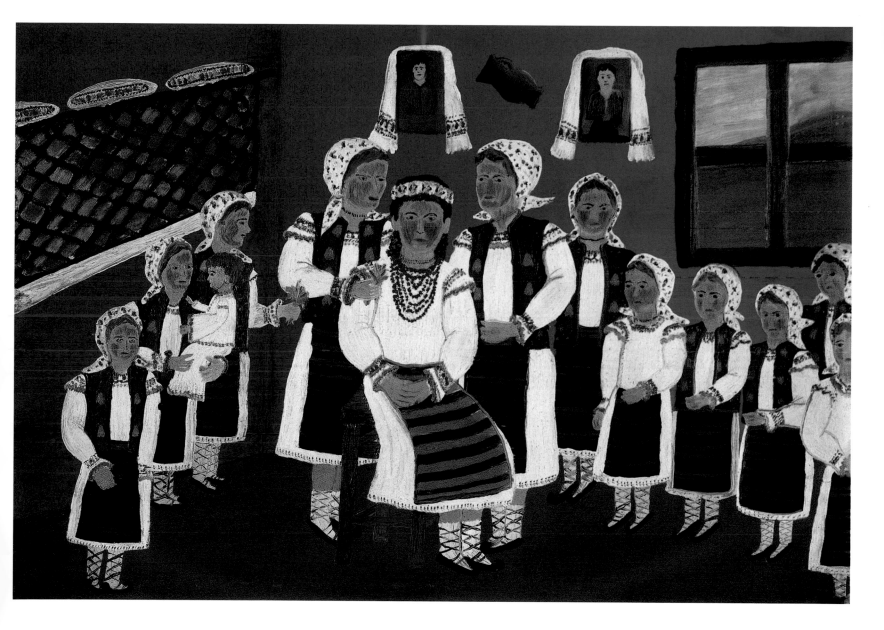

Niko Pirosmani,
Wedding.
Oil on canvas, 113 x 177 cm.
National Museum of Art and People of
the Orient, Moscow.

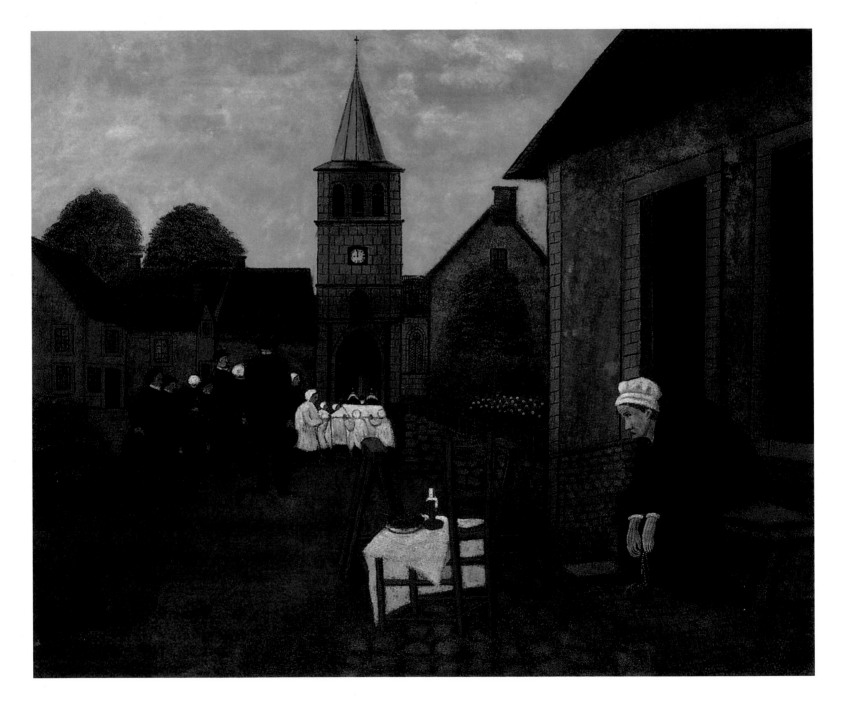

Louis Vivin,
The Burial of My Father, c. 1925.
Oil on canvas, 69.8 x 81.3 cm.
Museum Charlotte Zander,
Bönnigheim.

(in which he or she may be expert enough to achieve considerable job satisfaction), and which takes up much of his or her daily life. The twentieth century has seen many a 'Sunday artist' who has attracted imitators and patrons but who has never ceased to look at the world through the eyes of his or her workaday occupation. Particularly characteristic of them is an artisan's diligence and pride in the works of art they produce. They are taking their 'professional' attitude towards their workaday occupation and transferring it on to their creations. They have no access to elite artistic circles, and would not be accepted by them if they had. The naive artists thus live in a small world, often a provincial world, a world that has its own artisans - the producers of folk art.

Some say that folk artists have for centuries repeated the same forms using the same colours in the same style, and are doomed therefore endlessly to reproduce the same subjects in their art and to the same standards. But folk artists do not only produce traditional forms of applied art - they also make shop-signs and colourfully ornate panels for stalls and rides at fairs. And although these artisans' work is rooted in their own form of expertise, it is often very difficult to draw a distinct line to separate their work from that of naive artists. Sometimes, after all, the power in the coloration, the sense of modernity and the feel for line and form in an artisan-made sign can elevate it to the level of an outstanding and individual work of art. At the same time it should be remembered that when Henri Rousseau or Niko Pirosmani painted a restaurant sign or was commissioned by neighbours to depict a wedding in their house or their new cart in the barn, the resultant piece would be considered by all to be an artisan's work.

In Russia, the painted sign has always enjoyed a special status, and those who are exceptionally talented at producing them deserve recognition as genuine naive artists. "A sign in Russia has no equivalent in Western cultures", wrote the artist David Burliuk in 1913. "The utter illiteracy of our people [and he was being quite serious at the time] has made it an absolute necessity as a means of communication between shopkeeper and customer. In the Russian sign the folk genius for painting has found its only outlet." [21] A multitude of bylaws and regulations governed the size and shape and even the look of signs in urban environments. It was the inventive capacity of the creators that helped them find a way through the maze of restrictions. By the end of the nineteenth century the best of the sign-painters were putting their names to their works: one or two were even making a reputation for themselves.

At the turn of the twentieth century one name that became well known in St Petersburg in this way was that of Konstantin Grushin. His work on behalf of the shopkeepers of the city included magnificent still-lifes of fruit and vegetables, and picturesque landscapes with bulls or birds.

Signs were supposed to be painted against a black border. Despite this regulation, the painter Yevfimiy Ivanov managed to produce works of art that truly befitted such a

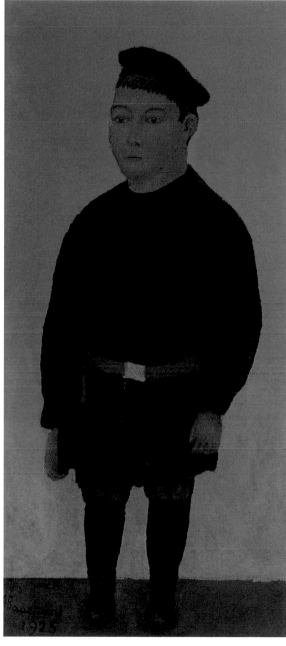

André Bauchant,
The School Boy, 1925.
Oil on canvas, 45 x 21 cm.
Museum Charlotte Zander,
Bönnigheim.

description. His style was free and broad, his composition uninhibited yet expert. Notwithstanding the fact that the functional nature of signs imposed upon them a certain need for a quality of flatness and ornamentation, each artist dealt with this requirement in his or her own way. A panel meant to advertise Shabarshin's Furniture Delivery Services, for example, painted by the talented Konstantin Filippov, may be called a sign only because there are words on it. In all other respects it is an easel-painting. Powerfully-portrayed draught-horses are set against a delicately refined backdrop. The wheels and harnesses of the horses are meticulously executed. In overall style this work is typical of urban naive artists, reminiscent of the famous *The Cart of Father Juniet* by Henri Rousseau.

Ready-to-wear clothes shops were particularly blessed in the quality of their signs. Vasily Stepanov's advertising signs for the shops of a certain Mr Kuzmin featured fashionably-dressed ladies and gentlemen, but he made them look as if they had been asked to sit for ceremonial portraits, virtually in salon style. Stepanov did, however, include some elements of parody. Singular in themselves and yet typical of their kind, these signs were supremely representative of their time and their location, and as such constitute a sort of historical document.

Gheorghe Dumitrescu,
Celebration Day.
Oil on cardboard, 35 x 48 cm.
Private collection.

It was no wonder that signs like these were prized so highly by the artists of the Russian avant-garde - the artists of Picasso's generation - that they started to collect them. The poet Benedikt Livshitz wrote, "A burning desire for things primitive, and especially for the signs painted to advertise provincial establishments of such trades as laundry, hairdressing, and so on - as had had a profound effect on Larionov, Goncharova and Chagall - caused Burliuk to spend all the money he had on buying signs created by artisans... For Burliuk it was not simply a matter of satiating a temporary whim involving a fad for folk art, a sudden craze for the primitive in all its manifestations, such as the art of Polynesia or ancient Mexico. No, this enthusiasm was far more profound." [22]

Reflecting on the origins of the interest of the avant-garde in primitive art as a whole, Livshitz quoted an eloquent statement by the brothers David and Vladimir Burliuk: "There has been no progress whatsoever in art - has been none, and never will be any! Etruscan statues of the gods are in no way inferior to those of [the ancient Athenian] Phidias. Each era has the right to believe that it initiates a Renaissance." [23]

Historical circumstances delayed the onset of the industrial revolution in Russia. The chaos that surrounded the political Revolution hindered the authorities from re-establishing

Ion Nita Nicodin,
Apple Picking.
Oil on canvas, 50 x 60 cm.
Private collection.

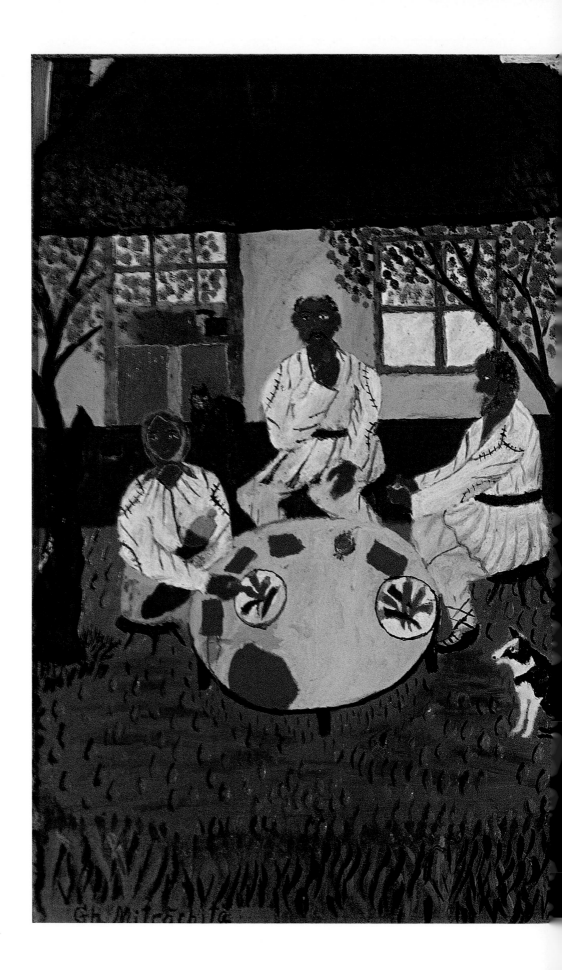

Gheorghe Mitrachita,
*Peasants at Table Yesterday
and Today,* 1908.
Oil on canvas, 50 x 60 cm.
Private collection.

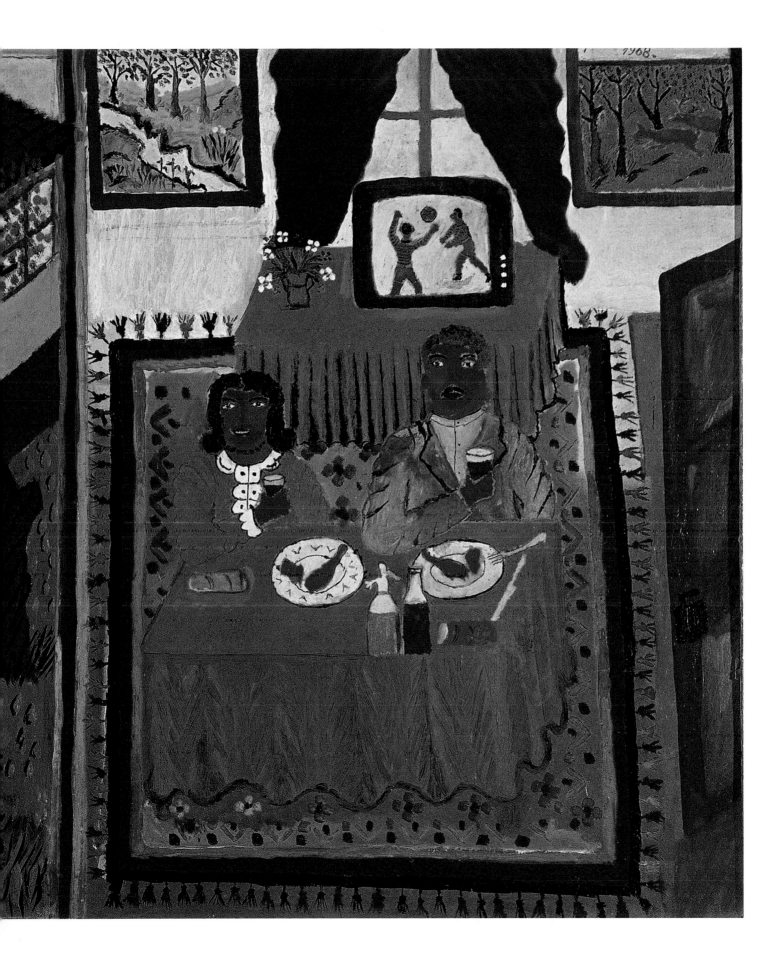

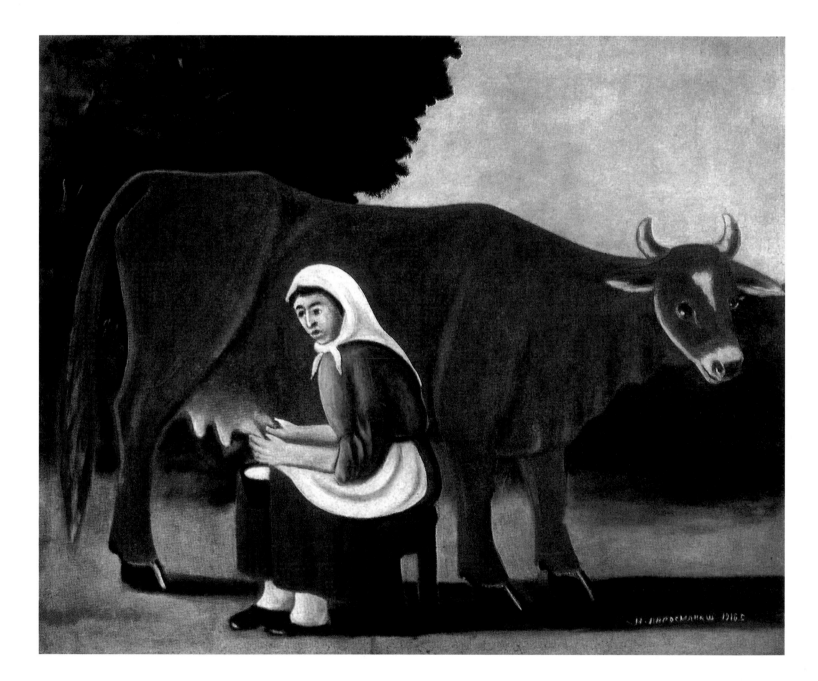

Niko Pirosmani,
Woman Milking a Cow, 1916.
Oil on cardboard, 81 x 100 cm.
Georgian State Art Museum, Tbilisi.

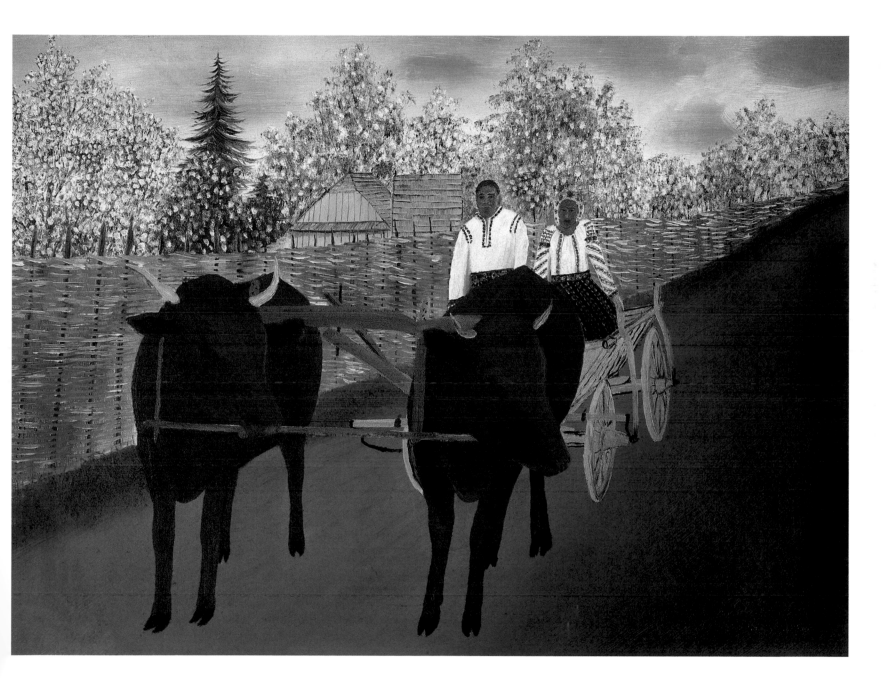

Gheorghe Coltet,
The Ox-Cart.
Oil on cardboard, 42 x 56 cm.
Private collection.

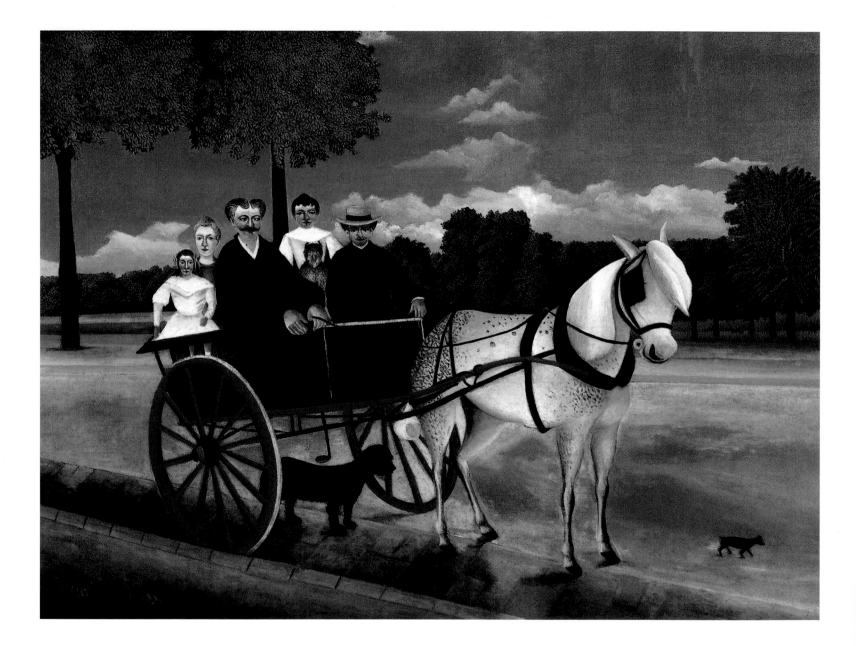

Henri Rousseau, also called
the Douanier Rousseau,
The Cart of Father Juniet, 1908.
Oil on canvas, 97 x 129 cm.
Musée de l'Orangerie, Paris.

order in urban centres for some considerable time. Nevertheless, the production of the traditional shop-signs continued for a while not only in rural areas but also in St Petersburg and in Moscow. The German philosopher and diarist Walter Benjamin, who endeavoured to create a written 'portrait' of contemporary Moscow, inscribed in his diary on 13 December 1926, "Here, just as in Riga, they have wonderful painted signs - shoes falling out of a basket, a Pomeranian [Spitz dog] running off with a sandal between his jaws. In front of one Turkish restaurant there are two signs set like a diptych featuring a picture of gentlemen wearing fezzes with crescents on them sitting at a laid table." [24]

Painted shop-signs eventually disappeared. They became unnecessary, too expensive in time and cost, thanks to the arrival of the machine-dominated world in which everything could be produced mechanically and where there was no place left - in the severely insensitive urban environment - for naive art that came from the heart. During the decades of the Soviet Union, some naive artists continued to paint privately, deep within a closed family circle involving only family members and trusted neighbours who went on thinking of them as artists. Others joined the numerous art studios, so leaving the ranks of the naive while yet not being accepted into the ranks of the professional artists.

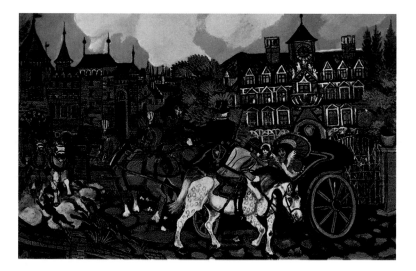

The popular Russian magazine *Ogonyok* has from time to time included prints of works of art by 'ordinary people'. In 1987 its readers were introduced to the pictures of Yelena Volkova. Brought up on an island not far from the Ukrainian city of Chuguyev, she tended to concentrate on painting riverside trees with bright green foliage, other scenes featuring people and animals, and equally colourful still-lifes. The disparate elements of everyday existence combine in Volkova's art to produce works that have much of the idyllic in them - a trait characteristic of many (and quite possibly all) naive artists. A generally happy world is painted to portray that happiness, only in a brighter, richer, yet more serene way.

Yelena Volkova came to painting at a mature age, but her creative imagination draws on her childhood memories, particularly those filled with the dazzling colours of the village fairs. Folk crafts were still blossoming in Russia in those days. Pottery, lacework, wooden toys and household articles, and so forth, were an integral part of ordinary rural life. Unhappily, today many of these traditions have been irretrievably lost. Yet aesthetic notions that derive from them continue to have some influence not only in rural districts but in urban areas too.

Eccentric personages who have a driving passion for painting pictures in their spare time should not automatically be associated with folk arts and crafts, however. On the contrary, such an association remains relatively rare by the end of the twentieth century. For one thing, whatever the conscious intentions of naive artists are when they create their works of art, it is their own interests - their own choice of subject matter and presentation - that they are realising. In that respect, such interests, influenced, for instance by the kitsch environment of a city market, remain the same no matter what or where the city is, no matter even if the city is Paris and the artists regularly visit the Louvre. But where this association between naive art

Antonio Ligabue,
Coaches and Castles with Policeman on a Horse.
Oil on facsimile, 92 x 130 cm.
Private collection.

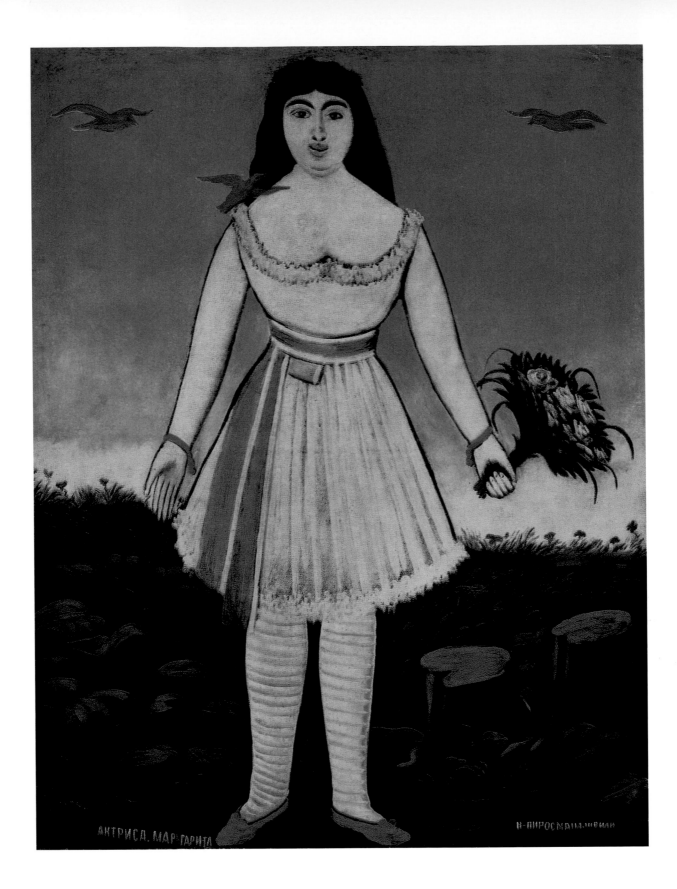

Niko Pirosmani,
The Actress Marguerite.
Oil on canvas, 117 x 94 cm.
Georgian State Art Museum, Tbilisi.

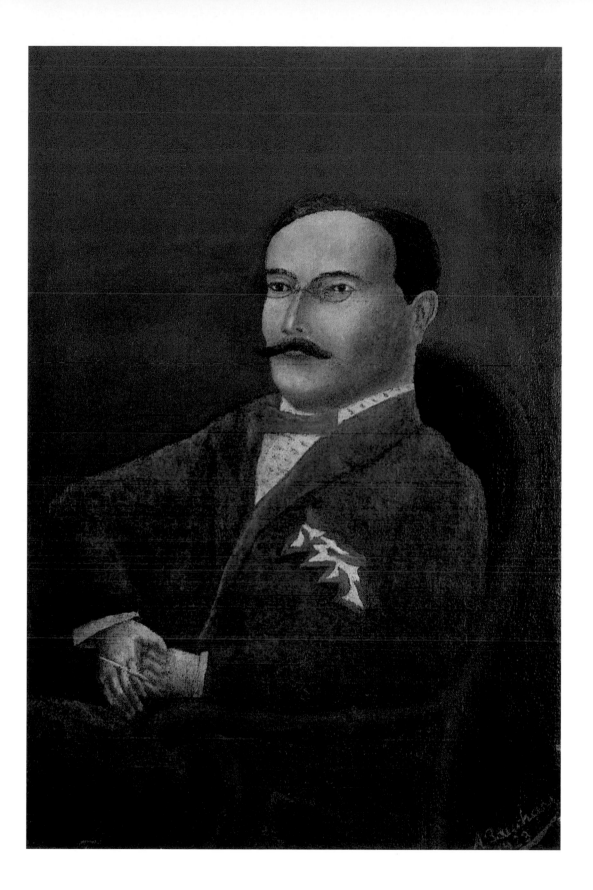

André Bauchant,
*Portrait of a Man with Lorgnon
(Dr Binet)*, 1923.
Oil on canvas, 59 x 35.5 cm.
Galerie Charlotte, Munich.

and folk art has been established in an artist, is it possible to distinguish the different elements in the artist's work, to differentiate between the art of naive art and the kitsch of the city-market folk art?

National characteristics manifest themselves in a much more powerful way in the sort of naive art that is closely associated with folk art than in the unified classical system of art. Their presence is more evident where such an association remains intimate, most often in the work of rural artists, and less evident in the sanitised environment of a big city. Anatoly Yakovsky has suggested that a fondness for folk art is more noticeable in a country that has undergone a sudden transition from the era of the artisan to the age of the modern industrial complex.

This would explain how it is that in some of the Latin American countries, for instance, or in Haiti, where there has been a synthesis of a darkly pagan religion with no less primitive forms of Christianity, enthusiasts have searched for and found naive paintings of outstanding

quality. The works of the Brazilian and Haitian naive artists retain an essentially Brazilian or Haitian feel to them because their connection with the assorted influences of local religions and crafts has not yet loosened.

Back at that threshold between the nineteenth and the twentieth centuries, Russia was in the process of becoming an industrial power in Europe, yet its virtually medieval artistic craftsmanship remained pretty well unchanged. The diarist Walter Benjamin (quoted above) was astounded by the multicoloured diversity of life on the Moscow streets:

"Women - dealers and peasant-farmers - set up their baskets with their wares in front of them… The baskets are full of apples, sweets, nuts, sugary confections… It is still possible here to find people whose baskets contain wooden toys, small carts and spades. The carts are yellow and red, the spades are yellow or red… All the toys are simpler and more robust than in Germany - their rustic origins are very plain to see. On one street corner I encountered a woman who was selling Christmas-tree decorations. The glass spheres, yellow and red, were shining in the sun as if she was holding a magic basket of apples, some yellow and some red. In this place - as in some others I have been to - I could feel a direct connection between wood and colour." [25]

It was this multicoloured Russia which at the beginning of the twentieth century provided the impetus for a rejuvenation of painting, a new palette for the pictures of Boris Kustodiev, Wassily Kandinsky, Kasimir Malevich, Ilya Mashkov, Pyotr Konchalovsky, Aristarkh Lentulov and Marc Chagall, together with those of Mikhail Larionov and Natalia Goncharova. And it was here, among its thronging city streets and markets, at the junction of East and West, where talented but untaught painters were devising and executing their own works of art. The artists 'discovered' by Larionov could hardly be compared with Niko Pirosmani - but the point is: they existed!

One of them has since become fairly well known. Morris Hirshfield was born in 1870 in what is now Poland but was then part of the Russian Empire. His pictures

Dominique Lagru,
Before Man.
Musée du Vieux Château, Laval.

Henri Rousseau, also called
the Douanier Rousseau,
A Walk in Montsouris Park, c. 1910.
Oil on canvas, 46.5 x 38.5 cm.
The Pushkin Museum of Fine Arts,
Moscow.

Gheorghe Sturza,
The Park of Distraction.
Oil on cardboard, 38 x 47 cm.
Private collection.

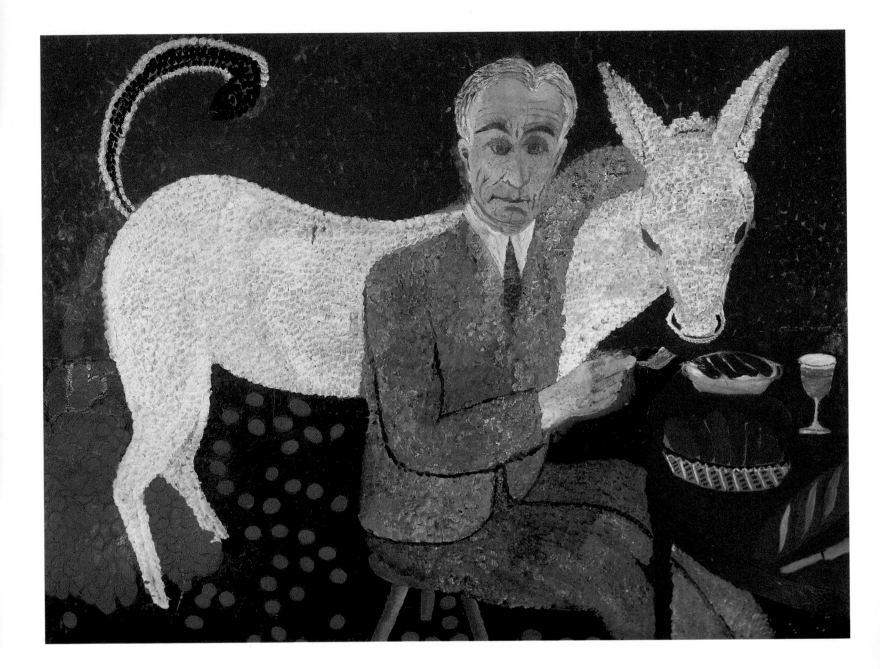

Ion Gheorge Grigorescu,
The Donkey Who Makes Money.
Oil on canvas, 40 x 60 cm.
Private collection.

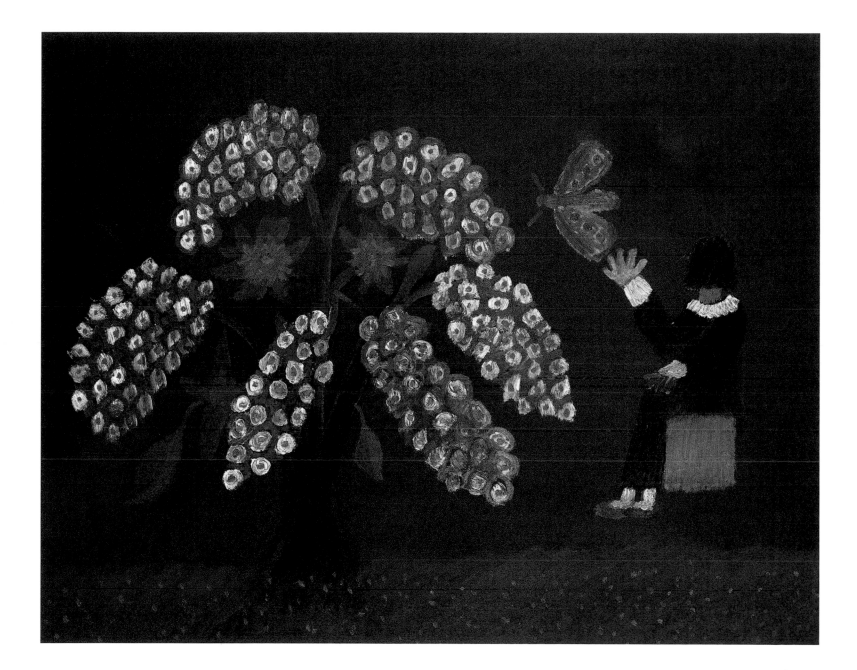

Onismi Babici,
Flowers.
Oil on canvas, 40 x 45 cm.
Private collection.

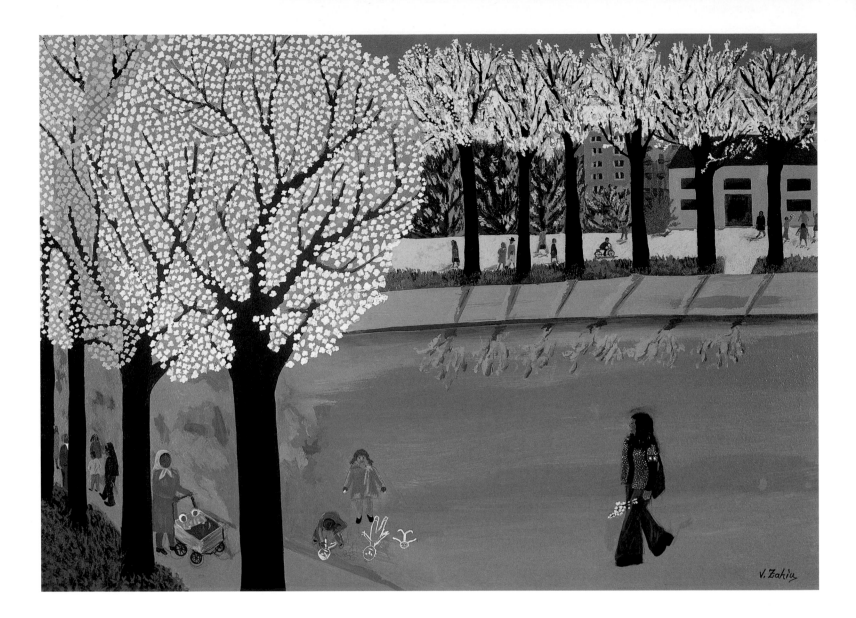

very much reflect the rural tastes of Polish life at the time, and feature clay cat-shaped money-boxes, wall-hangings with butterflies and flowers, and nudes.

The pictures of Camille Bombois also have a lot to do with fairs (at once stage he earned his living as a wrestler in a travelling circus), only for the most part those of Paris. His vigorous depictions of athletes, circus shows and nude models are the very embodiment of Parisian street life of the time.

For clear evidence of national traits in the work of naive artists we need look no further than Krsto Hegedušić. His intention was specifically to identify the roots of Croatian art, and to encourage works that represented those roots. The result was not so much an artistic school that he founded at the village of Hlebin as a collection of individual talents all working according to similar precepts. Brightest among his protégés was Ivan Generalić.

Generalić was born in 1914, and for various reasons received only four years of formal education. He started painting on wood and glass – as was the custom in Balkan villages – and only later took to watercolour and oil painting on paper and canvas. In his approach to art he

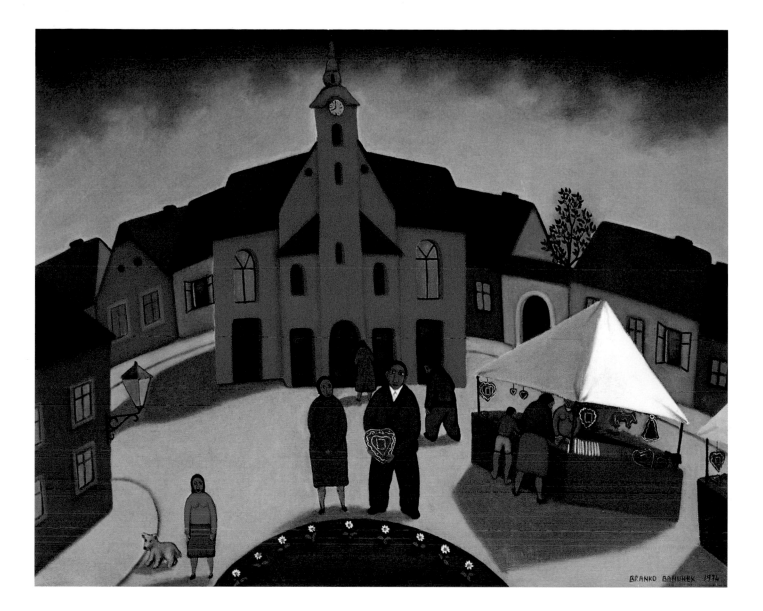

was a classic 'Sunday artist'. "Generalić is a peasant - a real peasant - who does all the work in the fields and in the vineyard himself", wrote Robert Wildhaber, who visited Generalić in search of folk art objects to display in his museum in Basel. "When he has time, and in moments of inspiration, he sits and paints on the very table on which he served us our dinner… His bedroom he uses as a picture gallery. His own paintings hang there interspersed with photographs. His custom is to paint on glass - only rarely does Generalić work on wood. It is quite delightful how this thickset giant of a man with the strong hands of a peasant is apt to explain that the wood of a tree is hard, and he does not always feel its inner warmth, but that he always feels the inner warmth in glass." [26]

This last comment is especially interesting. Painting on glass has long been a traditional form of folk art not only in the Balkans but also in Switzerland, in France, in Germany and in the Ukraine, whereas painting on wood has been the standard form for village craftsmen and icon-painters all over Europe and in much of the world besides. It is natural, then, that wood and glass tend to be the media on which naive artists paint their first works, if not all

Branko Babunek,
The Village Square, 1974.
Private collection.

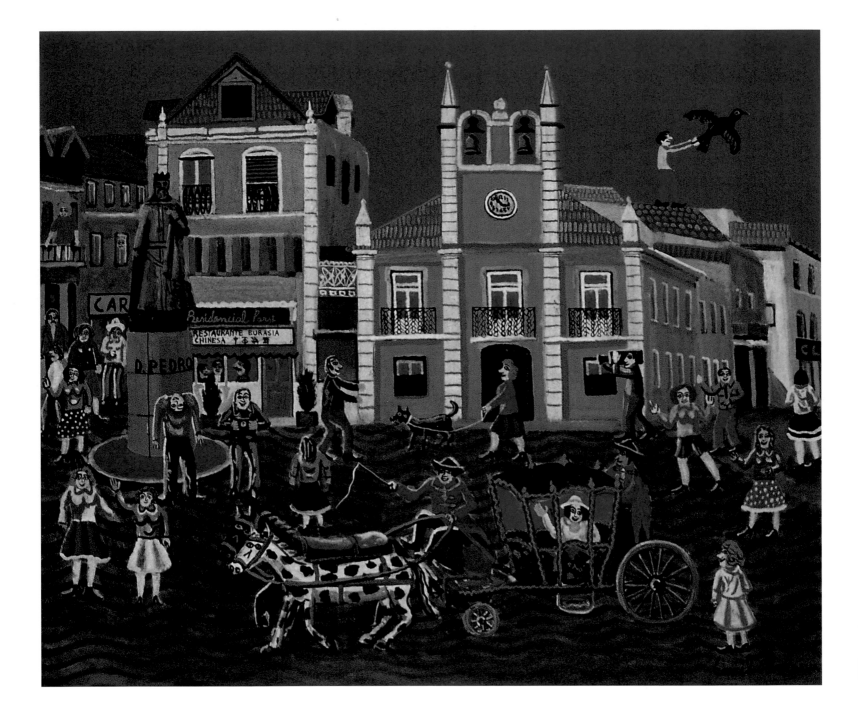

Emil Pavelescu,
Crossing the Town in a Carriage.
Oil on canvas, 80 x 100 cm.
Private collection.

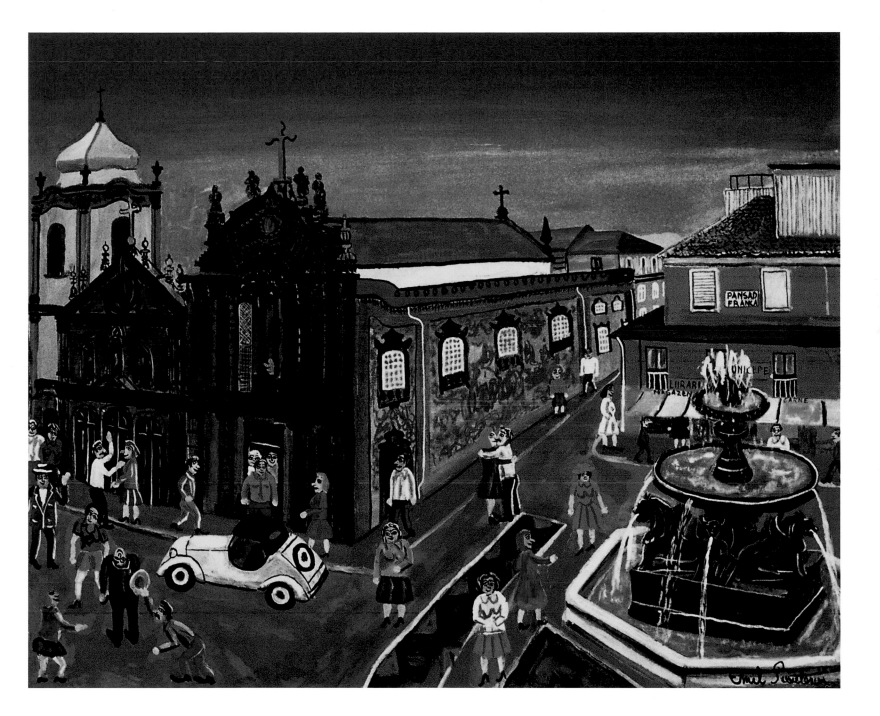

Emil Pavelescu,
View of Estoril.
Oil on canvas, 80 x 100 cm.
Private collection.

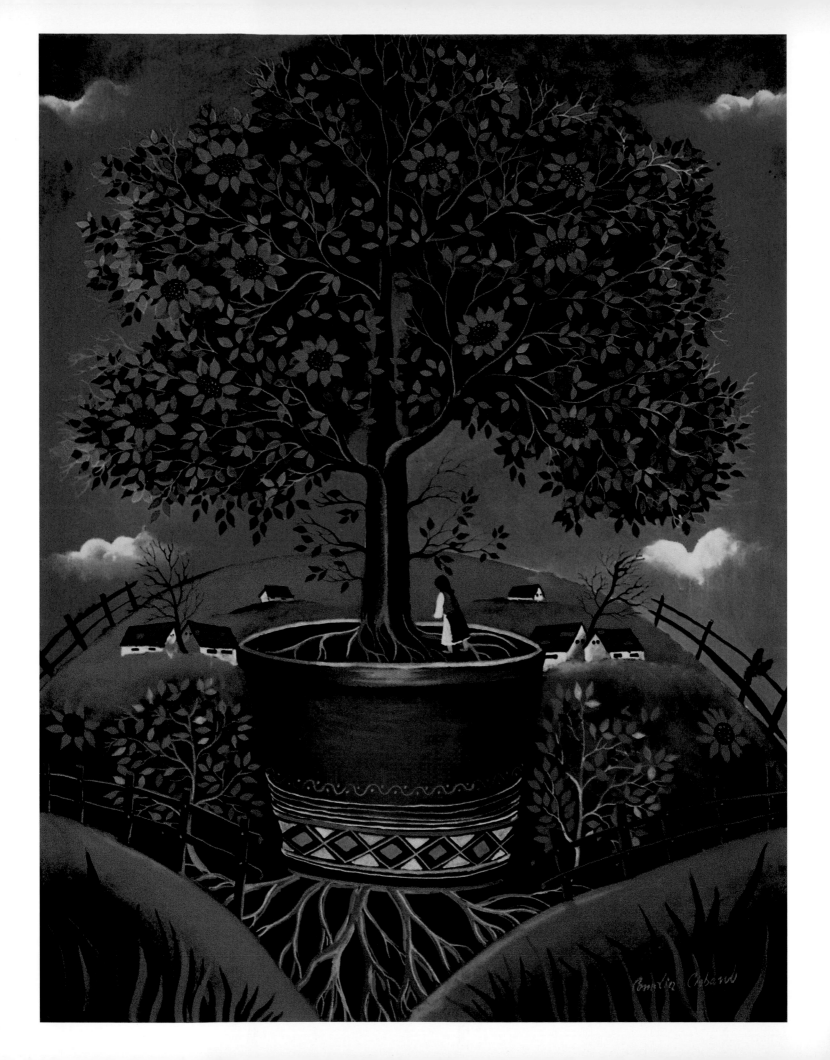

their subsequent works. Most of the talented rural painters of Hlebin have therefore continued to paint in oil on glass for the duration of their creative life; rarely have they ever crossed over to canvas. The connection with traditional, local arts and crafts by no means disqualifies village artists of anywhere in the world from the worldwide community of naive artists. Such rural pictures have every right to be regarded as a genuine easel-painting and to be compared with those of Rousseau. Rustic artists acquired their devotees and their patrons, and their works have become prominent in some museum collections.

In the comparatively small but diversely populated country of Switzerland, located right in the centre of Europe, there has long been concern that forms of folk art might disappear under the manifold pressures of industrial society. This is an area where the traditions of folk art exist perhaps less at the level of the nation than at the level of the canton: not only the artists themselves but the cantonal authorities too are much concerned to preserve what they can of their local culture.

Oil painting on glass (and in particular, the works of René Auberjonois, of Lausanne) has received some notable commendation from 'professional' artists, which constitutes formidable support for it. Artists of truly rustic traditions, however, have tended to paint in oil or watercolour on cardboard, and their primary subject matter has been the cows going up to an Alpine meadow. The oldest extant examples of paintings like this date back to the 1700s, although it is more than probable that such scenes really go back hundreds of years and focus on a geographical area surrounding the Säntis mountain group in the east of Switzerland, on the Liechtenstein border. Sharp outlines and an individual sense of colour in these works make them reminiscent of the Russian lubok. Unlike a lubok, however, each Swiss scene is signed by its artist, and the names of some Swiss artists of this sort have been known since the nineteenth century. Nor have they been forgotten in the meantime, thanks to their individual style and perception of the world.

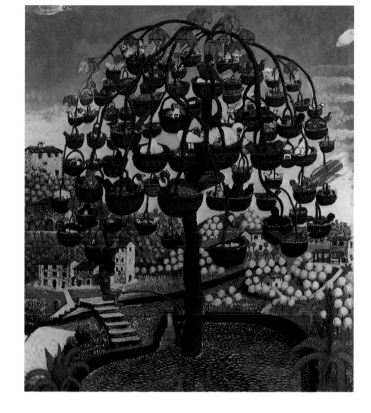

One of them was Conrad Starck, perhaps most famous for the painted scene with which he decorated a milking-pail. Typifying the local Swiss scenery as he knew it, there is a cow, slung around the neck of which is a huge cow-bell; there is a rustic labourer wearing a red waistcoat above yellow trews; a rather sketchy tree; and some dogs, without which no Swiss mountain-farmer could work. This somewhat stereotyped though uninhibited approach by the artist is of course excused by the fact that it is all simply decoration for a milking-pail. Very much the same stock subjects are included also in another painting upon yet another milking-pail by Bartolomäus Lemmer in 1850, although the painting is totally different. The labourer is striding forward with a confident gait, a pipe between his teeth, followed by a shabby dog. A group of large, not to say fierce, cattle charge towards him in the background. Such functional decoration is rarely painted with distinctive expressiveness or freedom. Many rural artists painted virtually nothing else but cows going up to an Alpine meadow,

Camelia Ciobanu,
The Enchanted Tree.
Oil on canvas, 100 x 80 cm.
Private collection.

Francesco Galeotti,
The Large Family, 1974.
40 x 50 cm.
Private collection.

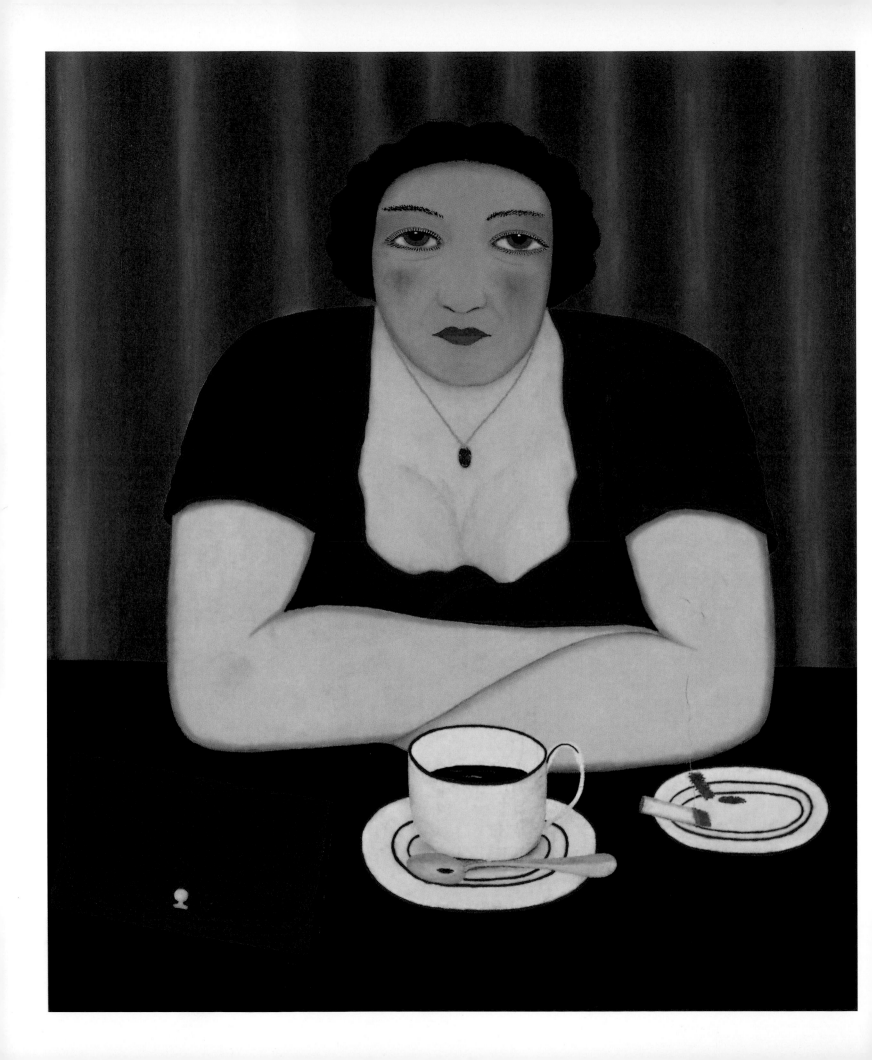

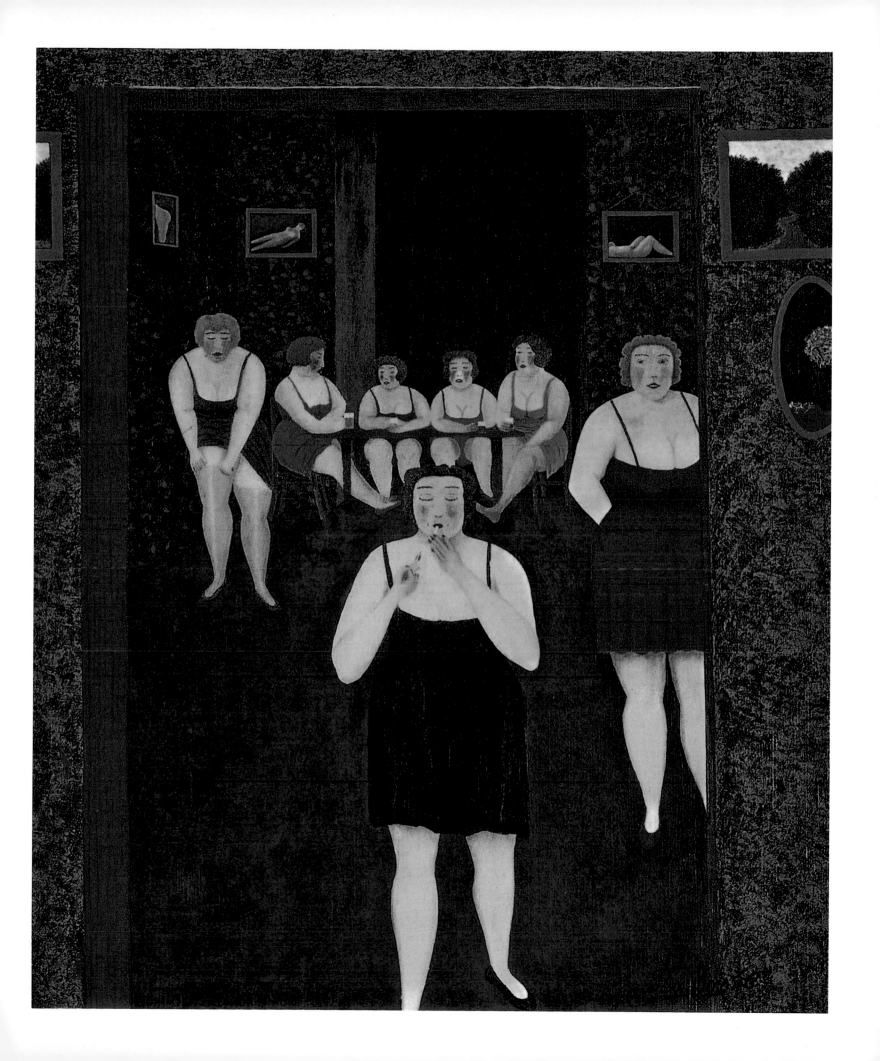

strangely clean farms, herds of goats and pigs, and the occasional yokel on a mountainside. But each artist had his or her own way of painting. For the most part the pictures were neither sensational nor innovative, especially when an artist was deliberately following an older, traditional style. Sometimes, just sometimes, the style is broad and free – a reminder that the artist has truly been part of the twentieth century. In this dual way the artists have created an image of their country that is comparatively modern and have yet preserved the spirit of the art of their tradition. To paraphrase the words of one of Henri Rousseau's defenders in the Salon des indépendants, 'It is unreasonable to believe that people who are capable of affecting us in such a powerful way are not artists.'

Naive Artists and Photography

The end of the nineteenth century and the beginning of the twentieth gave naive artists another source of inspiration. By this period photography had become so practicable that photographs – of parents, of brothers and sisters, of children and grandchildren, of entire family groups – decorated the walls of houses. This is the way it was in Ivan Generalić's house. For many people, from the time photography began to 'compete' with painting, the qualities of a photograph represented aesthetic criteria. The result was that some artists were simply defeated by it. Others, like Edgar Degas, turned the world-view as seen through the lens of the camera to their own advantage.

Now it was possible to commission from the local artist a portrait of your child which should 'look like a photo', because photography had that unique ability to catch and retain an image with the honesty of a mirror. No idealisation was allowed, and the scrupulous rendition of every little detail of a face or of clothing was not only mandatory but tended to influence the poses people took up and the overall composition of the picture.

It is often because they reflect the standards of photography that pictures produced by otherwise very different naive artists – a French Rousseau, say, a Georgian Pirosmani, an Italian Metelli or a Polish Nikifor – may look similar. Rousseau's portrait of a female figure that was purchased by Picasso, and even the *Self-Portrait* by Joan Miró, conformed in many ways to the aesthetics of photography – not perhaps to those of genuine artists with the camera but to those of the photographers at fairs, who sat their models one after another on the same plain chair in front of the same velvet curtain.

Whereas reproductions and prints of paintings were not widely available, photography soon became an established part of urban and rural life. Photographers were to be found at bazaars and fairs among the stalls of folk arts such as painted pottery and crockery, woven baskets and rugs, and wooden artefacts. Photography entered every house as a form of art. Its influence on what people thought of 'art' is simply impossible to ignore. Naive artists probably mastered the lessons of photography before the pros and cons of the medium in relation to professional art were fully appreciated by professional artists.

Camille Bombois,
In the Bistro.
Oil on canvas, 55 x 46 cm.
Museum Charlotte Zander,
Bönnigheim.

Camille Bombois,
In the Brothel, c. 1930.
Oil on canvas, 46 x 55 cm.
Museum Charlotte Zander,
Bönnigheim.

André Bauchant,
Mother and Child with a Bouquet of Flowers, 1922.
Oil on canvas, 72.5 x 58.5 cm.
Museum Charlotte Zander,
Bönnigheim.

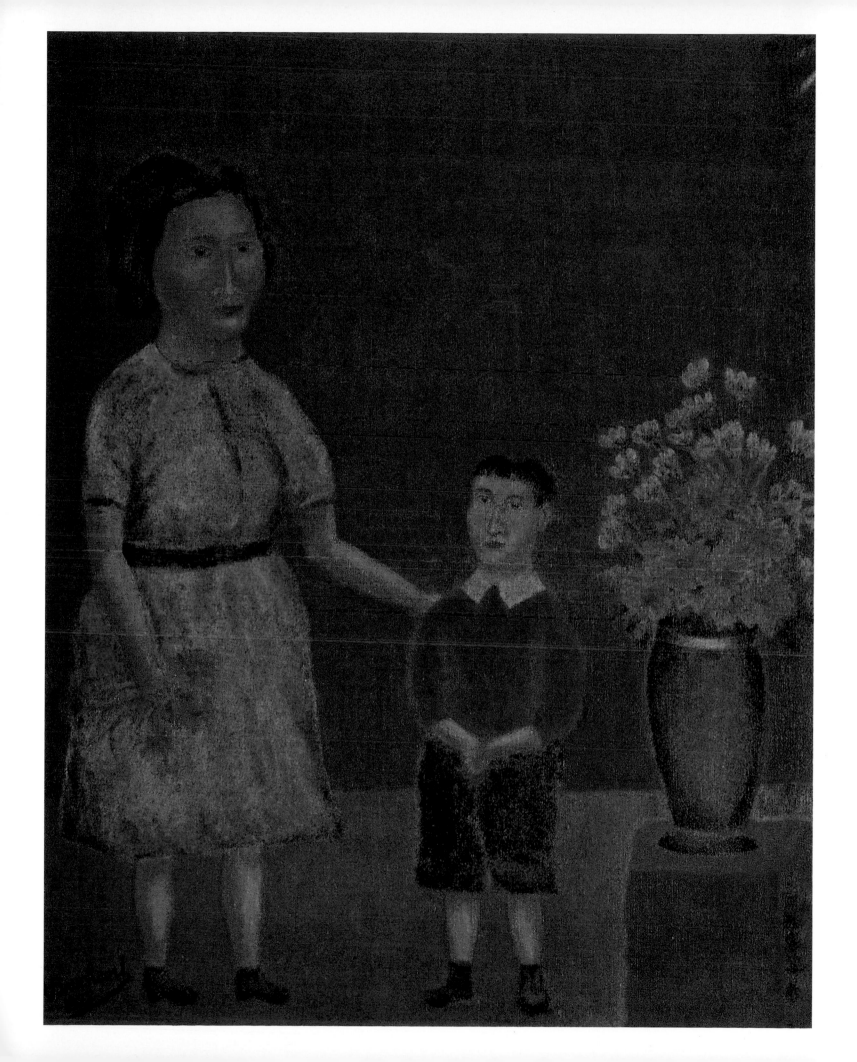

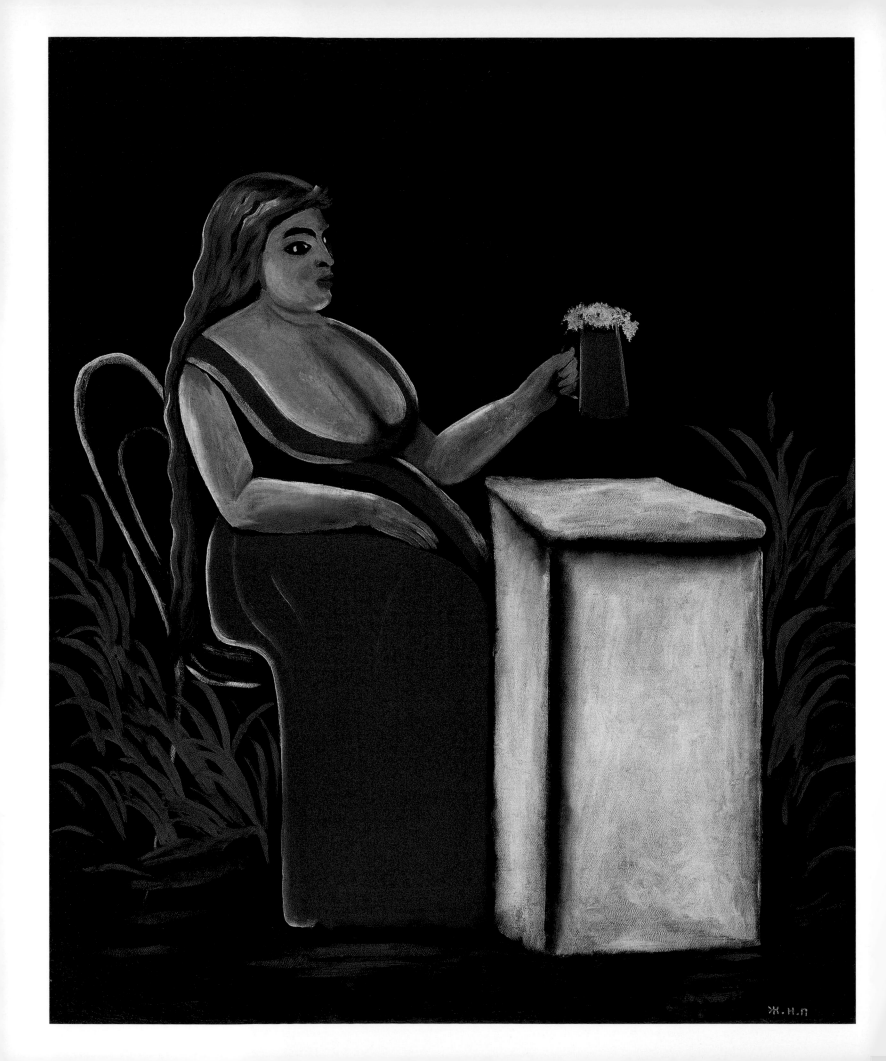

III. Discoveries in the East

Pirosmani's Case

In 1904 the Russian artist Mikhail Larionov began to take an interest in the painted shop-signs that adorned the outsides of the shops of the city in which he lived. He incorporated some of them in a number of the urban landscapes he produced, and by doing so, 'invented' a new facet of art. He had discovered that pictorial representation even of such a casual kind as on shop-signs – generally ignored by everyone and certainly never seriously studied, 'invisible' details of everyday life – nonetheless added colour to an urban landscape and in many ways actually determined the face of that landscape.

At the end of the first decade of the twentieth century, another Russian artist, Boris Kustodiev, took the notion one stage further. Similarly finding inspiration in shop-signs, he not only incorporated them in his paintings but tried to learn from their uninhibited (and often garish) vividness and their utter directness of style. You could say that in deliberately searching out the unexpectedly interesting from within the familiarly ordinary, Kustodiev was the first person to make a study of what we now think of as kitsch. Before Kustodiev it would have been impossible to imagine that commonplace household carpets decorated by rustic hands with rustic patterns and rustic lack of skill, or clay cat-shaped money-boxes, could ever have been thought to have anything to do with folk art, let alone high art. Kustodiev's paintings of tradesmen's wives are full of such details. His stock characters and scenery are those of the Russian bazaar.

One form of rustic but very popular folk art, available in all Russian bazaars of the time and part of everyday life in the Russian countryside for centuries before, was the lubok. It now suddenly acquired a value and status equal to those of works by professional artists. In February 1913 the first-ever exhibition dedicated to the lubok opened at the Moscow School of Painting, Sculpture and Architecture, organised by Mikhail Larionov and Nikolai Vinogradov. Exhibits other than folk prints included decorated household trays, pieces of cooper-work, and carefully-moulded pryaniki - spiced biscuits. In his preface to the exhibition's catalogue Larionov wrote: "All this is lubok in the broadest sense of the term, and it is all high art." [27]

Such an 'official' enthusiasm for standard objects of rural culture produced for the most part by untaught amateurs who had never bothered to sign their work created a veritable fever among the young people of Russia. It caused the 'discovery' of several important naive artists, of which one was Niko Pirosmanashvili (Pirosmani).

It was summer in 1912 when the poet Ilya Zdanevich and his brother, the artist Kyrill Zdanevich, came to the capital city of Georgia, Tbilisi, to visit their parents. In the evenings they used sometimes to stroll together around the streets of the old city, and it was on one occasion of this kind that they found their attention held by a sign above a cheap restaurant called Varyag. "The cruiser after which this establishment was named", Kyrill Zdanevich wrote in his memoirs, "was painted as if it was searing at high speed through the choppy water. Its funnels were belching smoke, and its flags of St Andrew were stretched out in the breeze. Flames gushed out of its guns. Clouds of smoke billowed into the sky. Rough waves smacked against the frame of the sign." [28]

Niko Pirosmani,
Young Girl with a Glass of Beer.
Oil on canvas, 114 x 90 cm.
Georgian State Art Museum, Tbilisi.

The Zdaneviches entered the restaurant, to find more paintings on the walls. "We had never seen anything like those paintings!" wrote Kyrill Zdanevich. "Incredibly original, the paintings were just the kind of miracle we were looking for. Our first impression was so strong that we could do nothing but stand there in silence to marvel… The artist was self-taught, but his technique and his understanding of the medium he was using testified to his skill and the originality of what he was doing. Looking at the pictures more closely, we realised that they were painted on black oilcloth, and that the black in the pictures was where the oilcloth had been left unpainted…[29] We raised our glasses to the artist and his pictures, and asked who this genius was, where he lived, and what his name was. Everybody in the room reacted with animated astonishment that we had never heard of Niko the house-decorator."[30] The newspapers of the Georgian capital were shortly afterwards to publish the first appreciative articles on the paintings of Niko Pirosmanashvili.

'It turned out', Zdanevich carried on, 'that many in Tbilisi knew about Pirosmani's paintings but dismissed the idea that they might be true art because they were painted on oilcloth. They looked nothing like pictures you might see at an art exhibition, and above all, they were hanging only in some of the lowest dives in the city.'[31] It was true. The only people who were really familiar with Niko's work were the customers of some of the cheapest restaurants in the outlying districts of Tbilisi. Hardly any of Tbilisi's cultural nobility - the intelligentsia of the city - had ever heard of him, let alone knew of his work. It was only after his death - which occurred in 1918 - that Pirosmani became renowned among his friends and acquaintances as something of a 'martyr of art'.

The same was not true, however, in Russia. In March 1913 no fewer than four of Piromani's works were put on display in an exhibition in Moscow entitled Mishen ('Target'). Several of his 'signs' were also put on display there for the first time.

To be the 'discoverer' of a naive artist suddenly became extremely important for Russian avant-garde artists. Larionov determined to find a 'Russian Pirosmani', and eventually unearthed a certain mineworker T. Pavlyuchenko and a Sergeant Bogomazov whose works he displayed at the Mishen exhibition. Their productions have since been lost, but the fact that they appeared alongside the works of professional artists meant that naive artists could turn up just about anywhere. It has to be said, though, that there was one grave disadvantage against naive pictures of this kind when they were put on display: they were not considered true art.

In this way, the 'Rousseau banquet' may well be thought of as the symbolic beginning of the nascent group of naive artists. And from that beginning the doctrine was spreading.

In Croatia during the 1920s the artist Kristo Hegedušić formed a group known as Zemlya ('Earth') with the specific purpose of finding the roots of national art. In a village called Hlebin he discovered some extraordinary paintings by a sixteen-year-old peasant boy named Ivan Generalić. The lad later himself became the leader of a group of local artists.

In Switzerland, a museum in the town of Sankt Gallen (Saint-Gall) started collecting pictures painted by the rural folk who lived in the mountains around. Many such paintings were then displayed in a large exhibition of Swiss folk art in Basel in 1941.

But for the most part, talented self-taught artists tended to crop up in cities where, quite naturally, it was easier for them to come into contact with professionals. Back in France, that very same Wilhelm Uhde who had enraged Gustave Coquiot by 'discovering' Henri Rousseau mounted an exhibition of the works of naive artists in the Galerie des Quatre Chemins in Paris in 1928. It featured several paintings by Rousseau, but there were also works there by Séraphine Louis, Uhde's

Niko Pirosmani,
Portrait of Ilja Zdanevitch, 1913.
Private collection.

84

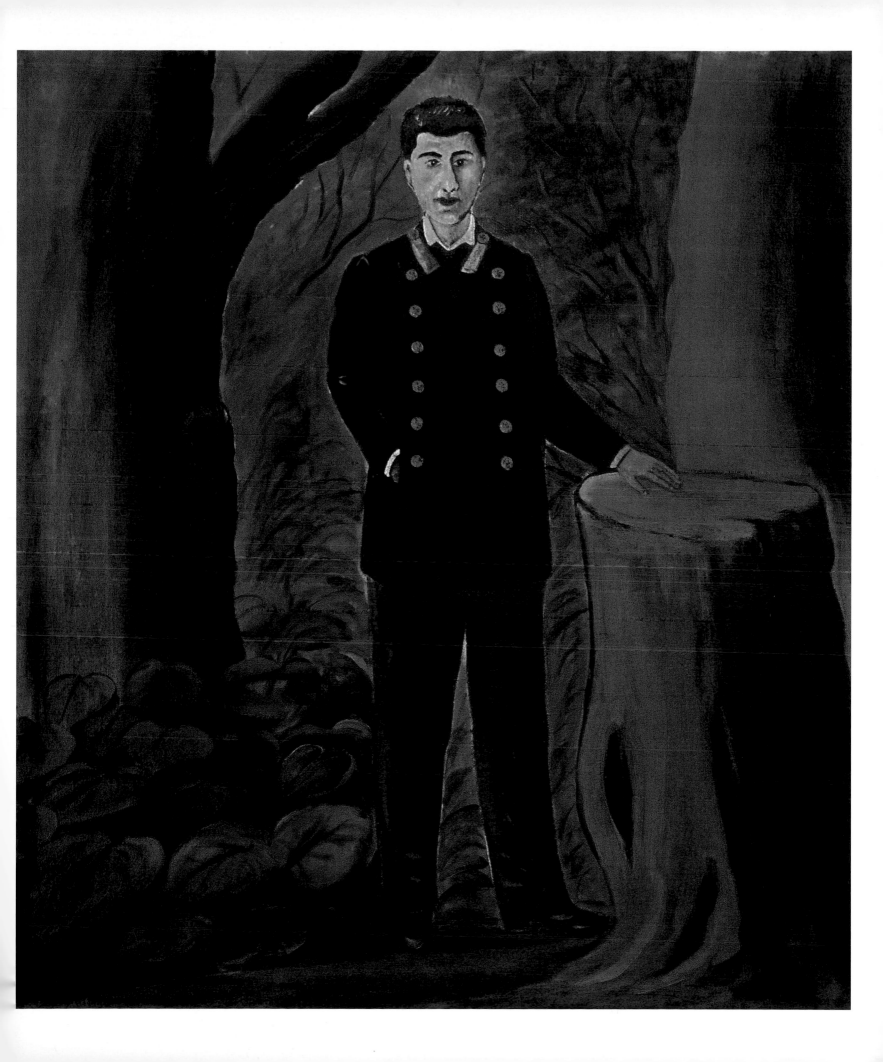

housemaid, by Louis Vivin (who had been 'discovered' by professional artists in Montmartre), by Camille Bombois (who had been 'discovered' by a Parisian journalist) and by André Bauchant (who had been picked out by the architect and designer Le Corbusier at the Salon d'automne in 1921).

But naive art was not the sole preserve of Europe. The United States and the countries of Latin America, countries of the Middle East and the Orient all found their own Henri Rousseaus living in their midsts, and duly presented them to the world.

When the Zdanevich brothers saw the paintings of Niko Pirosmanashvili, they reminded them immediately of the work of Henri Rousseau - although they were very different indeed. Whereas Rousseau's work was a product of the cosmopolitan city of Paris, Pirosmani's could only be Georgian and from nowhere else. He lived in Tbilisi, a fascinating city, the capital of Georgia and cultural centre of the entire TransCaucasian region. In Tbilisi the feudal Georgian way of life tended to complement the otherwise foreign European stratum of culture.

His use of black oilcloth was determined by the general rule that signs should be painted within a black border. This colour, however, plays a highly specific role in Georgian culture. It is the standard colour of the clothing of both city and rural dwellers. Nothing in the world resembles the black pottery of Georgian ceramics. So black oilcloth was a godsend to a painter so subtle as Niko Pirosmani - it helped to create unearthly decorative effects, to enhance the romantic mood in moonlit night scenes, and finally to produce those large forms of which the only analogues are to be found in Spanish painting of the seventeenth century.

Naive Painting in Romania

Popular art in Romania, and particularly rural art, has been largely of one and the same style across the centuries, although differing in regional aspects.

Niko Pirosmani,
Ensign for a Wine Merchant.
Oil on white metal, 57 x 140 cm.
State Art Museum of Georgia, Tbilisi.

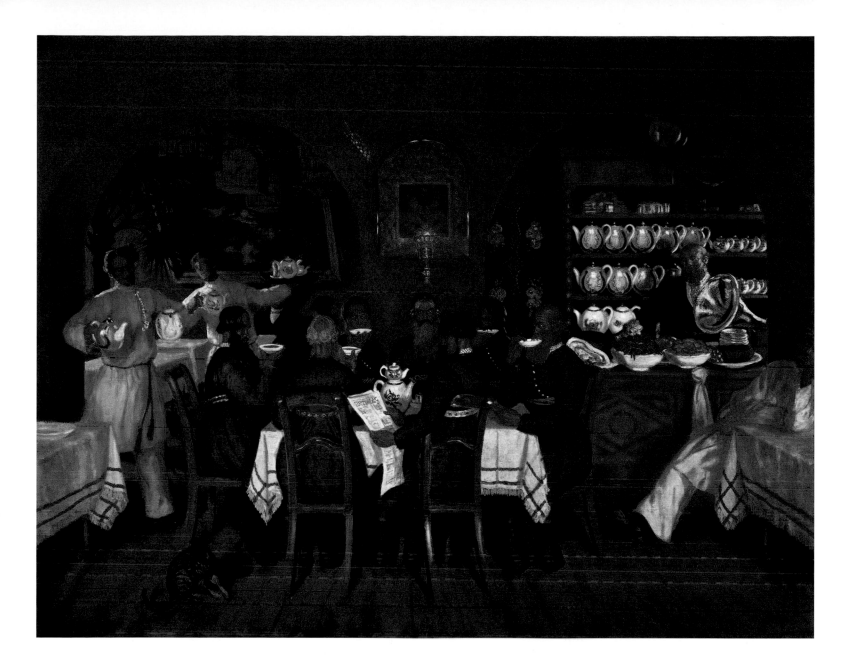

Documents that have come down to us from the nineteenth century and the period immediately before then – from the seventeenth and, especially, from the eighteenth centuries – demonstrate more or less directly (in prints and in water-colours) the wide-ranging artistic enthusiasm of the middle classes in contemporary provincial Romania. Additional evidence for this is provided by the carefully carved wooden ornamentation on architectural features, the elaborate painting of household furniture, the hand-embroidered tapestry wall-hangings, and the highly decorative ceramics. All these practical applications of the arts together exhibit a distinctive character that was no less profound for being the product of non-professional craftspeople, and constitute works of the precursors of what today are known as the naive artists.

At a European level, the representation of popular artistic sensibilities by people who had not been professionally taught and who, indeed, were outside of the mainstream of the applied arts – the so-called naive artists, sometimes held to produce 'secular iconography' in painting or sculpture – received proper recognition only after a considerable time had elapsed. In Romania it was to have its echoes during the 1960s.

Ion Gheorge Grigorescu,
The Street Organ Player.
Oil on canvas, 60 x 45 cm.
Private collection.

Boris Kustodiev,
Moscow Tavern, 1916.
Oil on canvas, 99.5 x 129.5 cm.
The State Tretyakov Gallery, Moscow.

Mircea Corpodean,
Michael the Brave and the Turks.
Oil on glass, 40 x 30 cm.
Private collection.

Anonymous,
*Saint Georges Striking Down
the Dragon*.
Painting on glass.
Private collection, Italy.

Anuta Tite,
The Wedding.
Oil on cardboard, 38 x 45 cm.
Private collection.

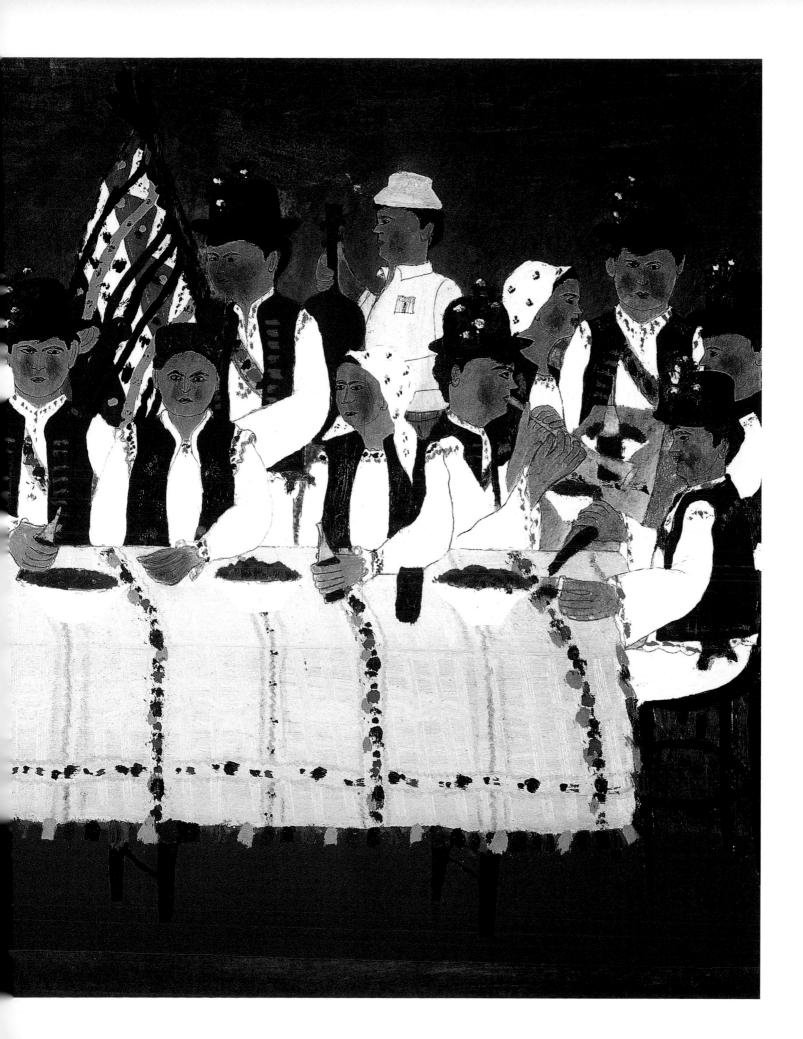

It was the work of the naive painters of what used to be Yugoslavia that caught the interest of Romanian art critics, who then took upon themselves the difficult task of discovering 'naive art' in Romania. And to their own huge amazement, by scouring the dusty nooks and crannies of houses and entire villages, by dusting over just about anywhere that such artistic works of amateurs might have been stored out of sight, they actually did come across incontrovertible evidence of Romanian naive art dating from a time well before it had been acknowledged to exist.

Two pieces of artwork, both of great significance, came to light in 1968 and 1969 and revealed a new approach to art to a surprised general public.

Ion Nita Nicodin – a rural painter from Brusturi (in the Arad area of western Romania) – with the assistance of the art critics Petru Comarnescu and George Macovescu, became the first of the 'naives' to have his own exhibition at the Institute of Writers in Bucharest in 1969.

Almost simultaneously, the Regional Museum at Pitesti (in Walachia) – again with the help of specialists, on this occasion Vasile Savonea, Mihail Diaconescu and Roland Anceanu – established the first permanent Gallery of Naive Art in the country.

Given a new authority in this way, Romanian naive art consolidated its position at an international level by being the focus of a good many more exhibitions. And the names of such artists as Ion Nita Nicodin, Ion Stan Patras of Sapanta (Maramures), Gheorghe Mitrachita of Bârca (in the Dolj area), Vasile Filip of Baie Mare (in Maramures), Alexandru Savu of Poenari (in the Dambrovitza area), Ion Gheorghe Grigorescu of Campulung Muscel (Arges), and Neculai Popa of Târpesti (Neamt) became known to a much wider audience as they were awarded various prestigious prizes and medallions. The triennial Naive Art Exhibitions at Bratislava and Zagreb, and other exhibitions in Switzerland, Italy, Japan, Germany, Denmark, Norway, the Indian subcontinent, Egypt, Morocco, the United States, Canada and elsewhere were all locations at which the sensitivity, the naturalness and the purity of expression displayed by the Romanian naive artists came close to overwhelming the appreciative faculties of art lovers. Best known through these international events were the artists Gheorghe Sturza, Viorel Cristea, Gheorghe Babet, and Constantin Stanica.

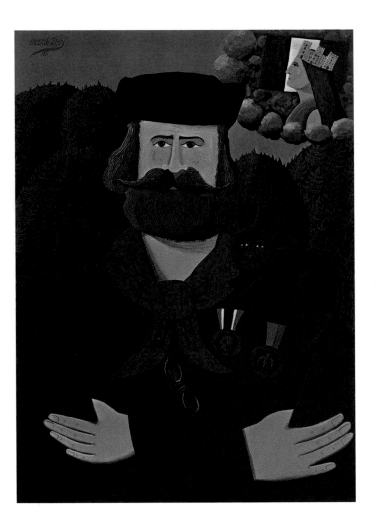

Oscar de Mejo,
Garibaldi.
Musée International d'Art Naïf, Vicq.

Ion Pencea,
"… and with the Sergeant It Makes Ten".
Oil on canvas, 50 x 55 cm.
Private collection.

Among publications devoted to the subject, mention should be made of *Naive Art in Romania*, produced in 1981 by the painter Vasile Savonea who devoted no less than thirty years to the subject, and who – despite the obfuscation of the contemporary cultural authorities – managed to impress the term 'naive art' on the general consciousness, and to give it a comprehensible definition as a genre. Another important work to place the genre in the international context was Naive Art, edited by the critic Victor Ernest Masek [32] and published in 1989.

The enormous changes in Romania following the historic events of 1989 opened people's eyes to new perspectives. Even though the old art salons continued as they always had, from 1991 onwards the biennial Exhibition of Naive Art took place in Bucharest and likewise became

Gheorghe Mitrachita,
Michael the Brave and the Turks.
Oil on canvas, 60 x 80 cm.
Private collection.

the focus of interest for both artists and critics. Thanks to a new approach on the part of the civic authorities and to special efforts on the part of cultural organisations to promote this form of art, many previously closed avenues of progress were opened to Romanian naive artists (by way both of national and international exhibitions and of individual and group display).

The resulting vivacity of art and artistic expression was soon apparent to all, as evidenced by the prizes awarded it. The works of Romanian naive painters were to be found hanging at exhibitions, featured in specialist catalogues, and on view at the most prestigious of art salerooms. Famous – not to say celebrated – artists included Paula Jacob (of Vaslui, Moldavia), Camelia Ciobanu, Mihai Vintila, Mihai Dascalu (of Resita, western Romania), Ion Maric (of Bacau, Moldavia), Gheorghe Ciobanu, Calistrat Robu (of Iasi, Moldavia), and Emil Pavelescu (of Bucharest).

The first published catalogue of the Bucharest International Salon for Naive Art (1997) clearly demonstrated the creative vigour of Romanian artists – and showed too that they were more than happy for their work to be compared with the work of artists from any other country. The travelling exhibitions of Romanian naive art on view in Madrid (1993), New

Anonymous,
Rouman Painting.
Private collection.

York (1994), Venice (1995), Vienna (1996), Bangkok (1997), Thessaloniki (1997) and Paris (1998) all contributed to affirming the existence of an artistic mode that was individually Romanian. Meanwhile, the annual art courses organised for the national and international 'summer universities' attended by a country-wide student population have done much to promote the exchange of ideas and of working techniques.

All these new opportunities are bound also to have repercussions on the overall quality of naive paintings produced. The subject matter, until current times virtually uncensured in any way, has recently been exposed to a critical disposition hardly known before 1990. New techniques have gradually infiltrated until they parallel traditional methods – so that, for example, the more vivid acrylic colours permit an artist to treat (more and) different subjects in a different manner. The lifting of cultural barriers has also granted artists direct access to displays, exhibitions and international galleries where their merit has afforded them commensurate financial reward.

Over almost forty years of being recognised, Romanian naive art – through its individuality, its originality and its sensitivity – has attained an important place in the hearts of art lovers.

Ivan Rabuzin,
Three Flowers with Branches, 1972.
Watercolour on paper, 56 x 76 cm.
Rabuzin Collection, Ključ.

Paula Iacob

Conclusion: Is Naive Art Really Naive?

Once when I was in a small town in Estonia during the mid-1960s, I was lucky enough to meet an elderly landscape painter. With a small brush he was making neat strokes with oil-paint on specially prepared cardboard. In the foreground he was establishing a pattern of lacy foliage, while clusters of trees in the background created large circles. He was building up spatial perspective according to the classic method - with a transition from warm to cold colours - although the contrasts between yellow, green and blue tonal values in the foliage were transforming what was an overgrown park into a magical forest.

The artist told me that he had created his first works way back during his childhood. There then followed a gap of many decades during which he was employed at the local match factory. He returned to painting only upon his retirement. He insisted that he had never been outside Estonia, had never seen works of art at the Hermitage - the nearest large art museum (in St Petersburg, Russia) - had no knowledge about other European art or artists, had never himself attended any kind of formal art training, and was not acquainted even with any other 'Sunday artists'. It was difficult to believe him, for his work was distinctly reminiscent of the landscapes of Jacob Van Ruisdael, Meindert Hobbema and Paul Cézanne. If he was telling the truth, how can such a likeness be explained? If he was not telling the truth - why not?

Not only did Naive Artist Number One, Henri Rousseau, make no attempt to conceal his admiration for professional art - on the contrary - he made it evident on every possible occasion. He idolised those professional artists who received awards at the salons and whose works were despised as academic banalities by the avant-garde artists. In his autobiographical jottings he loved to name-drop, mentioning particularly advice given to him by Clément and Gérôme. When he received permission from the authorities in 1884 to make copies of paintings in the national galleries such as the Louvre, the Musée du Luxembourg and Versailles, Rousseau told others (including Henri Salmon, who repeated it later) that he was going to the Louvre 'in order to seek the Masters' advice'. His pictures thereafter testify that he knew how to put this advice into practice. The most diligent of Academy graduates might have been envious of his working method. He made many drawings and sketches in situ, paid close attention to his painting technique, and thoroughly worked the canvas surface. The condition of Rousseau's paintings today is much better than that of many of the professional artists of the time. His work was never spontaneous, details were never an end in themselves, and each picture has an overall integrity of composition. His virtuoso brushwork inspired admiration, and the refinement evident in his technique is reminiscent of the paintings of Jean-Baptiste-Camille Corot.

It is in Rousseau's attempts to render perspective that his limitations become obvious. The lines often do not converge at the correct angle, and instead of receding into the distance his paths tended to climb up the canvas. Perhaps we ought to remember, however, that Rousseau himself said in one of his letters that 'If I have preserved my naiveté, it is because M. Gérôme... and M. Clément... always insisted that I should hang on to it.' [33] But in view of the imperfections of his painting it is difficult to believe that they all stem from

Paula Jacob,
Ship with Butterflies and Flowers.
Oil on canvas, 70 x 55 cm.
Private collection.

the deliberate rejection of the scientific principles of perspective laid down by Leonardo da Vinci and Leon Battista Alberti.

The history of art affords us a number of excellent examples of artists who became professional only at a mature age and managed nonetheless to master that science of painting that comes much easier to those who are younger. The number is, however, not large. Only a few outstanding individuals - like Paul Gauguin and Vincent Van Gogh - are capable of such achievement. For all that, striving for the 'correct' way to paint and endeavouring to follow methods taught in art schools and practised by the great masters is a trait present in almost every naive artist.

Although Niko Pirosmani had no Hermitage or Louvre to visit, he was familiar with the works of other artists in contemporary Tbilisi, and tried to follow the professional 'rules' as far as he could. Perspectives in his landscapes, however, the anatomical proportions of his models and the positioning of human figures within his pictures were all prone to the errors also to be seen in the works of the Douanier Rousseau. They reveal that characteristic awkwardness common to artists who start painting as adults. But like Rousseau, Pirosmani took great pride in his own individuality.

Despite the amazing diversity of naive artists, then, their relationship with professional art is basically the same. It would, after all, be extremely difficult to find a person who took up a brush and just started creating oil paintings without any previous knowledge of painting and without ever having seen the pictures of the great masters even by way of reproductions on postcards.

Moreover, the seeds of this knowledge has fallen on to many different sorts of ground. The landscapes of Ivan Generalić, for example, are remarkable for their classical construction and spatial perspective. His figures move with such expression that those of Claude Lorrain and Pieter Bruegel spring to mind. He most probably owed these qualities to his mentor, Hegedušić. The other Croatian rural artists of Hlebin quite often established perspective in stages up the canvas, and their portrayals of the human figure were little or no more than childish.

Analysis of naive art against professional criteria points to the conclusion that French and German, Polish and Russian, Latin American and Haitian artists all have some qualities in common. On the one hand all of them have a fairly clear idea of art as taught in art schools, and strive towards it. On the other hand they all possess that clumsiness which results in a characteristic manner of expression and which is itself responsible for the lack of balance in their works, resulting in outlandishly bold exaggeration or, conversely, in painstaking attention to detail. These, though, are the very qualities for which naive artists have become best known.

At the same time, if an adult person finds himself or herself striving earnestly towards an artistic goal and yet comes to the realisation that his or her limitations make the goal unattainable, he or she might well be tempted to conceal any familiarity with the basics of art. Indeed, André Malraux once described Rousseau as being "able to get what he wants like a child, and slightly devious with it".

Adolf Dietrich,
Hunting Dog, 1934.
Oil on canvas, 69.5 x 55 cm.
Private collection, Zurich.

Fernando De Angelis,
Winter's Day, 1973.
50 x 70 cm.
Private collection.

Catinca Popescu,
Winter in the Country.
Oil on canvas, 30 x 40 cm.
Private collection.

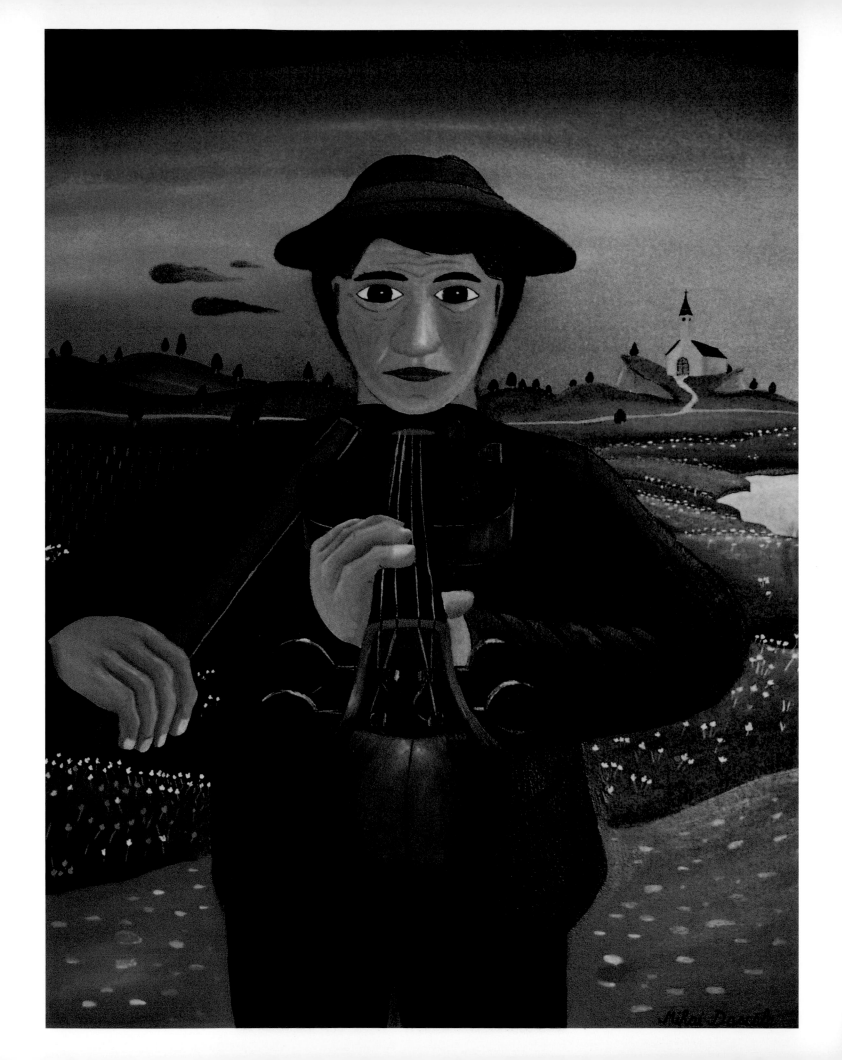

Major Artists

Mihai Dascalu,
The Violin Player.
Oil on canvas, 120 x 80 cm.
Private collection.

France

Henri Rousseau, also called the Douanier Rousseau

(Laval, 1844 – Paris, 1910)

Originating from a modest family, born into labour and poverty, nothing predisposed Henri Julien Félix Rousseau to become an artist. In a society where the practice of fine arts almost always belonged, from birth, to an environment favourable for its development, the Douanier Rousseau found in painting his Sunday outlet. After his week's work, Henri Rousseau gave up his only day off to stimulate his senses with painting and music.

Contrary to alleged stories that he had travelled to Mexico, travel which would have inspired his creative world throughout his life as a painter, Henri Rousseau never left Paris. He borrowed the exotic flora and fauna, the wildlife and the extraordinary colourful plants which fill his paintings, from the Jardin des Plantes, the Jardin d'Acclimatation and from the Natural History Museum in Paris.

Originally a legal clerk in Angers, Henri Rousseau then joined the French army. He left the army in 1868 and after the death of his father he returned to Paris. The following year he married Clémence Boitard with whom he had seven children, only one of which survived to adulthood.

After the war of 1870, he entered the Paris toll collector's office as a second class clerk, managing the control of imports at each gate of the city. From this job, Rousseau was given his pseudonym.

It is at this time that he taught himself to paint. Obtaining a copier's card for the Louvre, he began to familiarise himself with its masterpieces. In 1885, he tried unsuccessfully to exhibit at the Salon des Artistes Français but the following year he exhibited at the Salon des indépendants where he notably showed his painting *Carnival Evening*.

However, the presence of Rousseau in the Salon proved unfruitful and the Douanier was not taken seriously. His paintings, without perspective, with massive figures and unreal proportions were considered to be 'puerile' and amused the visitors who couldn't see the soul of the artist in them. The public, astounded by these new forms, the outburst of slick and faultless colours, and by this work in which no influence nor preliminary training was evident, remained speechless, often mocking and amused by this little man who pretended to be a painter.

Henri Rousseau, also called **the Douanier Rousseau**, *Tiger in a Tropical Storm (Surprised!)*, 1891. Oil on canvas, 129.8 x 161.9 cm. The National Gallery, London.

Henri Rousseau, also called **the Douanier Rousseau**, *The Snake Charmer*, 1907. Oil on canvas, 169 x 189.5 cm. Musée d'Orsay, Paris.

Yet, as a painter of genius, Rousseau created his own methods of expression, through his dreams and these places he never knew, but in which he found himself at home. Painting with his heart, without ever disowning the Art that preceded his, without disowning his working friends either, Rousseau only found later on the place he deserved within the art world.

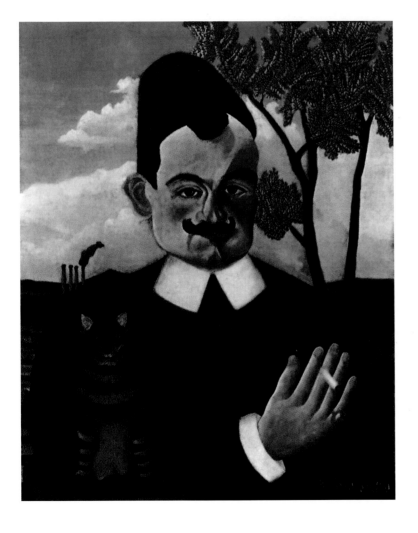

No one, amongst the intellectuals whom he might have rubbed shoulders with, notably during the parties he organised and to whom he sent invitations embellished with his drawings of birds, animals or flowers, dared to openly support him in his modest pretensions. His reputation first originated from his working class friends who were the only ones to be able to understand and above all admire this worker who had for a long time given up his only day off to dedicate himself to Art, which he had destined himself to, and with good reason, even if his background was not favourable to this vocation.

Henri Rousseau began to exhibit at the Salon des indépendants while still undertaking his occupation as a Douanier. The pseudonym of this original man who claimed to be a 'Sunday painter' was easy to find in a Paris still anchored in its traditions and conventions. For over more than twenty years, the Douanier had exhibited his paintings at this Salon which was the competitor of the official Salon and out of principal accepted all artists, without a selection jury process.

Beginning in 1903, Henri Rousseau also exhibited at the Salon d'automne. He was fifty-nine years old and had to wait another four years before receiving any kind of recognition and admiration from the art world to which he tried to be linked for twenty-six years.

It was Alfred Jarry and Guillaume Apollinaire who acknowledged at last, during the Salon d'automne of 1907, the great artist that he was and who did not cease exhibiting his paintings in public, which were of a revolutionary nature,

resolutely different and innovative compared to the art one could see at the time. In front of this painting that the Douanier so rightly entitled *The Dream*, Apollinaire is supposed to have said: "This year, no one laughs, all are unanimous: they admire", and the amusing douanier became the 'Douanier Rousseau'.

Then came Picasso, Sonia and Robert Delaunay and all the avant-garde of the emerging twentieth century, grasping for revolution and independence, who were able to see in the difference of the work of Henri Rousseau a true liberation and an access to this dream world sometimes terrifying but always captivating, that conventions, for too long respected, had reduced to a state of silence. Rousseau, through his works that they condescended at last to look at, gave them back a part of the magic indispensable to art and its evolution. From 'puerile', the style of Rousseau will become 'naive'. In Italy, the painters renounced momentarily Futurism to practise this new and refreshing genre, while the symbolists were going to draw their influence from it.

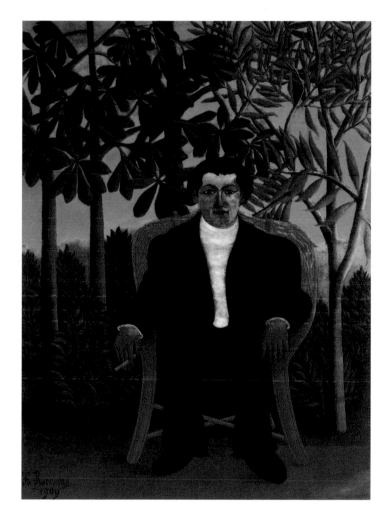

In 1907, the genius of Henri Rousseau that was revealed to everyone's eyes for years was finally recognised. The painter was sixty-three and only had three years to live.

Like his life, the artistic career of the Douanier Rousseau was made of labour, perseverance and hope. Married twice, first to Clémence and then to Joséphine, then widowed twice, Rousseau found for the last time an unhappy love in Léonine, a sales girl at the Bazar de l'Hôtel de Ville, who was a burden on his meagre savings and did not turn up on their wedding day, breaking for the last time the heart of the great dreamer.

The Douanier Rousseau died in Paris in 1910, in a hospital bed where, despite everything, he was forgotten. Without money, the body of Henri Rousseau was buried in a common grave, while his paintings, like the wild birds in his jungles took flight never to cease gliding over the art of the twentieth century and to become incontrovertible in the history of art.

Henri Rousseau, also called
the Douanier Rousseau,
A Country Wedding, c. 1905.
Oil on canvas, 163 x 114 cm.
Musée de l'Orangerie, Paris.

Henri Rousseau, also called
the Douanier Rousseau,
A Carnival Evening, 1886.
Oil on canvas, 106.9 x 89.3 cm.
Philadelphia Museum of Art,
Philadelphia.

Henri Rousseau, also called
the Douanier Rousseau,
Portrait of Pierre Loti, c. 1891.
Oil on canvas, 62 x 50 cm.
Kunsthaus Zürich, Zurich.

Henri Rousseau, also called
the Douanier Rousseau,
Portrait of Mr. Brummer, 1909.
Oil on canvas, 116 x 89 cm.
Private collection.

Henri Rousseau, also called
the Douanier Rousseau,
The Dream, 1910.
Oil on canvas, 204.5 x 298.5 cm.
The Museum of Modern Art,
New York.

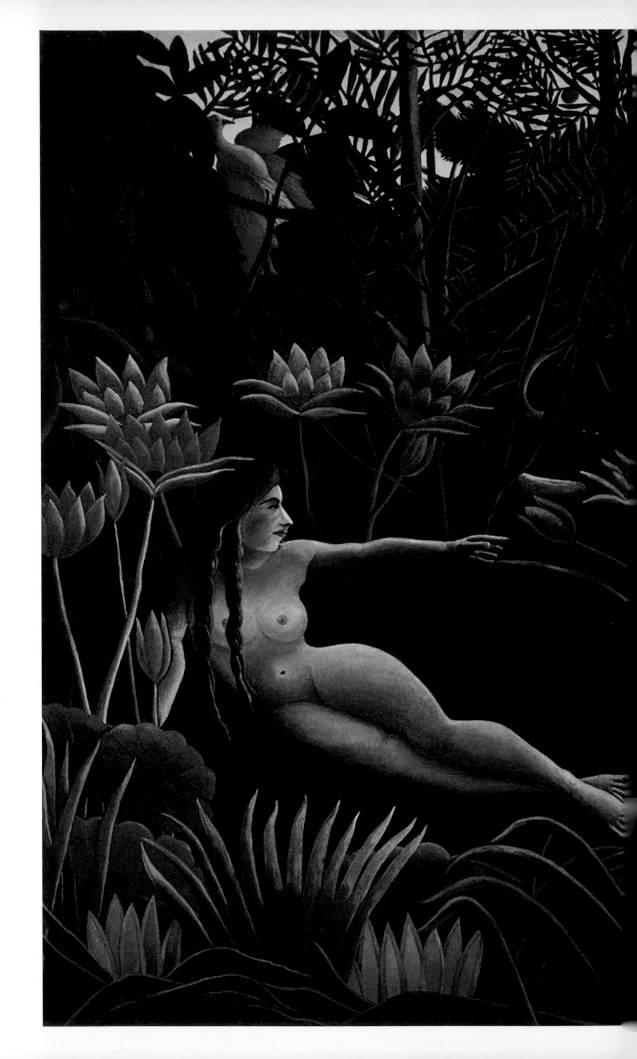

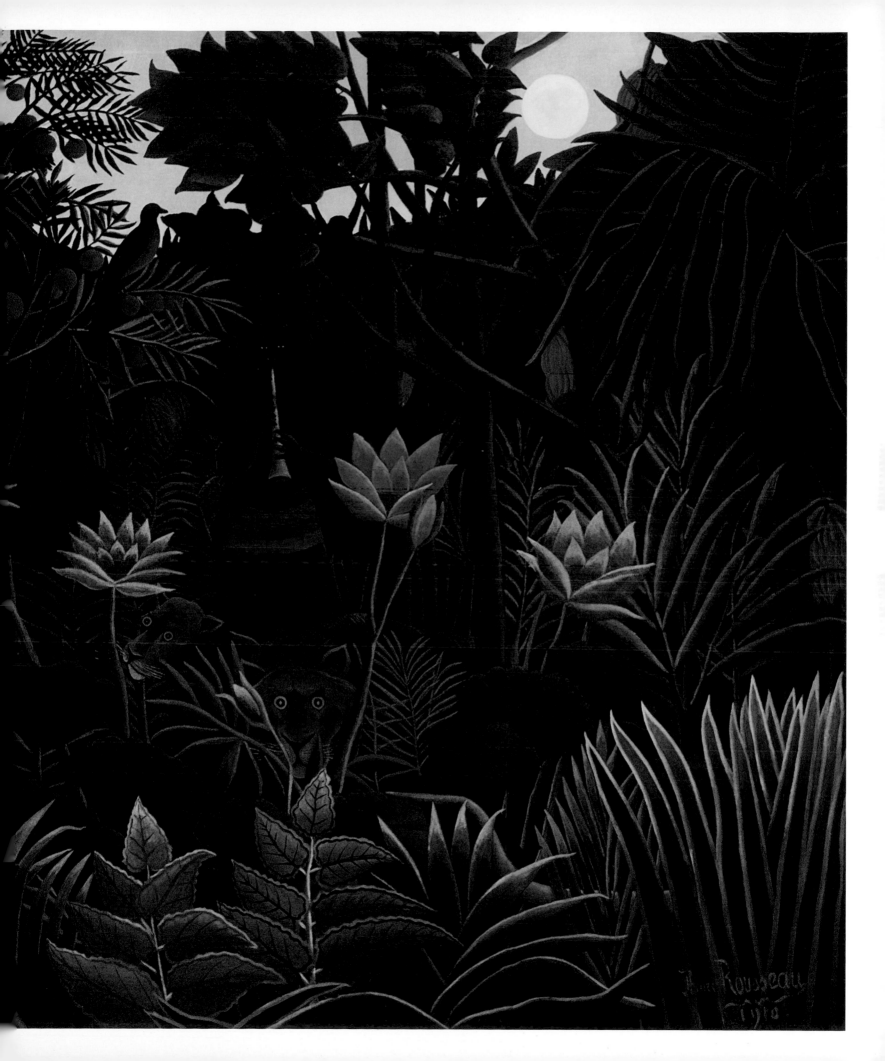

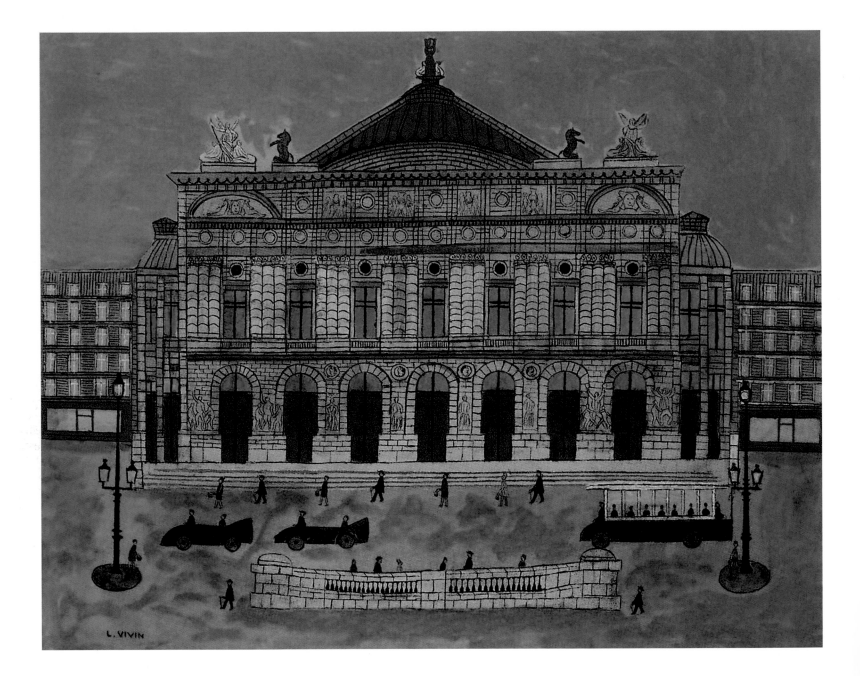

Louis Vivin,
The Opera in Paris.
Oil on canvas, 73 x 92 cm.
Museum Charlotte Zander,
Bönnigheim.

Louis Vivin

(Hadol, 1861 – Paris, 1936)

Fascinated by drawing from a very young age, Louis Vivin studied fine arts at the secondary school of Epinal. Then, without financial means, he worked as an itinerant for the postal service. He will travel the roads of France for thirty years and will not be able to draw until his retirement.

Like many others, he was discovered by Wilhelm Uhde who organised an exhibition of his work, gaining public interest. His obsession was for detail and multiplying, and his thoroughness was often emulated by other naive artists. It is one of the rare constants that one can find in this movement. He painted numerous views of the capital, striving to paint every slate on the roofs, every leaf on the trees; hunting scenes, etc.

His interest in animals underline also the nostalgia of childhood, specific to naive artists, animal representation being often used as a subject. He was notably known for his use of geometric lines. Dina Vierny will say of him that he was "the cleanest and most poetic of naive artists [...] the Mallarmé of naive art". With Séraphine de Senlis, Camille Bombois and André Bauchant, he belonged to the group of painters that Uhde called the painters of the 'Sacred Heart' for whom he would organise an exhibition: "Instead of calling them 'Sunday painters', which would be incorrect, or 'popular painters' which does not say enough, it would be more just to name them 'painters of the Sacred heart'. Not only because they live around the white luminous basilica of Sacré-Cœur, which they represent frequently like its elder and more elegant sister, Notre-Dame, but above all, because, full of simple love and modesty, they create their work with a strong and pious heart."[34]

Louis Vivin,
Gate Saint-Martin.
Oil on canvas, 50 x 61 cm.
Museum Charlotte Zander, Bönnigheim.

Louis Vivin,
The Hunters' Picnic
(A Disturbed Meal).
Oil on canvas, 38 x 55 cm.
Private collection.

Louis Vivin,
Hunting the Beast.
Oil on canvas, 46 x 61 cm.
Museum Charlotte Zander, Bönnigheim.

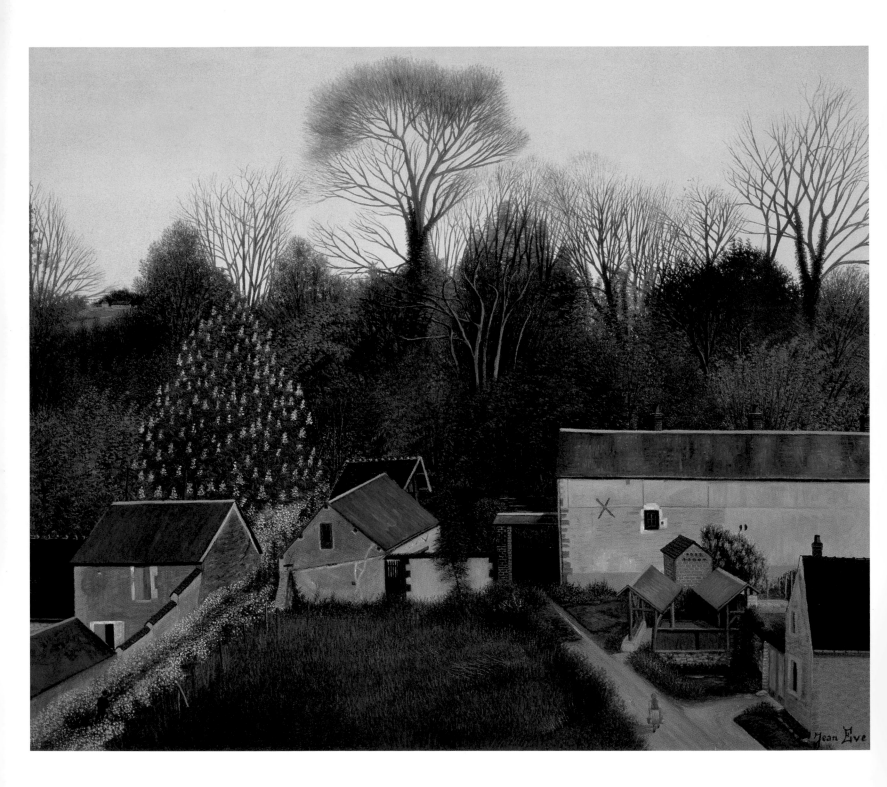

Jean Eve

(Somain, 1900 – Louveciennes, 1968)

Like a number of naive painters, most of them in fact, Jean Eve came from a modest background. Maximilien Gauthier in his preface in the catalogue for the famous exhibition *The Popular Masters of Reality* which took place in 1937, rightly wrote that history: "had ceased to occupy itself exclusively with the great to interest itself in the humble."[35] Jean Eve was the son of a miner. He became a mechanic and was then employed in the toll collectors' office like the Douanier Rousseau. His attention to detail, his delicate line and his point of view of nature shows his will to celebrate simplicity and daily happiness. His representations of villages or hamlets are an echo to our joys of yore. The calm that appears through his canvases underlines the tranquillity and the detachment with which those "recreational" artist painted. Indeed, the naive painters were more worried about their environment than about their hypothetical prosperity. This being so, the utilisation of technique in his painting, such as perspective, made him an artist on the border of the movement.

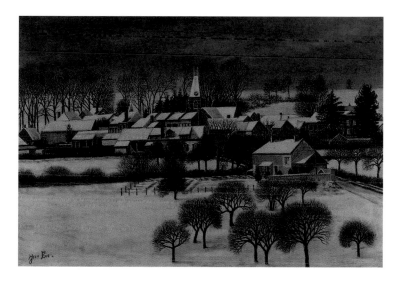

Jean Eve,
Spring in Bus-Saint-Rémy.
Oil on canvas, 46 x 55 cm.
Musée Toulouse-Lautrec, Albi.

Jean Eve,
Landscape in the Snow.
Private collection.

Séraphine Louis, also called Séraphine de Senlis

(Arsy, 1864 – Clermont, 1942)

Having lost her parents at a young age, Séraphine Louis had to find work on a farm as a shepherd, before becoming a chamber maid in Senlis, the town from which she took her pseudonym. Like a number of naive painters, she came to painting late, at around the age of forty. The critic Wilhelm Uhde, who was the first person to be interested in and encourage the naive painters, realised one day after buying a naive painting in a gallery that the artist was none other than his cleaner! He bought the materials in order to encourage her to paint. Fruit and flowers with painstaking outlines fill her dense paintings rich in lively and luminous colour. These explosions of colour which constantly spring up give a rare intensity to her paintings and to the sentiment they provoke. Imagination wins over, defying the laws of perspective and any rationality.

This is why Uhde said of her works: "Séraphine's trees have sometimes shells for leaves and take on the form of marine animals. These trees, which have never existed and which will never exist, we see them live like human beings".[36] *The Tree of Paradise* and *the Red Tree* are among her best known canvases. Séraphine de Senlis participated in the 'Sacred heart' exhibition which united the best naive artists of the time and whose organiser was none other than Wilhelm Udhe. The stained glass windows of the church of Senlis also had a diffused influence on all her work. Mystical and very pious, she worked most of the time by candle light in front of a statue of the Virgin Mary. Her works are full of spirituality and ecstasy, giving mystery to her still life painting as if full of a presence. She will even dedicate some of her works to Mary. Mentally unstable, Séraphine who had hallucinations (particularly about the end of the world), will end up in a mental institution.

Séraphine Louis, also called
Séraphine de Senlis,
Bouquet, c. 1927-1928.
Oil on canvas, 117 x 89 cm.
Museum Charlotte Zander,
Bönnigheim.

Séraphine Louis, also called
Séraphine de Senlis,
Yellow Flowers and Red Leaves.
Oil on canvas, 120 x 92 cm.
Museum Charlotte Zander,
Bönnigheim.

Séraphine Louis, also called
Séraphine de Senlis,
Flowers on Blue Background.
Oil on canvas, 21 x 26.1 cm.
Museum Charlotte Zander,
Bönnigheim.

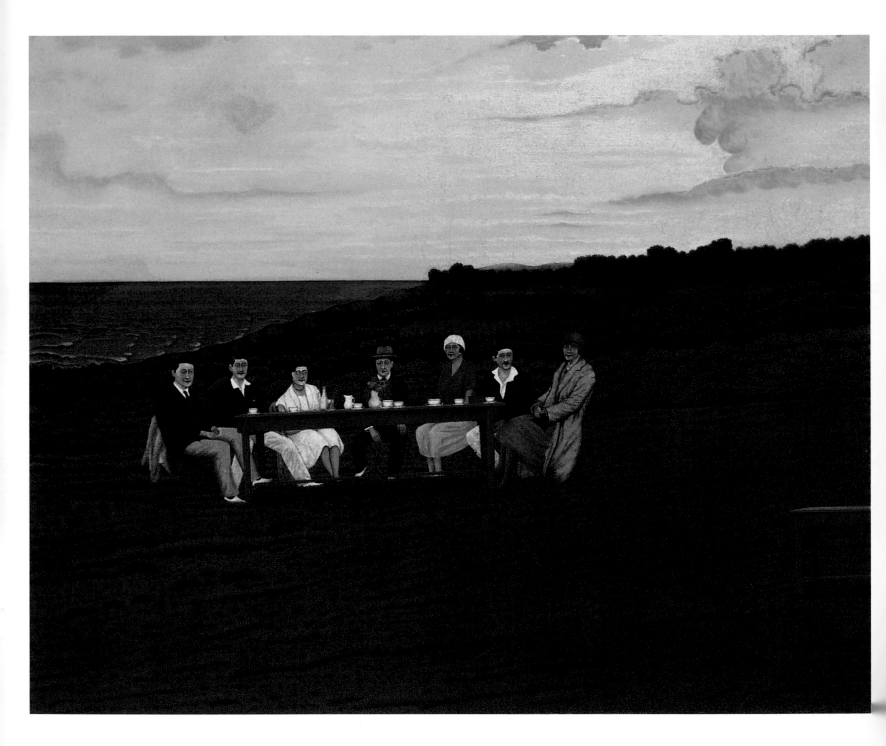

Dominique Peyronnet (1872 – 1943)

Before becoming a painter Dominique Peyronnet was a lithographer, which explains the quality and graphic precision of his drawings. This French artist was not prolific, only producing around thirty paintings. His favourite subjects were seascapes and wooded nocturnal landscapes. His line is lively and precise, his waves seem to be traced, cut out and fixed in time, and his colours remain enticing. The precision of his lines that seem to suspend time on the edge of the canvas, give his work a sensation of enchantment and eeriness. The dilatation which exists between intention and realisation creates in the work of the naive artists and that of Peyronnet in particular, a strange and poetic feeling. From this shift comes the unexpected. This troubled atmosphere distinguishes his work and gives it an energy that few artists managed to keep. We then understand why the surrealists for whom painting must 'make our abstract knowledge itself make a step forward' became interested in naive art.

Dominique Peyronnet,
Lunch by the Water.
Oil on canvas, 66.5 x 83 cm.
Galerie Charlotte, Munich.

Dominique Peyronnet,
Summer Siesta (Woman Lying), c. 1933.
Oil and collage on canvas, 50 x 61 cm.
Musée national d'art moderne,
Centre Georges-Pompidou, Paris.

Dominique Peyronnet,
Castle of the White Queen, 1933.
Oil on canvas, 65 x 81 cm.
Musée national d'art moderne,
Centre Georges-Pompidou, Paris.

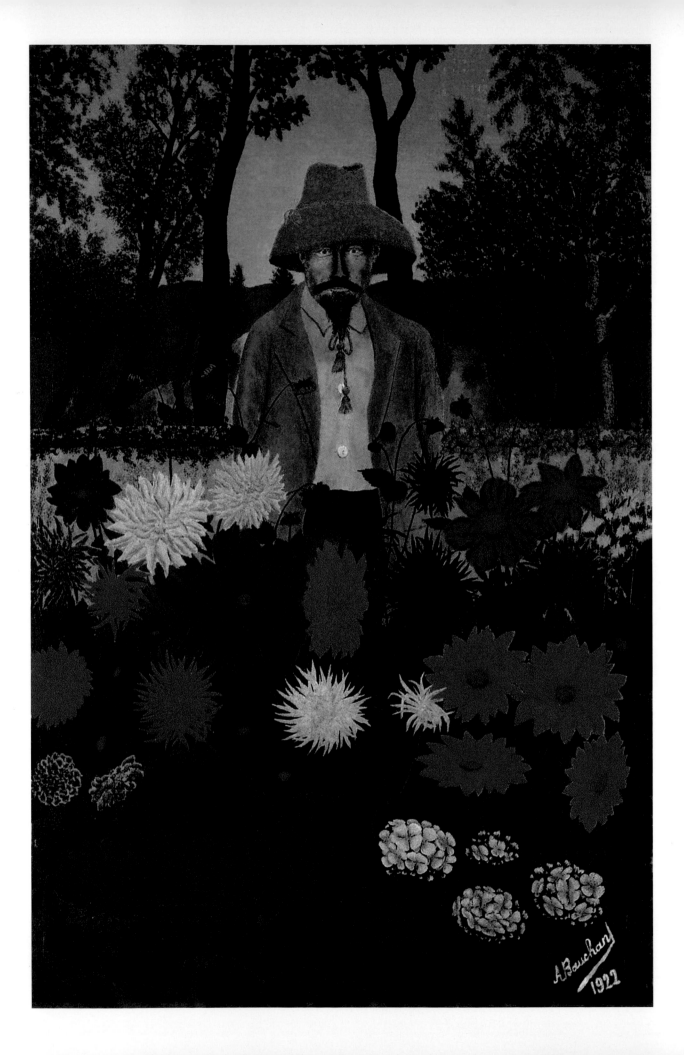

André Bauchant

(Château-Renault, 1873 – Montoire, 1958)

From a modest upbringing, André Bauchant became a nurseryman before being drafted into the military to fight in the Dardanelles. It was only on his return from the war in 1919 that he began to paint. Fascinated from childhood by the Greco-Roman civilisation thanks to reading old illustrated books, his poetic paintings have the taste for fantasy and the grotesque. In 1921, his paintings shown at the Salon d'automne were a great success. Le Corbusier was his first buyer. Thanks to his intervention, he was offered a commission from Diaghilev to create costumes for the ballet *Apollo* by Stravinsky. One finds in his world many nymphs and deities. As a trained nurseryman, his brightly coloured paintings also often depict fruit and flowers of a disproportional size. One of the particularities of his technique is that he always began painting his canvases from the bottom, like he has learned in his job as a cultivator: "a plant lives only from its roots, everything is in the base, if it is solid, your painting will be an accomplishment, otherwise it will be unable to live", he often explained.

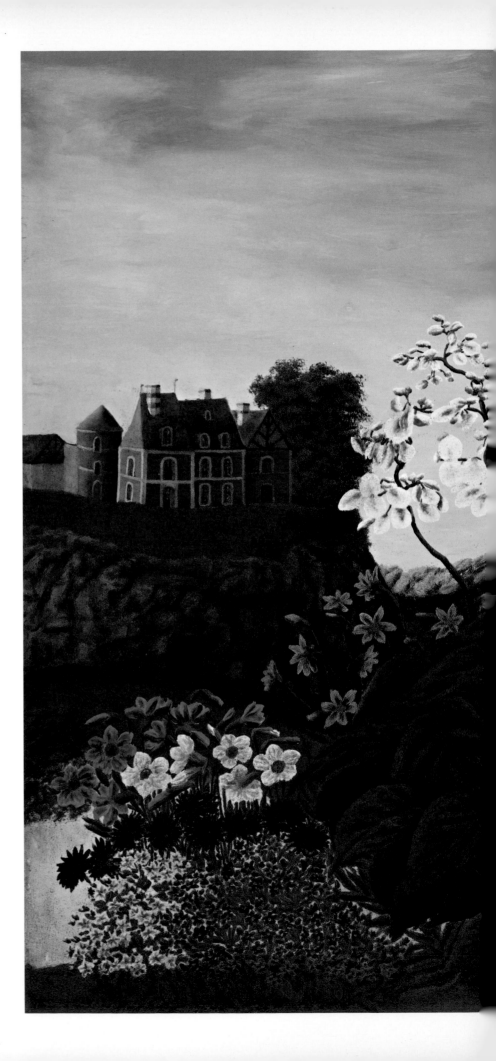

André Bauchant,
*The Gardener in the Flowers
(The Artist by Himself)*, 1922.
Oil on canvas, 93 x 59 cm.
Kunsthaus Zürich, Zurich.

André Bauchant,
*Bouquet of Flowers
in a Landscape*, 1926.
Oil on canvas, 100 x 67 cm.
Museum Charlotte Zander,
Bönnigheim.

André Bauchant,
Flowers in a Landscape, 1951.
Oil on canvas, 79.3 x 98.4 cm.
Private collection.

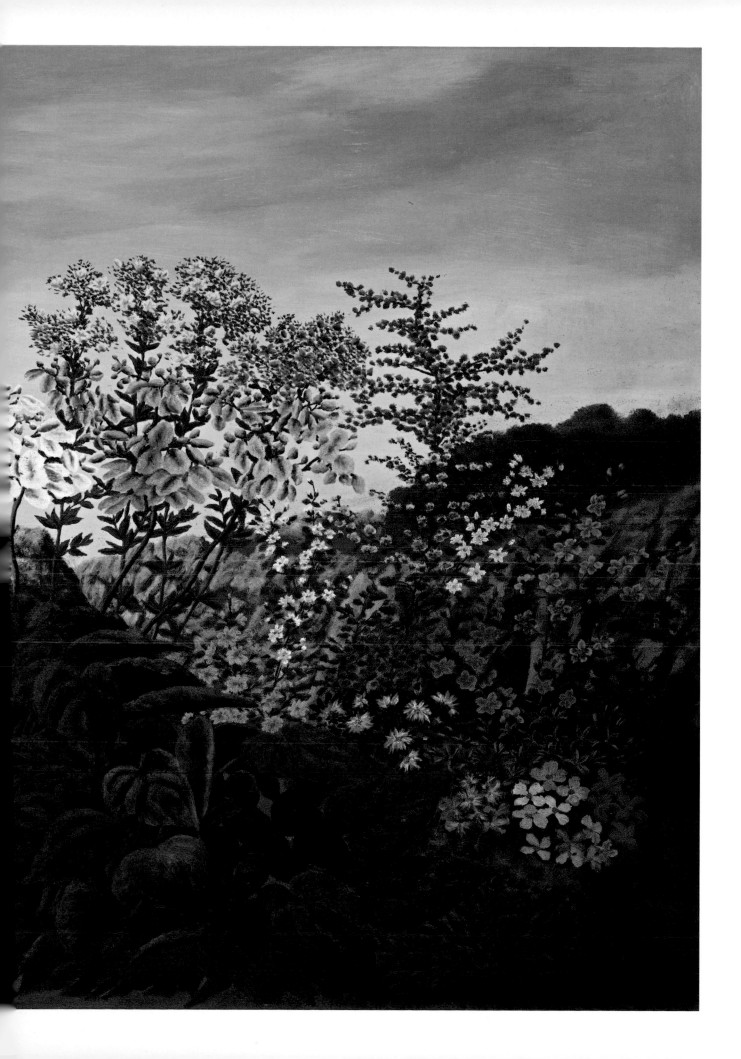

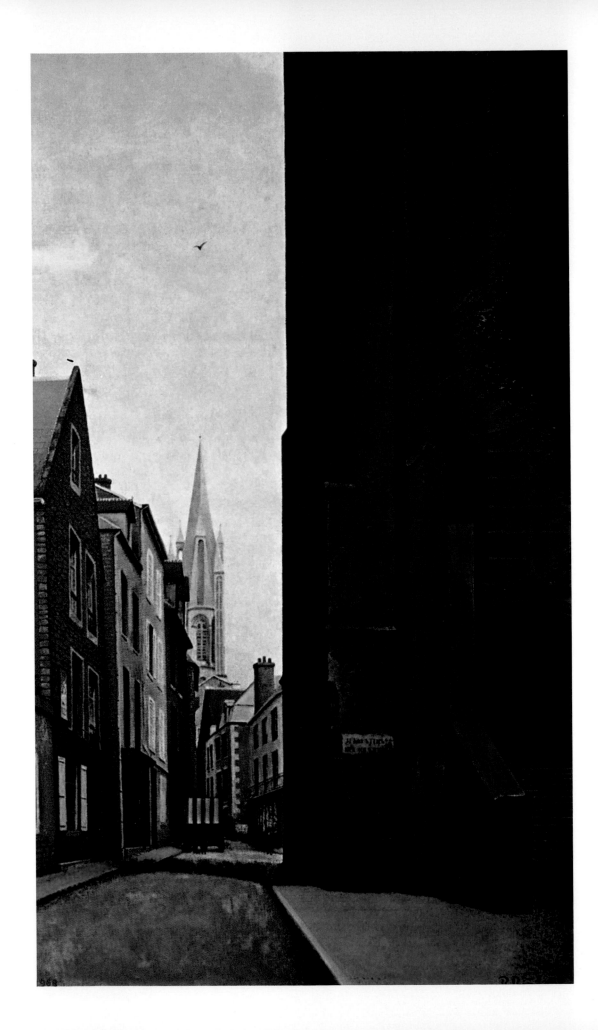

René Martin Rimbert,
Street Scene, c. 1972.
Oil on canvas.
Private collection.

René Martin Rimbert (1896 – 1991)

Employed by the Post Office, René Martin Rimbert is one of the most well known naive artists. "My painting appeals to connoisseurs and simple people who talk about it with feeling", he declared one day. He paints his daily life with simplicity and tries to achieve his work in a personal and autonomous manner. Naive artists were solitary artists who engaged in painting while nothing, and above all their social background, predisposed them to it. Ignorant of all the principles of painting, their art is above all an intimate experience, it is perhaps for this reason that clumsiness vanishes for the profit of emotion. The specialty of René Martin Rimbert was urban landscape. His paintings are an important testimony regarding the growing presence of modernity within the urban landscape of the time, which remind us of the paintings by the Douanier Rousseau. Many of these works evoke the silent life which takes places behind the curtains of these windows. The poetry of his paintings lies in an offset and 'off-centre' subject which is evoked without being condemned. His cold tones where the subject is plunged into the anonymous and the suspension of time remind us of a Magritte or a Hopper. There are worse references... A complete artist, René Martin Rimbert was also a great poet.

René Martin Rimbert,
The Storm, 1949.
Oil on canvas, 55 x 33 cm.
Musée national d'art moderne,
Centre Georges-Pompidou, Paris.

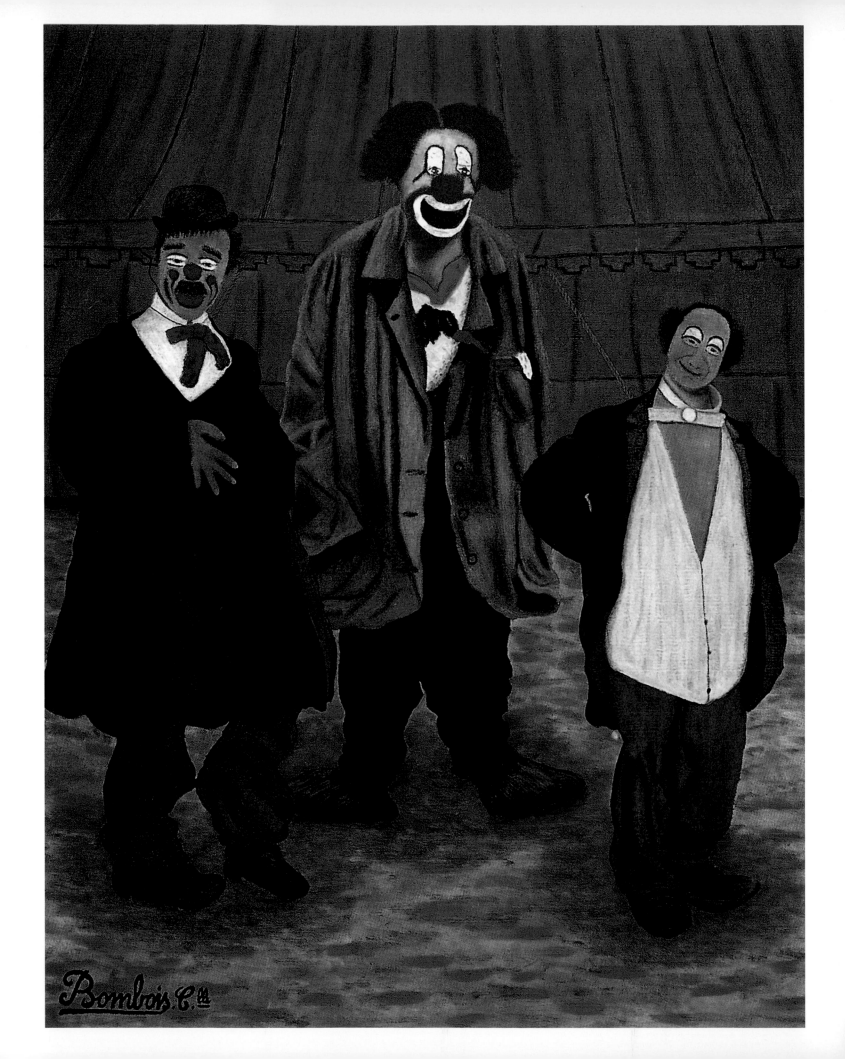

Camille Bombois

(Vénaray-lès-Laumes, 1883 – Paris, 1970)

Despite his precocious attraction to painting, the family financial difficulties meant that Camille Bombois had to work from a very young age. Working as a farmhand and sailor, he then became a wrestler in a fun fair in order to be able to travel to Paris. On his arrival, he works in the tunnels of the Parisian Metro and then finds a job working nights at a printer's so he could spend all day painting. After military service in the First World War where he showed great courage and bravery, (he was awarded three medals), he discovers that his wife had sold some of his paintings in order to survive.

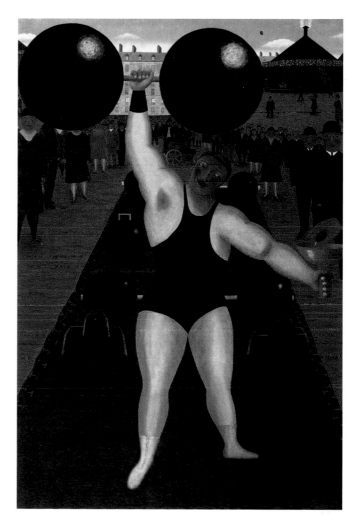

In 1922, he meets Wilhelm Uhde who opened the door for him to critical acclaim and success. He can at last spend his time as a full-time painter. He belongs to the inner circle of the five most reputed naive painters in France, named the 'painters of the Sacred Heart' by Wilhelm Uhde. His most famous paintings are without doubt those of the circus which are appreciated for their energetic drawing, their vivacity of tone and precision of line. His dynamic characters, his sword swallowers, his athletes, like *Athlete at the Carnival, The Wrestlers,* his fleshy women are all memories from his childhood.

His waterside landscapes, *View of Clerval* and *The Canal,* show his attention to detail, the precision of foliage, and reflections in water which accompany the eye of the spectator. All this underlines his sense of observation; *The Sacred Heart* is also a testimony to the activity of the square in Montmartre. Skipping ropes, housewives and 'bourgeois' women chatting on a sunlit bench... All is there to remind us of the good atmosphere of a Sunday afternoon. Camille Bombois is without doubt one of the artists whose art resembles most, that of the Douanier Rousseau. Wilhelm Uhde said of him: "It is only in the work of Bombois that reality is a true *raison d'être,* a goal in itself [...] He paints true life, what he sees, what he loves spontaneously in daily life."

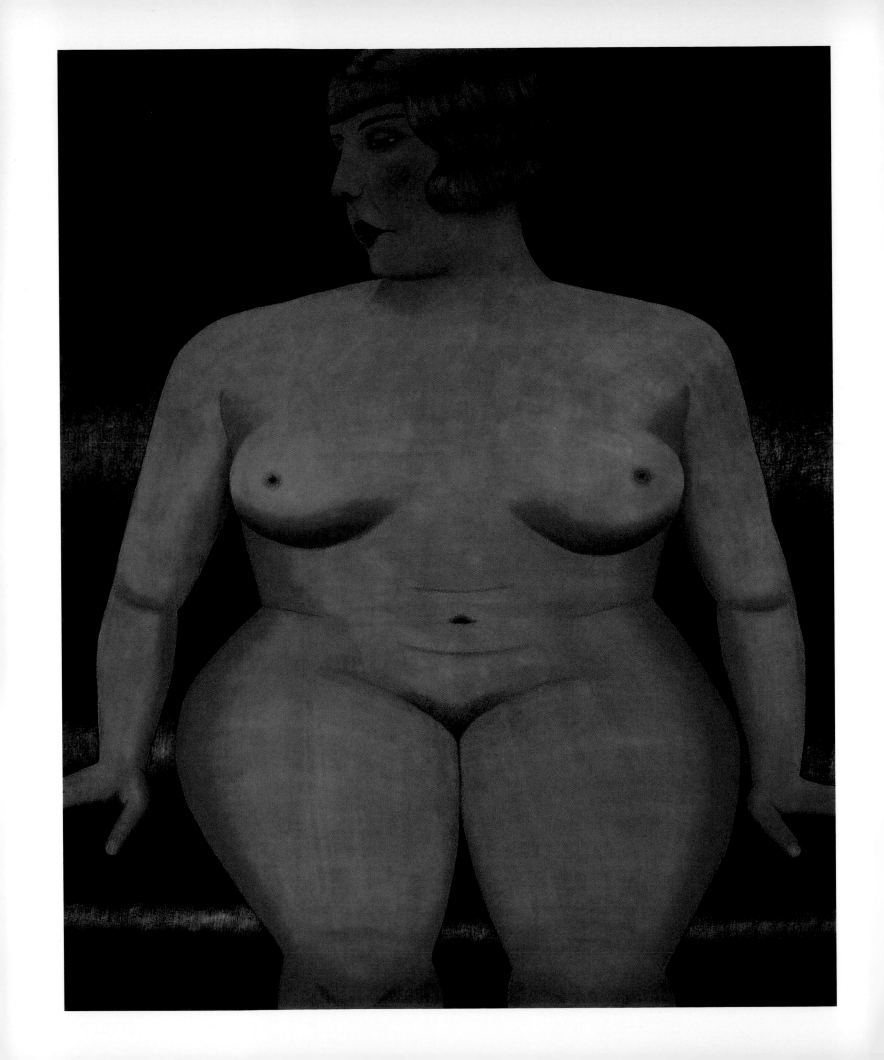

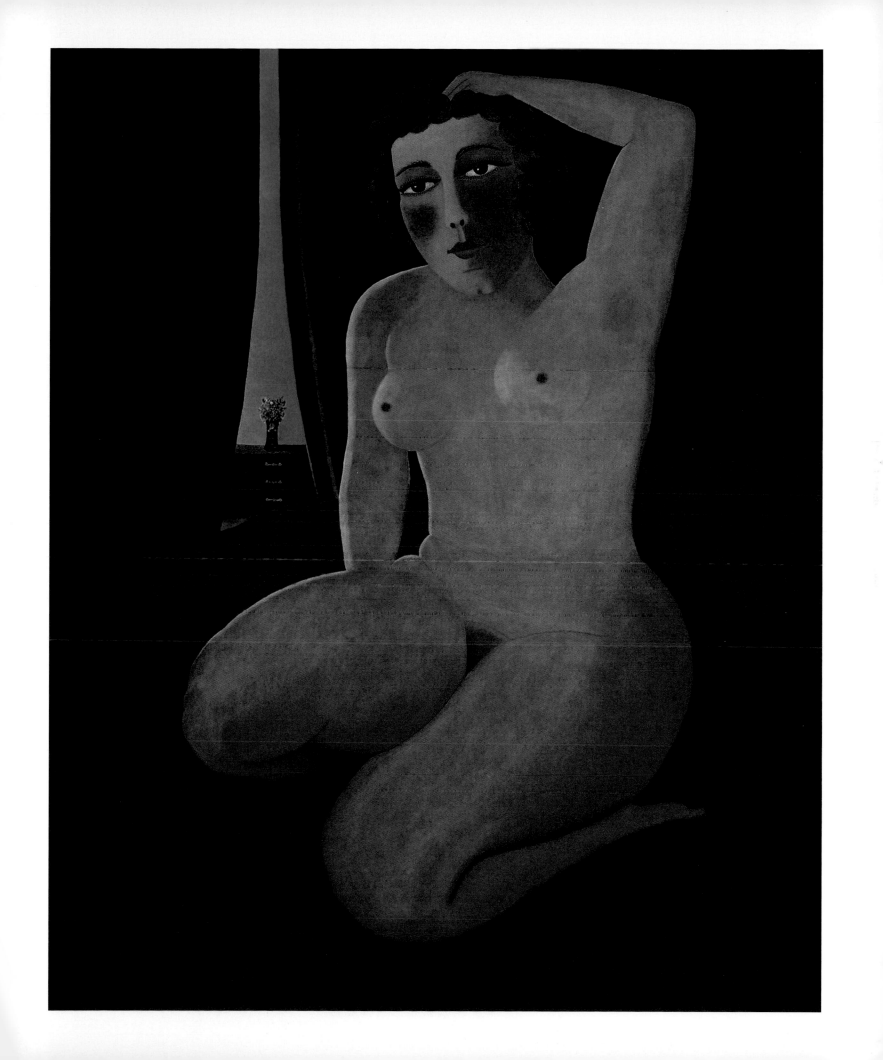

Camille Bombois,
Fratellino and Little Walter.
Oil on wood, 65 x 50 cm.
Museum Charlotte Zander, Bönnigheim.

Camille Bombois,
The Athlete, c. 1930.
Oil on canvas, 130 x 89 cm.
Musée national d'art moderne,
Centre Georges-Pompidou, Paris.

Camille Bombois,
Naked Woman Sitting, c. 1936.
Oil on canvas, 100 x 81 cm.
Museum Charlotte Zander, Bönnigheim.

Camille Bombois,
Nude on a Red Cushion.
Museum Charlotte Zander, Bönnigheim.

Camille Bombois,
Clerval.
Oil on canvas, 27 x 35 cm.
Private collection.

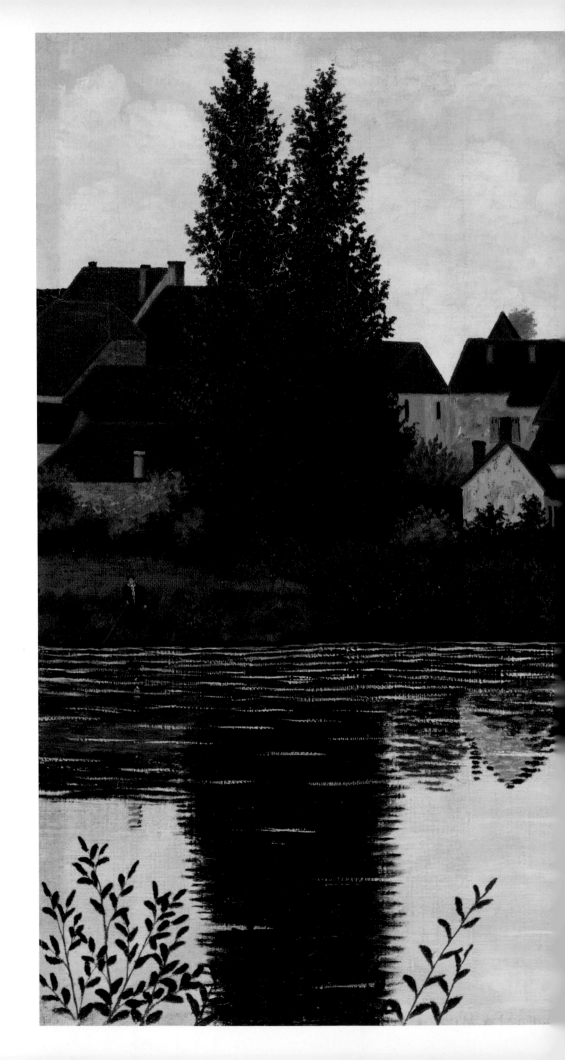

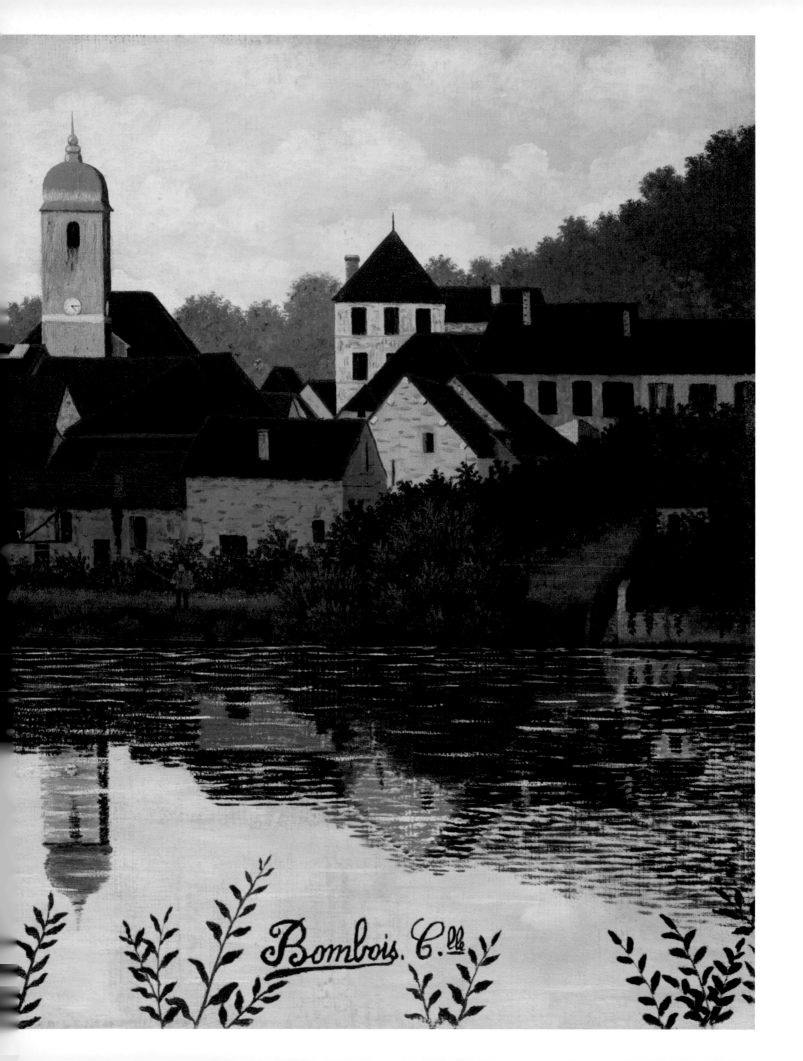

Bombois. C.^{lle}

142

Aristide Caillaud

(Moulins, 1902 – Jaunay-Clan, 1990)

From modest origins, this painter leaned for a time toward surrealism. His sense of unreality can be particularly seen in his painting *Mysterious Town*. "When I paint, my painting comes slowly, like a tree which grows in a dream."[37] His filled urban representations which take up all the surface of the canvas, until suffocation, betray his constantly active artistic mind. Facetious, he likes to be impish and to keep in his paintings the soul of a child, which is, with the frontality in the representation of his persona, one of the characteristics of naive painting. "What enchants in naive painting is not so much its decorative simplicity or its primitive method of narrative, but the joy of discovery itself and the infinite richness of the creative imagination. It then becomes art and produces masterpieces."[38]

Aristide Caillaud,
Resurrection of Menton, 1972.
116 x 89 cm.
Musée d'Art moderne
de la Ville de Paris, Paris.

Aristide Caillaud,
The Port of Rouen, 1954.
120 x 75 cm.
Musée d'Art moderne
de la Ville de Paris, Paris.

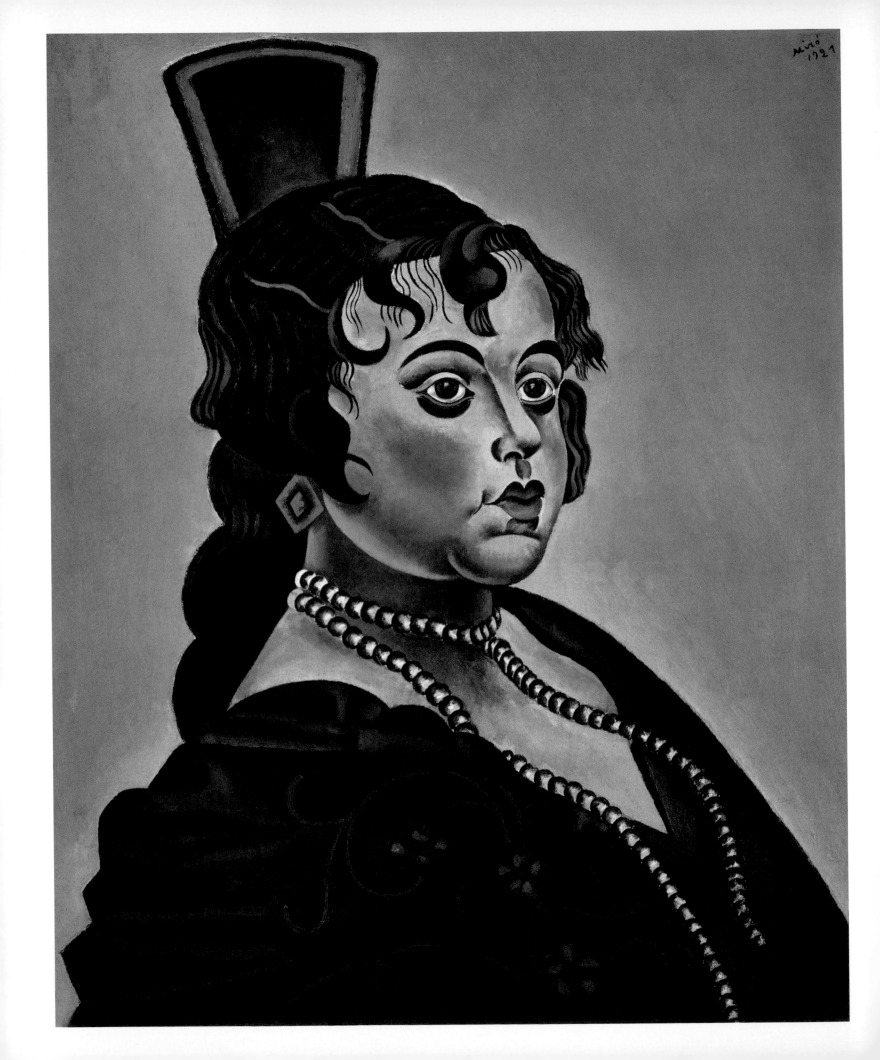

Spain

Joan Miró (Joan Miró i Ferra)

(Barcelona, 1893 – Palma de Mallorca, 1983)

Joan Miró was born in a room with stars painted on the ceiling. He grew up in the city of Barcelona, where rugged independence and creativity go hand in hand. In 1907, he enrolled in art classes at La Escuela de la Lonja, an academic and professionally oriented school of applied arts where a young man named Picasso had impressed the teachers ten years earlier. Then he entered Galí's private classes. Unlike the Lonja School, it offered a setting where Miró's distinctive ways of seeing were rewarded. At Galí's academy, Miró met some of the men who would become not only fellow artists but intimate friends. He and Enric Cristòfol Ricart soon rented a studio together near the Barcelona Cathedral.

Miró never really espoused any school or established style of art. "It was clear in his mind," as one critic has put it, "that he had to go beyond all categories and invent an idiom that would express his origins and be authentically his own". Over the course of his career, he even worked hard not to follow his own traditions.

Clearly Miró had studied Cubism's broken forms and had learned to admire the strident colours of the Fauves. But he had an eye of his own, and his paintings combined twisted perspectives, heavy brushwork, and surprises in colour. He was finding ways to merge the stylish two-dimensionality of the times with inspirations taken from Catalan folk art and Romanesque church frescos. Joan Miró began to recognise that, like Picasso, if he was going to become an artist in earnest, he needed to move to Paris.

His naive originality drew the attention and admiration of them all.

In his last years, Joan Miró spoke to his grandson of his lifelong love of Catalonian folk art - the natural forms, the independent spirit, the naiveté that is both beautiful and surprising. "Folk art never fails to move me," he said. "It is free of deception and artifice. It goes straight to the heart of things". In speaking of the art from the countryside that had nourished him, Joan Miró found the best words to describe himself. With his honesty, spontaneity, and childlike enthusiasm for shape, texture, and colour, he created a universe of artworks sure to delight, puzzle, and reward.

Son of a jeweller-watchmaker and grandson of a cabinet-maker, Miró was brought up to appreciate and respect craftsmanship. When he was eighteen years old, his parents bought a house out in the countryside near a village called Monroi which became one of his favourite hideaways for working and relaxing in. It is quite probable that this closeness to the culture and art of rural life had a formative influence on his later involvement with ceramics, and more

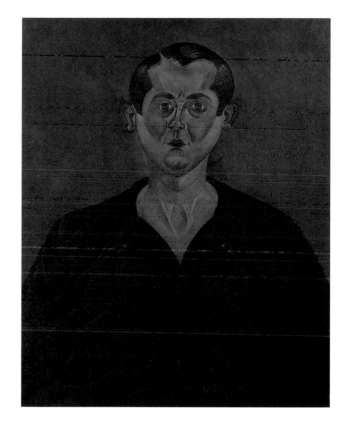

Joan Miró,
Portrait of a Spanish Dancer, 1921.
Oil on canvas, 66 x 56 cm.
Musée national Picasso, Paris.

Joan Miró,
*The Young Man in
a Red Overall (Self-Portrait)*, 1919.
Oil on canvas, 73 x 60 cm.
Musée national Picasso, Paris.

than possible too that the folk-motifs of plants and animals painted on village jugs and plates distilled in his paintings into the simplified figures of horses and bulls for which he became renowned. The simple artefacts of everyday rural life, roughly made and roughly decorated, caused him to look with increasing attention at the minutiae of life around him.

As a child, he saw the paintings in the churches of Catalonia and the Balearic Islands. For the most part these churches were decorated with paintings featuring scenes from the Bible lovingly produced by artists who belonged to that period during the Middle Ages when every element of nature was deemed worthy of attention. Even in the second decade of the twentieth century such artists were described as 'primitives'.

Following an upbringing that both fortuitously and fortunately brought him into contact with artistic ideas of bygone centuries, Miró was able as a mature, professional artist to incorporate something of their dynamic into his work. In this way he embodied a source of fresh artistic energy which his generation had been seeking for some time. Its effect on his own work was extraordinary. His paintings gradually focused less on representation and more on colour and essential form, with a strong sense of humour and a liking for curves.

In other words, his pictures took on the properties of the so-called naive artists, who were to burst upon the western European art scene and to become perhaps the greatest sensation of twentieth-century art.

Joan Miró,
Church and the Village of Montroig, 1919.
Oil on canvas, 28.7 x 24 cm.
Private collection.

Joan Miró,
The Farm, 1921-1922.
Oil on canvas, 123.8 x 141.3 cm.
National Gallery of Art,
Washington, D.C.

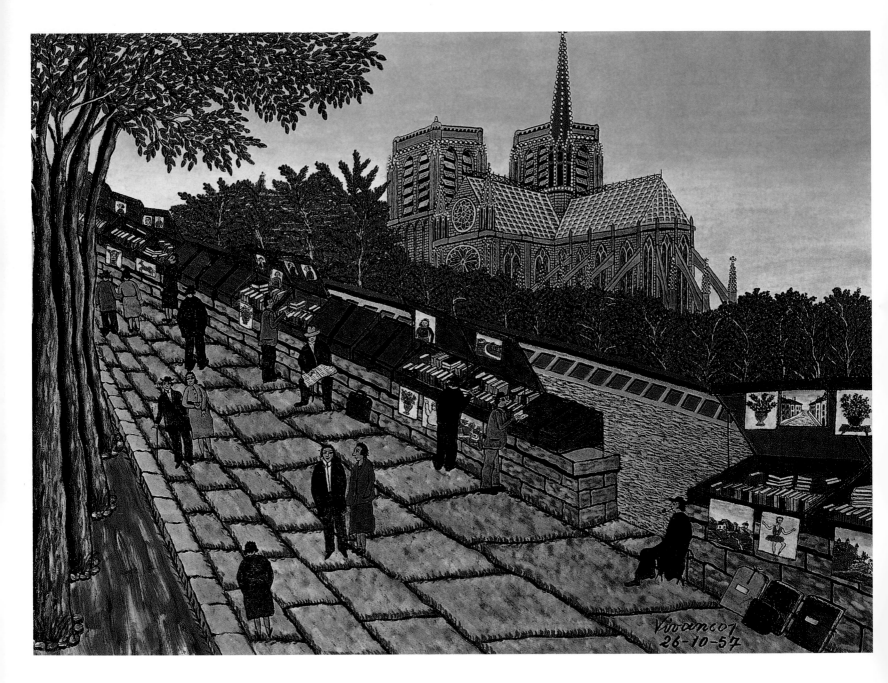

Miguel Garcia Vivancos,
The Quay of the Seine, 1957.
Private collection.

Miguel Garcia Vivancos

(Mazarrón, 1895 – Cordova, 1972)

Miguel Garcia Vivancos is the Spanish naive painter of rurality. He was a remarkable soldier during the Spanish civil war. Breton saluted him as "the man that the temporary defeat of his ideas and five years in the concentration camps of France didn't manage to destroy and whose surprising destiny is now able to celebrate like no other what he succeeded in defending: the simplicity of a village, a chestnut tree in spring, the old stones of history [...] the little dreamy shops and the philosophical dazzle of mature wheat." He actually celebrates the aestheticism of simplicity, the rurality in all its quietness and innocence. He picks up the smallest detail and knows how to make it significant like this harmless walk along the booksellers which witnesses the pleasure of the idleness of the French acquired through the third week of paid vacation. And if death is sometimes present in his work, it is only a stage. His painting is not a lament but praise. The fact that nature is in communion with man, like in *The Plough* where oxen and man unite their strength to plough the furrow, is a sort of prelude to a future life.

Miguel Garcia Vivancos,
Vase with a Lace Napkin, 1958.
Oil on canvas, 64 x 52 cm.
Musée International d'Art Naïf
Anatole Jakovsky, Nice.

Italy

Orneore Metelli

(Terni, 1872 – Terni, 1938)

A shoemaker by trade and a passionate musician, he has to abandon this because of medical advice, he therefore turns to painting late in life, at around fifty years old, like many of the other naive painters.

He lived in the village of Terni; a small village located in the heart of Italy not far from Orvieto and painted, during the night, mainly its monuments as well as representing its social life. These are a true historical testimony to the traditions and mores of the time. His works underline also the emotion and the freshness of mass movement. His work *The Fight at the Fountain* is a stolen moment, an open window on the everyday life of the inhabitants. Regarding this, Wilhelm Uhde will underline that, for naive painters, intention was more important than realisation. He also said that they painted "under the power of an emotion experienced in a strange and enchanted world."[39] Rousseau, the best known naive painter himself said: "It is not me who paints, but it is something on the tip of my hand."

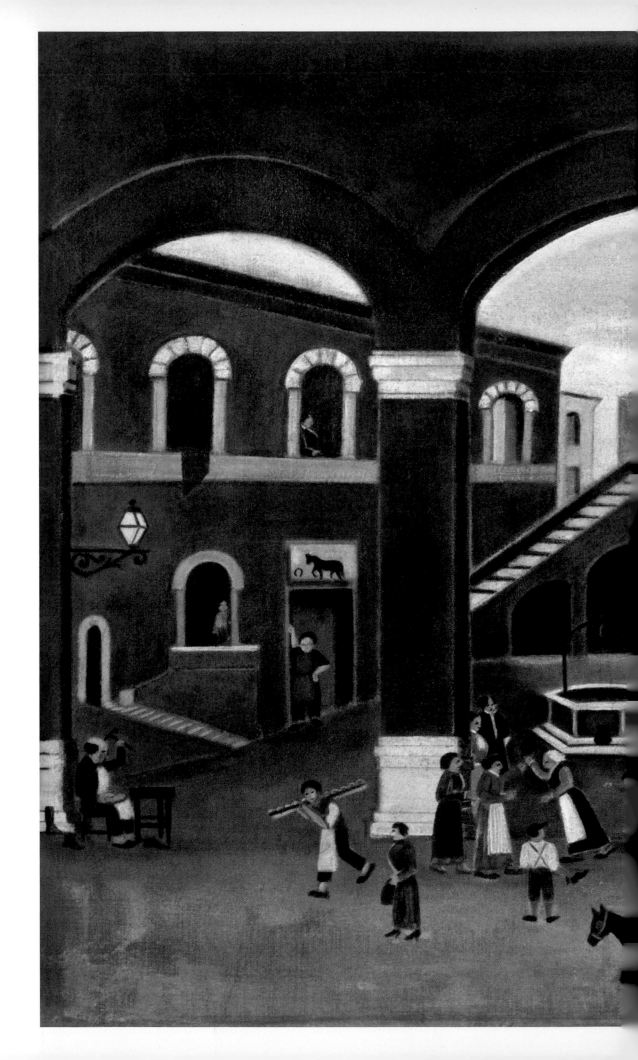

Orneore Metelli,
Self-Portrait as Musician.
Private collection.

Orneore Metelli,
The Venus of Terni, c. 1935.
Private collection.

Orneore Metelli,
Godmothers Quarrel
at the Fountain, 1935.
Private collection, Rome.

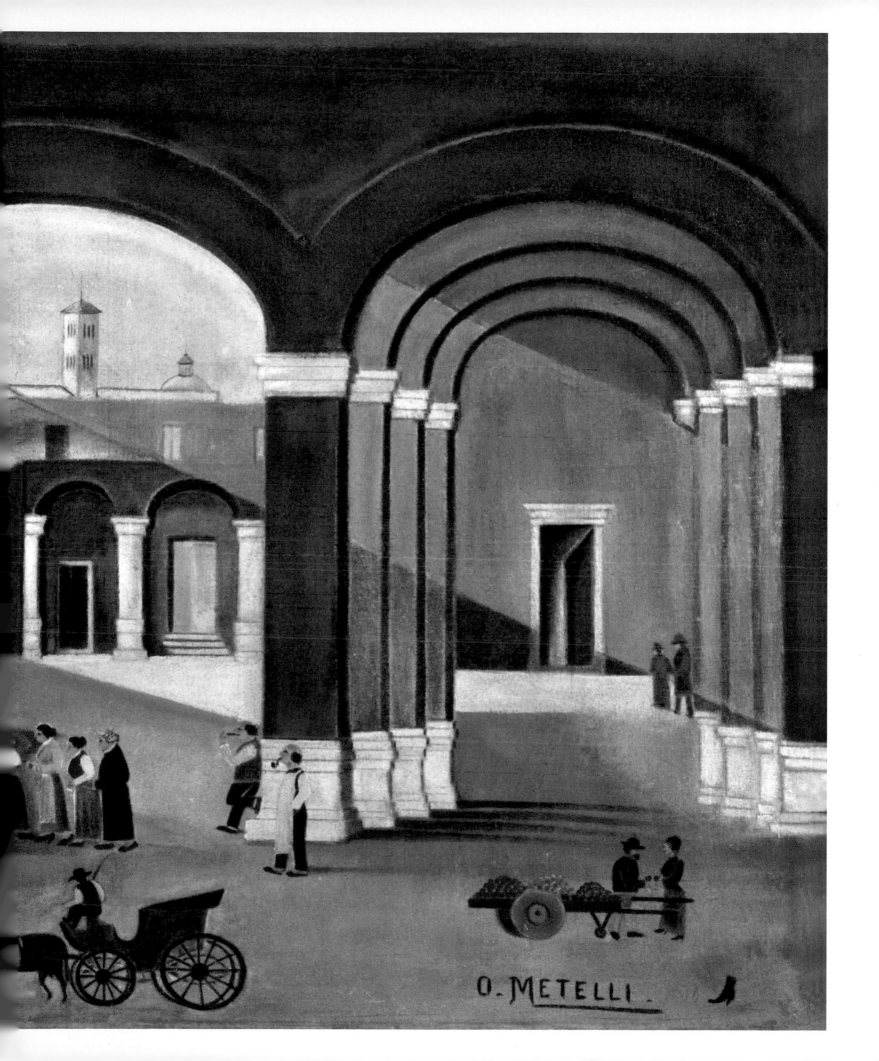

Guido Vedovato

(Vicenza, 1961 –)

Guido Vedovato was born in 1961 in Vicenza in the North of Italy. Self-taught, he progressively became, in the 1970s, a naive painter and sculptor, it started as a hobby then he became more and more professional.

His first exhibition was in 1986. Today, his works are exhibited widely, in Italy of course, but also in many other countries in Europe, the United States and Canada. His works have been acquired by the following museums: The Museum of Naive Art in Jagodina (Serbia), The National Naive Art Museum Cesare Zavattini (Italy), The International Museum of Naive Art in Bages (France), The Slovenian Naive Art Museum in Trebnje (Slovenia), The Jaén International Naive Art Museum – (Spain), The Museum of Naive Art in Béraut MAN (France), Vihorlatske Muzeum Humenné – (Slovakia), The Republic International Naive Art Museum Y. M. Daigle (Canada), The MIDAN International Naive Art Museum in Vicq (France), The Naive Art Museum in Lauro (Italy).

His work is close to that of Dominique Peyronnet regarding the strange and fantastic atmosphere that is portrayed in his work. The fall of night reveals its mystery through nocturnal birds and other animals. His rejection of perspective reminds us of children's drawings or those of the Egyptians who underlined, by this method, the hierarchical order. The artist, while highlighting a great number of details, forgets reality, making his paintings an invitation to immerse ourselves into his childlike and colourful world.

Guido Vedovato,
Pippo's Portrait.
Private collection.

Guido Vedovato,
Walk on the Rooftops.
Private collection.

Guido Vedovato,
Self-Portrait with Accordion.
Private collection.

Guido Vedovato,
The Pumpkin Dealer.
Private collection.

Guido Vedovato,
On the Way to the Village.
Private collection.

Guido Vedovato,
Posina Valley.
Private collection.

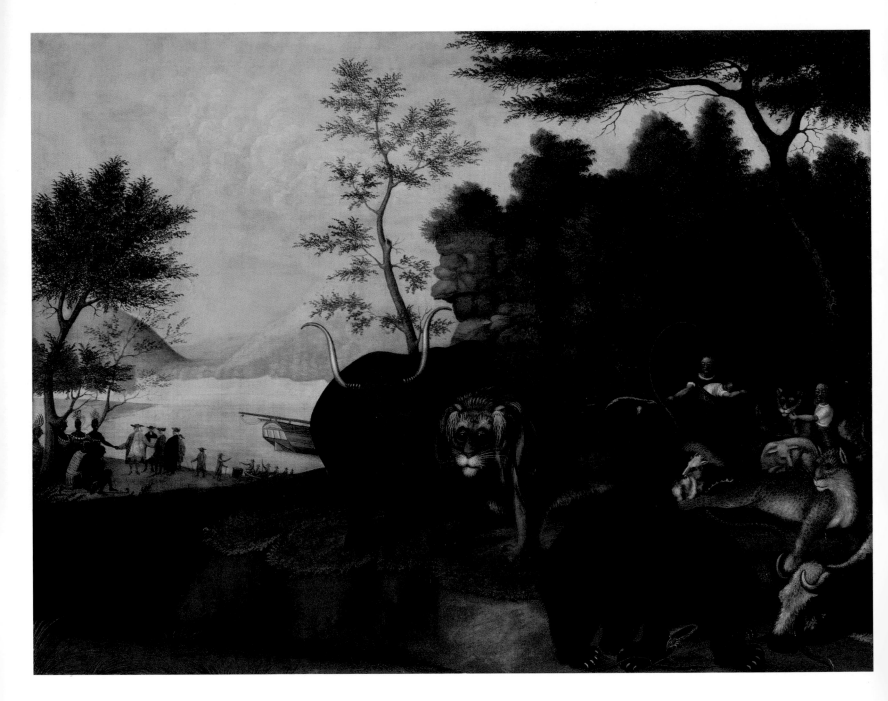

Edward Hicks,
The Peaceable Kingdom, 1847.
Oil on canvas.
Private collection.

United States

Edward Hicks

(Langhorne, 1780 – Newtown, 1849)

Edward Hicks originated from Pennsylvania. After having lost his mother at a very young age, he was brought up by the Quakers. After having been a painter and decorator of coaches, Edward Hicks abandoned painting for religion and was a preacher for many years. The pleasure he found in painting seemed to him in conflict and was even forbidden by his religion, but he was to return to it later in his life. Painter of large scale historical scenes (during the 1840s in particular), landscapes and rural scenes, his paintings were not without morals. His work is best known for the important number of reproductions of the *Peaceable Kingdom*, which is probably a reference to the book of Isaiah, chapter XI, verses 6-9. He produced more than a hundred versions of this painting. Filled with biblical symbols, this metaphor announces the coming of Christ to earth. Joy of life and naivety fill his canvases and evoke the peaceful way of life of the Quakers. Edward Hicks is the most well-known American naive artist of the nineteenth century.

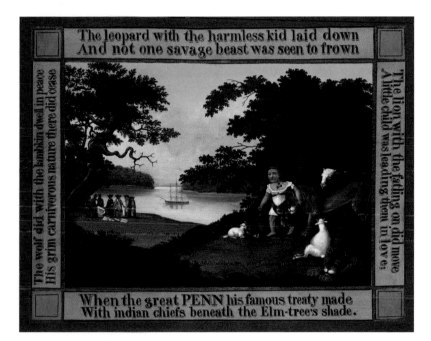

Edward Hicks,
The Peaceable Kingdom, 1826.
Oil on canvas, 83.5 x 106 cm.
Philadelphia Museum of Art,
Philadelphia.

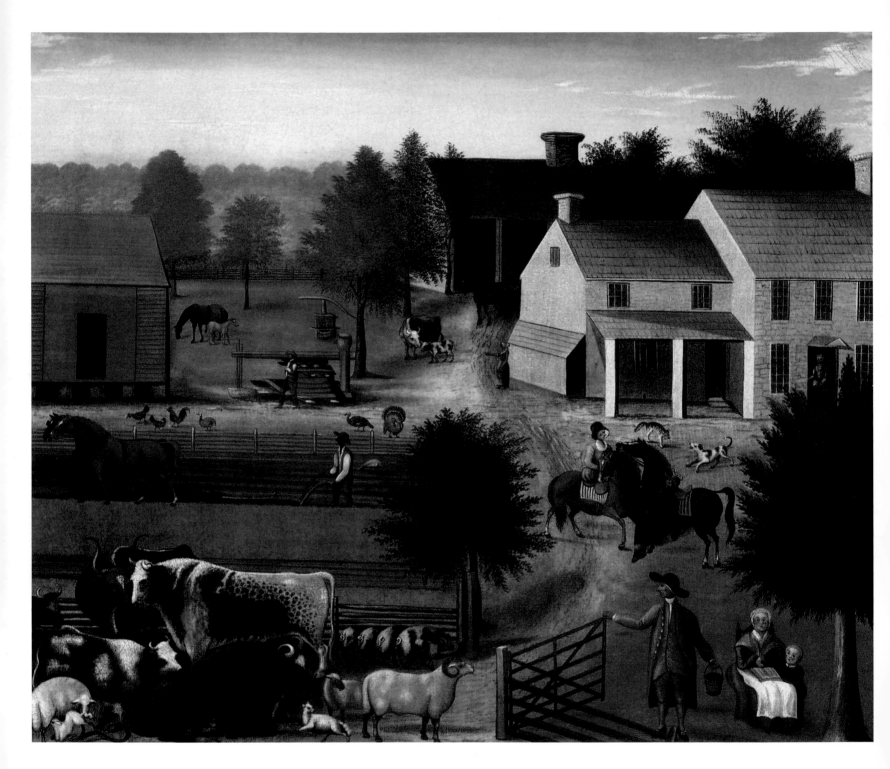

Edward Hicks,
The Residence of David Twining,
c. 1846.
Oil on canvas, 69 x 81.5 cm.
Abby Aldrich Folk Art Center,
Williamsburg.

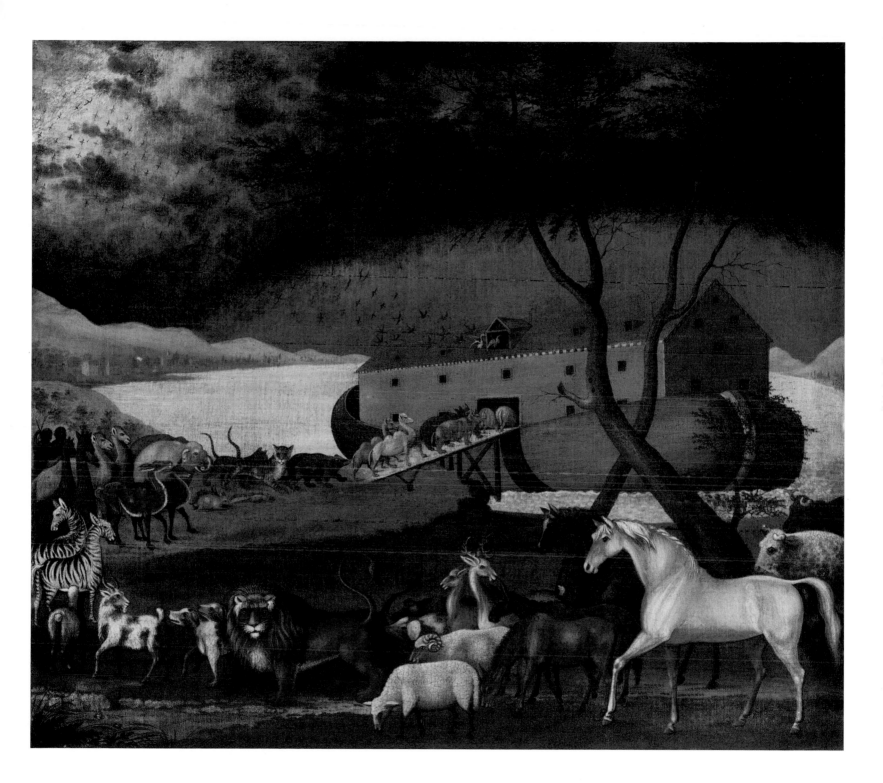

Edward Hicks,
Noah's Ark, 1846.
Oil on canvas, 66.8 x 77.1 cm.
Philadelphia Museum of Art,
Philadelphia.

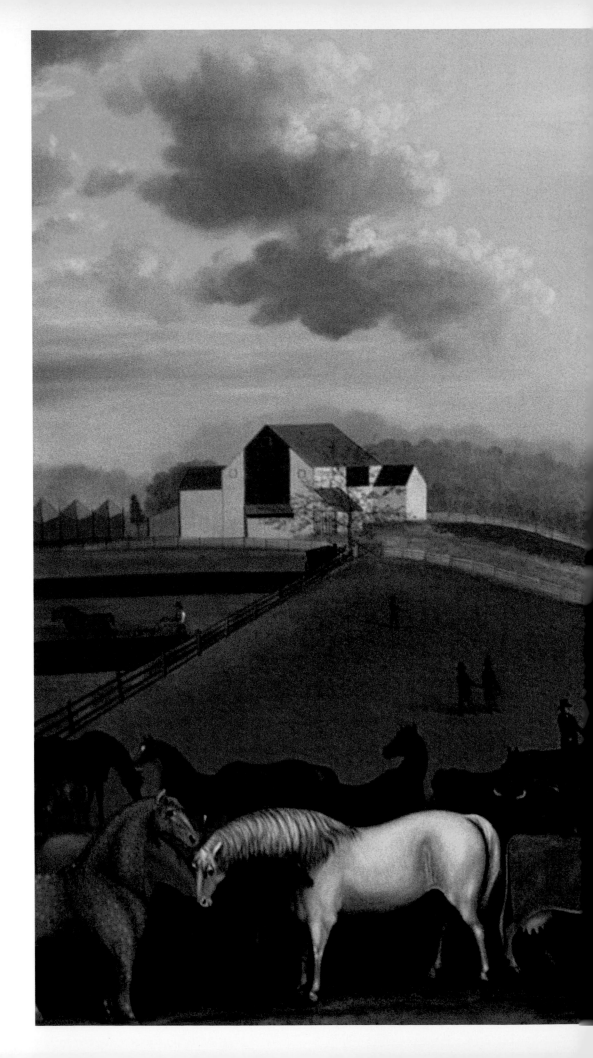

Edward Hicks,
Cornell Farm, 1848.
Oil on canvas, 93.3 x 124.4 cm.
National Gallery of Art,
Washington, D.C.

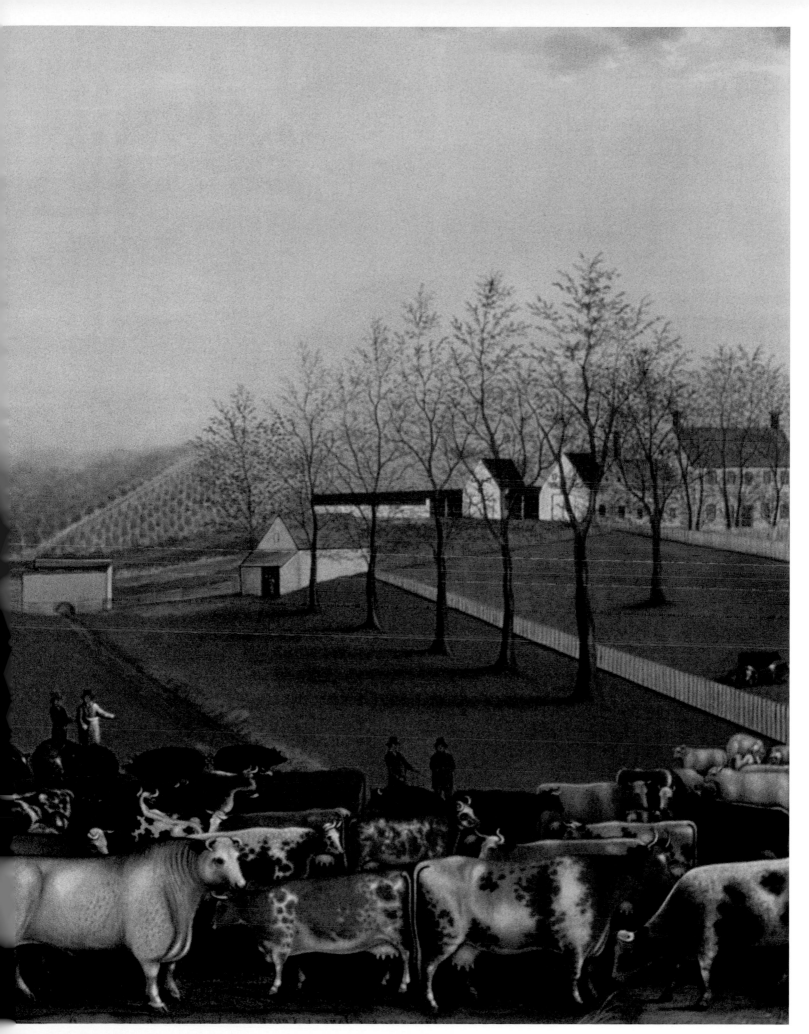

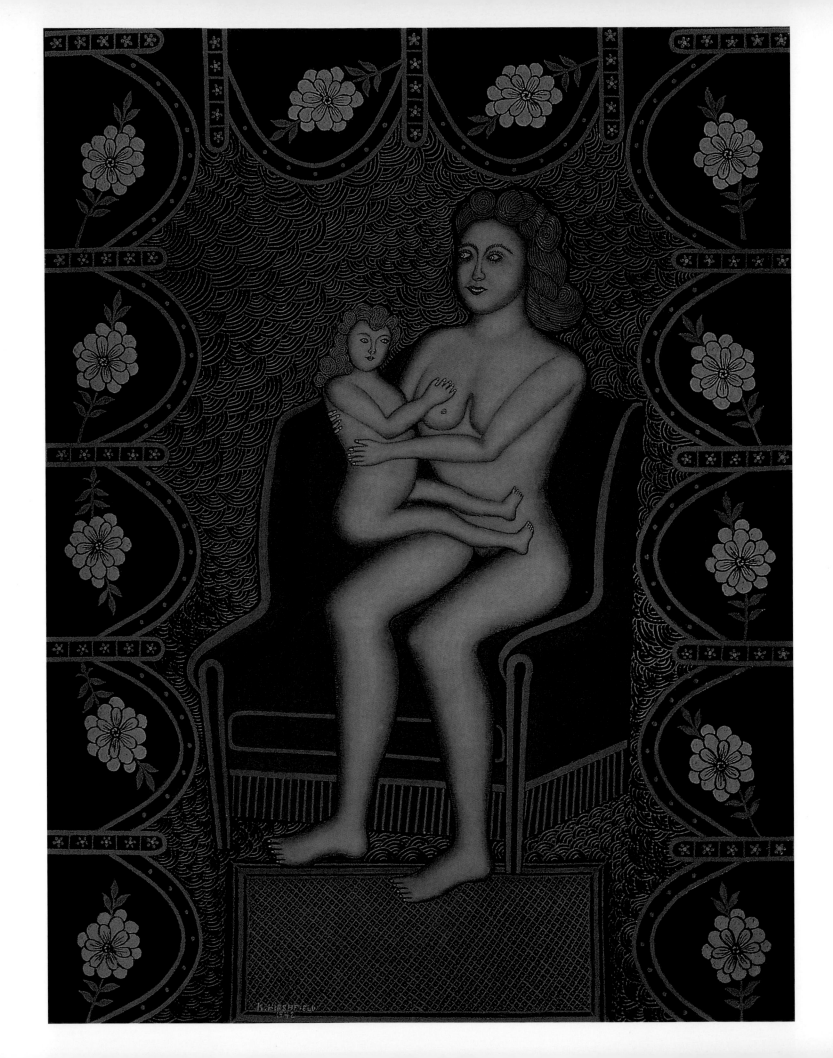

Morris Hirshfield (1872 – 1945)

Morris Hirshfield, was from Russian-Polish descent, even if he
had been a wood carver since a teenager, in particular of
religious subjects, he was not considered as a true artist until
much later in life. He went to the United States to work in the
clothing trade, as was the case for many Jewish immigrants at
the time. He began, with his brother, his own textile business
which was a great success. But he retired from business
because of an illness. He started painting late, at the age of
sixty-five. In his precise line one can see his training as a young
man and the refinement of his paintings shows his origins.
With an oriental influence, his paintings show a folklore and
an unusual originality for which they were appreciated more
than for their quality of realism. The overt eroticism displayed
in his art gives him a very special place amongst naive
painters. Sidney Janis discovered and exhibited him in
different museums, notably at the Museum of Modern Art.

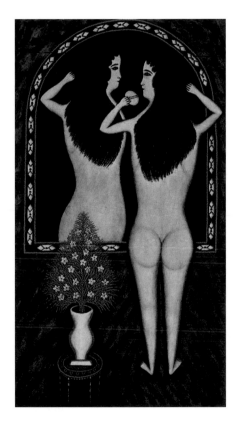

Morris Hirshfield,
Maternity.
Museum Charlotte Zander,
Bönnigheim.
Art © 2007, Morris Hirshfield/ Licensed
by VAGA, New York, USA

Morris Hirshfield,
Girl in a Mirror, 1940.
Oil on canvas, 101.9 x 56.5 cm.
The Museum of Modern Art,
New York.
Art © 2007, Morris Hirshfield/ Licensed
by VAGA, New York, USA

Morris Hirshfield,
Tiger, 1940.
Oil on canvas, 28 x 39 cm.
The Museum of Modern Art,
New York.
Art © 2007, Morris Hirshfield/ Licensed
by VAGA, New York, USA

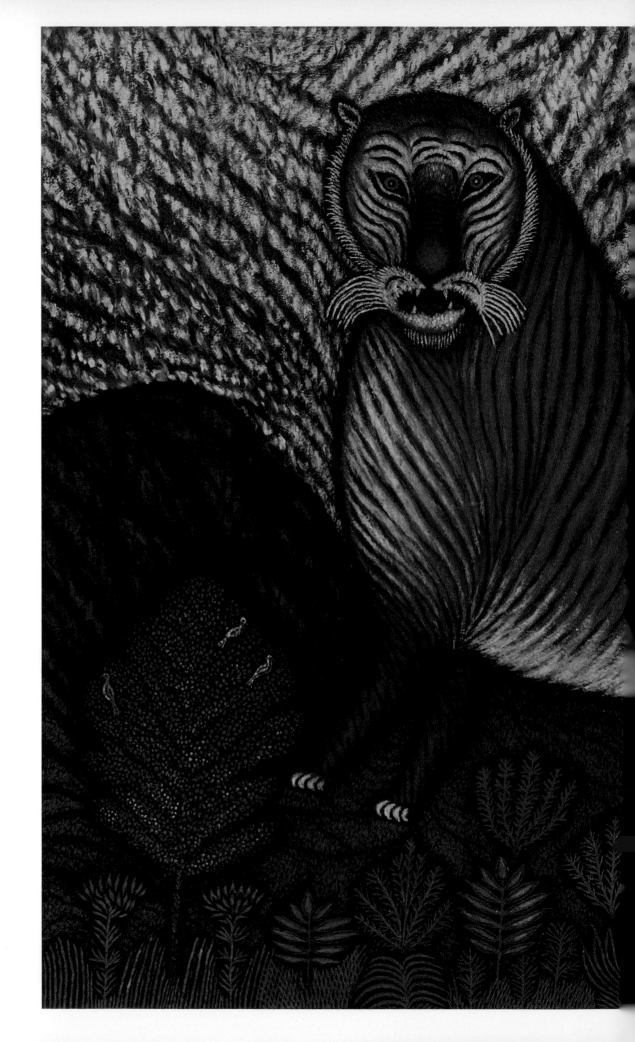

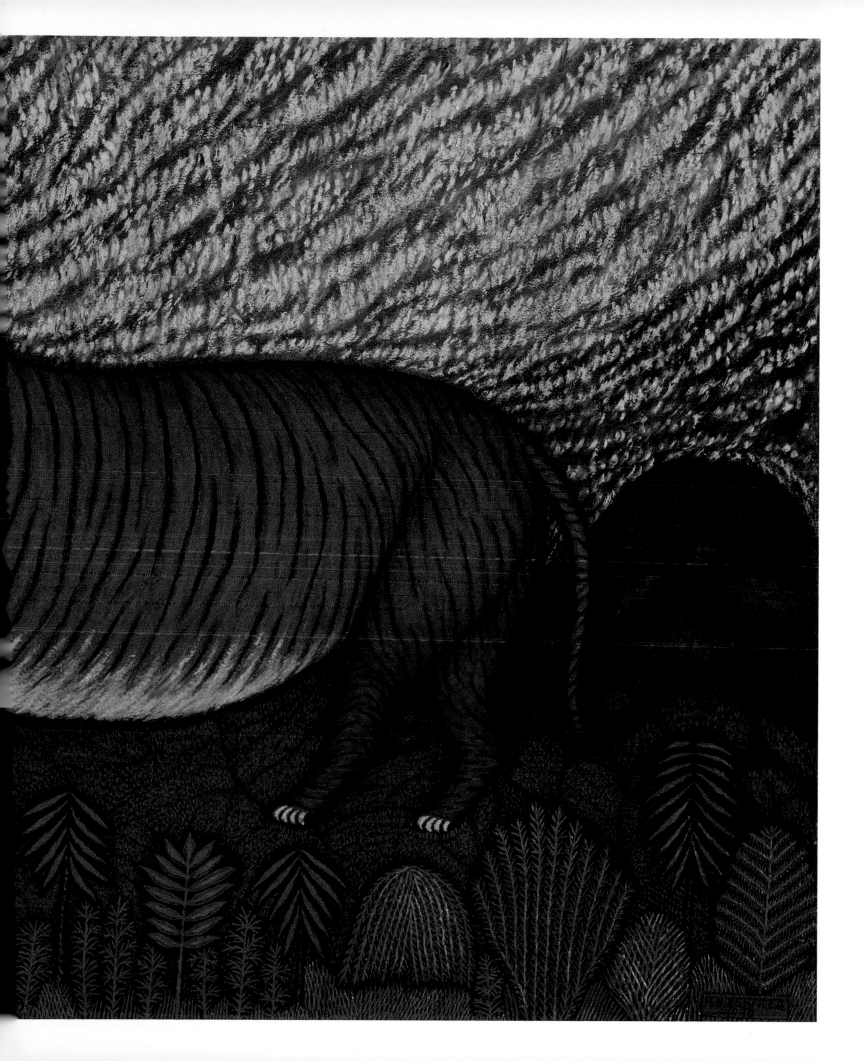

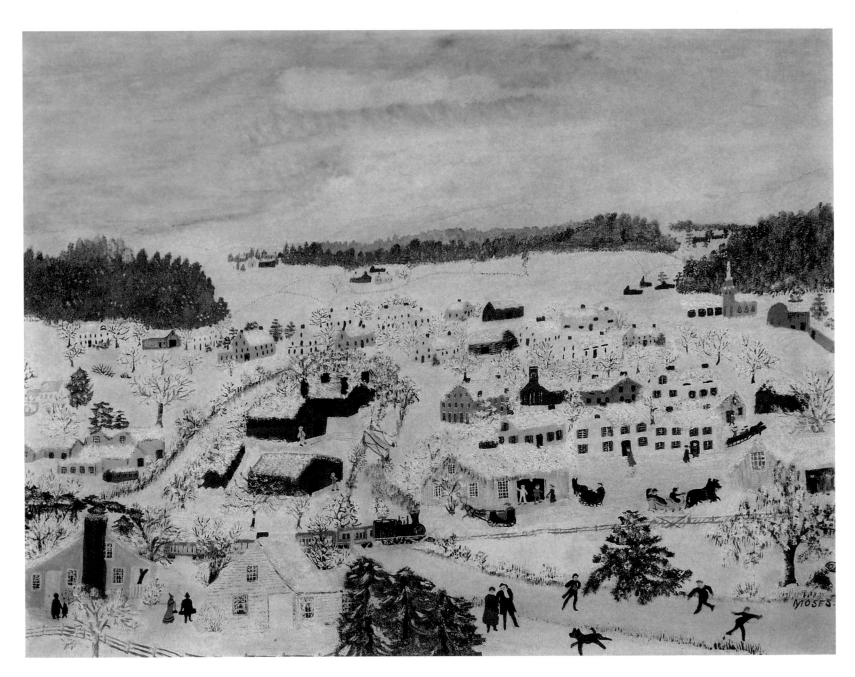

Anna Mary Robertson,
also called **Grandma Moses,**
Hoosick Falls in Winter (K 425).
The Phillips Collection.
Copyright © 1996 (renewed 1974),
Grandma Moses Properties Co., New York.

Anna Mary Robertson,
also called Grandma Moses

(Greenwich, 1860 – Hoosick Falls, 1961)

Before taking up painting, Grandma Moses had a career in embroidery in which she won several prizes but she had to give it up because of arthritis which made her fingers less and less agile.

She had great success during her lifetime as a painter, with a number of her paintings being made into postcards. The governor of the state, Nelson Rockefeller, declared that the day of her hundredth birthday would be 'Grandma Moses Day' in the state.

Having grown up on a farm as a child, her paintings often have the nostalgia of this particular atmosphere. The scenes are rural, they represent life on a farm as one lived then, making her paintings a testimony to a certain time and a way of life, today forgotten. Ice skates, hats, scarves are taken out of the shed. Characteristic in the art of appealing to the majority, her own words betray her and her will to touch and move the public at large: "Why paint an image if it is not lovable and nice?"

Anna Mary Robertson,
also called **Grandma Moses**,
Hoosick Falls in Winter (detail) (K 425).
The Phillips Collection.
Copyright © 1996 (renewed 1974),
Grandma Moses Properties Co., New York.

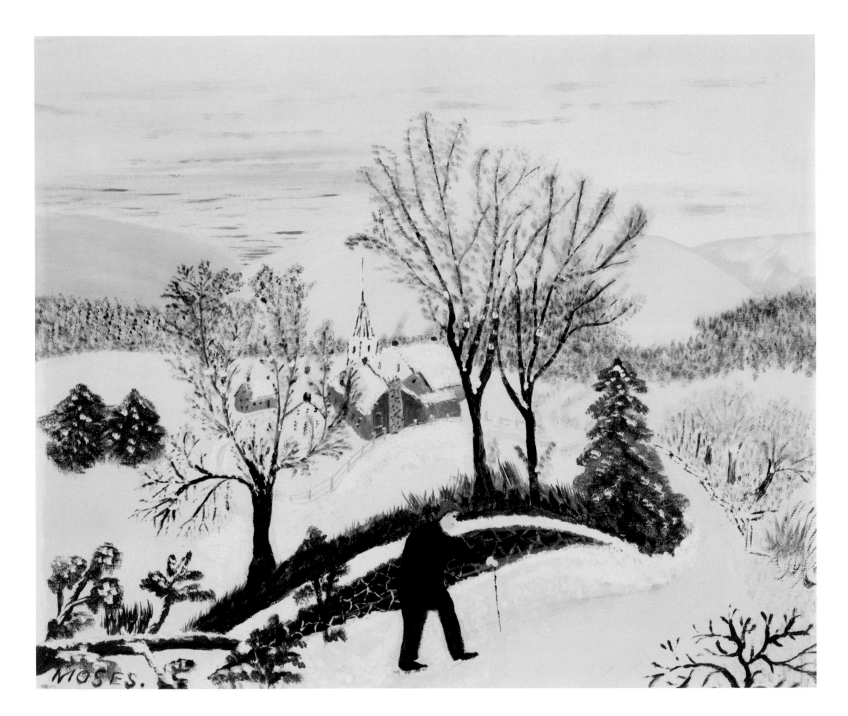

Anna Mary Robertson,
also called **Grandma Moses,**
Bridge (K 1328).
Private collection.

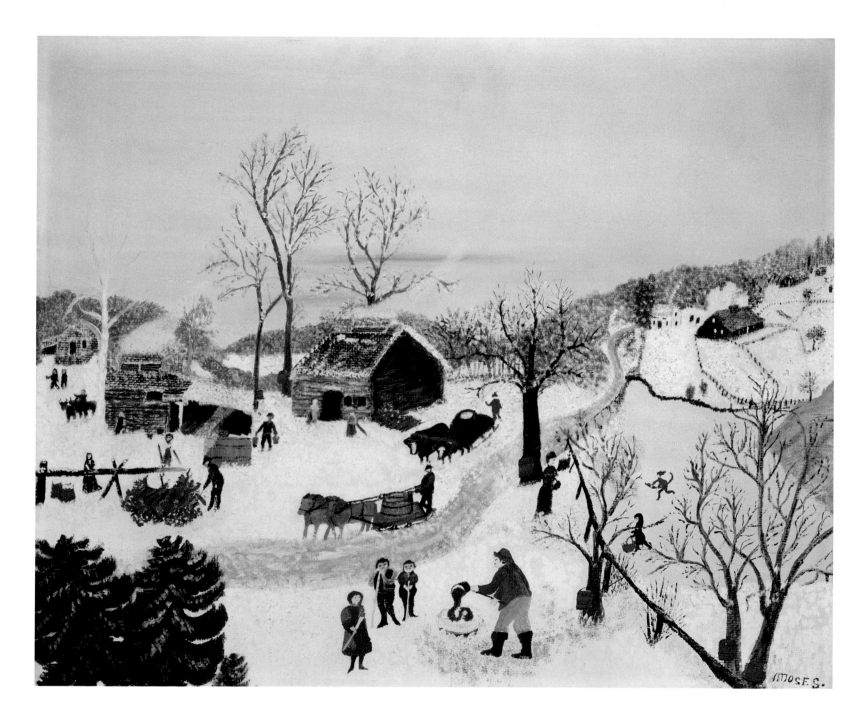

Anna Mary Robertson,
also called **Grandma Moses**,
Sugaring Off (K 90).
Private collection.
Copyright © 1973 (renewed 2001),
Grandma Moses Properties Co., New York.

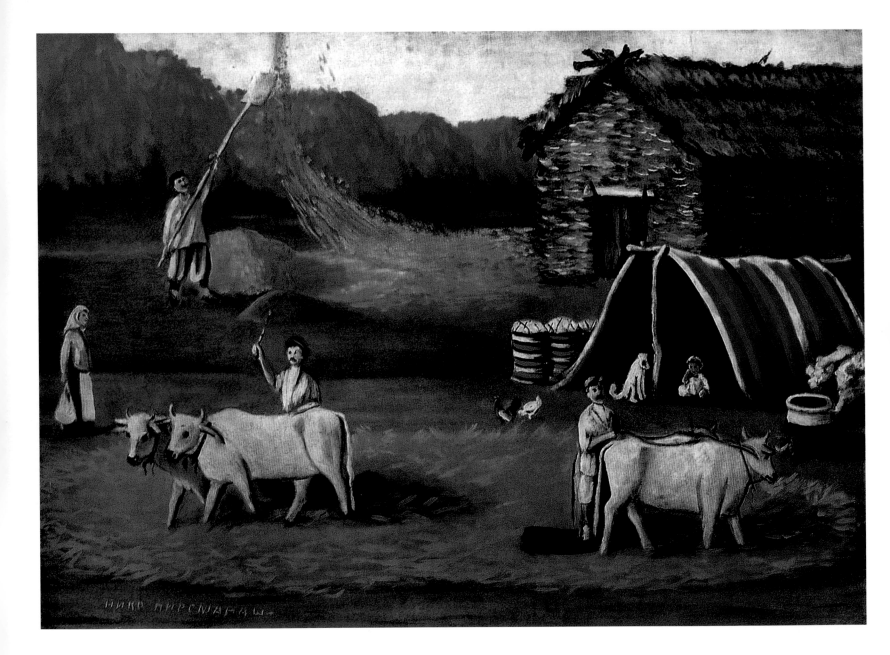

Georgia

Niko Pirosmani (Pirosmanashvili)

(Kakheti, 1862 – Tiflis (today Tbilisi), 1918)

Niko belonged to the lowest stratum of society in Tbilisi. "Niko – the 'house-painter' – is one of the poorest of all the down-and-outs who find shelter in the outskirts of Tbilisi," wrote Kyrill Zdanevich. "He has not had his own place to live in for a long time now, and stays in the house of one patron after another, sometimes working in the filthiest slums… and sometimes in the larger rooms of dukhans [restaurants]. In these surroundings he generally gets at least a bowl of soup, and if the patron is pleased with the picture he may even be served a glass of wine. Having come to the end of one commission, Niko takes up his paint-box and his home-made brushes and moves on to the next…" [40] He did not want to go back to where he had come from, the Alazan valley, because he did not want his sister or his former neighbours to see what poverty he had been reduced to. Yet even when he had achieved some recognition in Tbilisi, and some comparatively well-known artists considered him to be one of them, inviting him therefore to attend a meeting of the Artist's Union, he would not change his lifestyle.

Niko made an indelible impression on everyone who met him. The poet Ilya Zdanevich described how he and his brother first saw Niko at the side of a road in the old part of Tbilisi:

"He was painting the word DAIRY on a wall, using a brush, as a wall-sign. On our approach he turned round, bowed with great dignity, and turned back again to his work. Thereafter he supported our conversation with an occasional remark. I remember that meeting well. It was an artist who was standing at that white wall in a torn black jacket and a soft felt hat. He was tall, calm and self-confident, though not without a certain trace of sadness in his manner. (His acquaintances gave him the friendly nickname of 'the Count')." [41]

No one had ever taught him to paint. He started on wall-signs painted directly on to the walls or on squares or rectangles of tin. Had Niko never actually come to Tbilisi it is possible that he might instead have become an icon-painter in his native Kakheti, where the walls of the medieval churches were covered with the most marvellous and well-preserved frescos. The influence of such frescos is visible in Niko's work, particularly in the broad and stylistically general manner of painting (with the flat background and large figures) that makes his pictures instantly recognisable.

Niko Pirosmani,
The Barn.
Oil on cardboard, 72 x 100 cm.
Georgian State Art Museum, Tbilisi.

Niko Pirosmani,
The Grape Pickers.
Oil on canvas, 118 x 184 cm.
Georgian State Art Museum, Tbilisi.

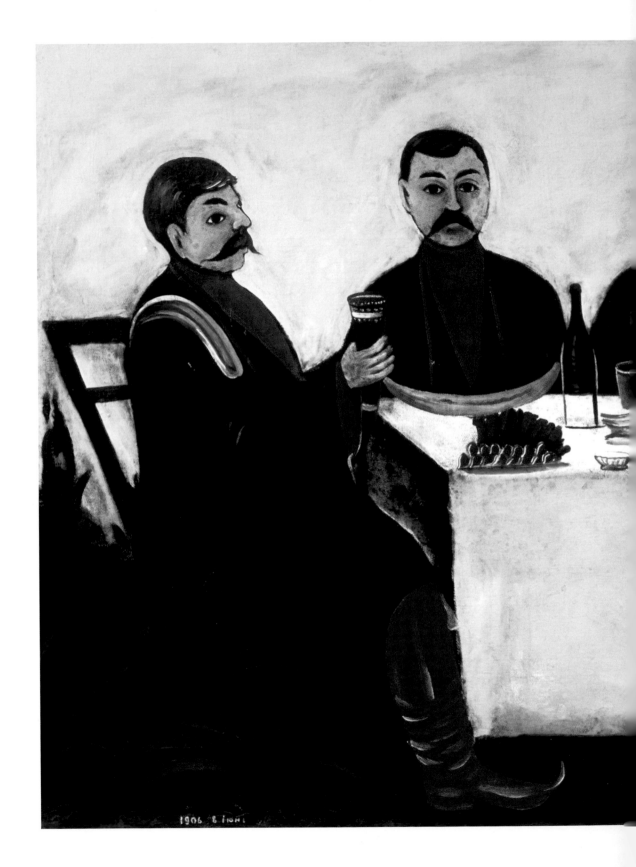

Niko Pirosmani,
The Feast of the Princes.
Oil on canvas, 105 x 195 cm.
Georgian State Art Museum, Tbilisi.

Niko Pirosmani,
Woman with Flowers and a Parasol.
Oil on canvas, 113 x 53 cm.
Georgian State Art Museum, Tbilisi.

Niko Pirosmani,
Fisherman.
Oil on canvas, 111 x 90 cm.
Georgian State Art Museum, Tbilisi.

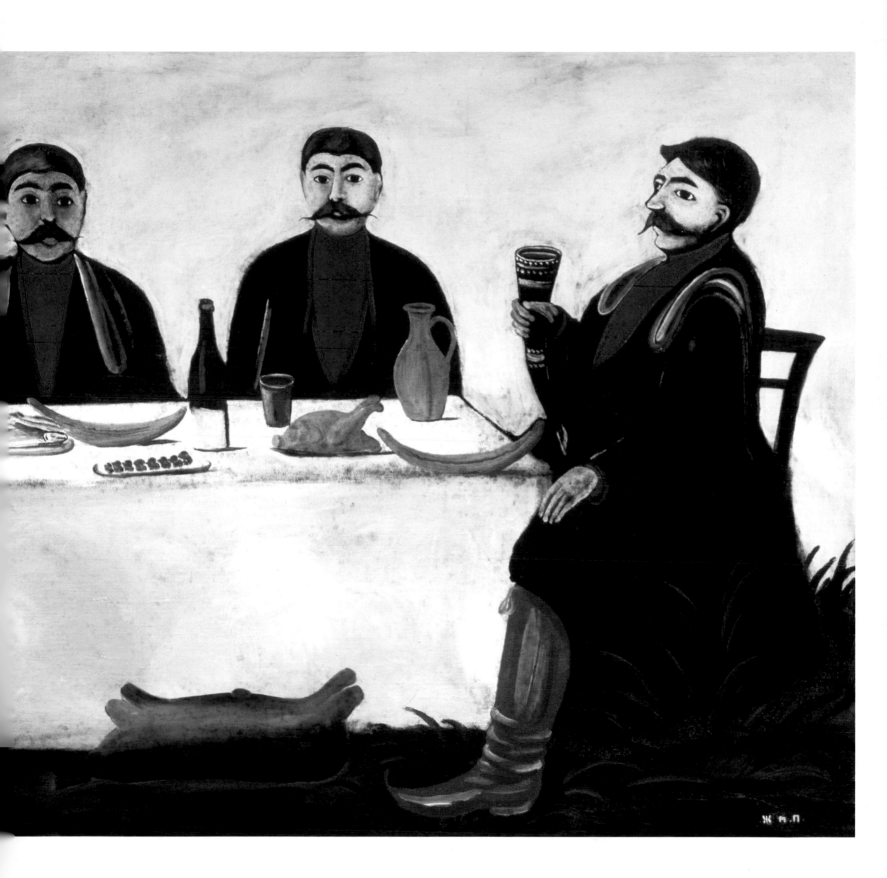

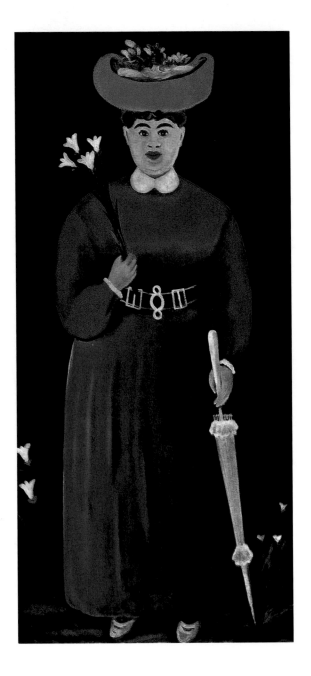

His first job, however, was on the railway network. He then turned minor tradesman, went bankrupt, and began to earn a living by doing what he had always loved to do since childhood. His imagination transformed restaurant-signs into glorious compositions that portrayed feasts and banquets, picnics with shashliyk (kebabs), and still-lifes with sausages and fruit and clay jugs. A typical 'Sunday artist', he painted for himself, although what he produced had to be used as payment for food and drink, which was after all what Henri Rousseau was sometimes similarly obliged to do. Yet his pictures were genuinely Georgian in style. They embodied the life and times of his country. The people he portrayed could be anything from janitors to bandits, restaurateurs to princes, aristocrats to beggars (with or without children), and fops to bourgeois party-goers. At the foundation of his imagination were the vineyards of his home in Kakheti, the rural labourers and shepherds of the region, the square architecture of the medieval churches there, and a strong liking for the shape of (oversized) ancient amphorae. Niko's paintings present us with a clear and virtually complete picture of the 'mythology' of contemporary Georgia. In addition, his pictures are full of wildlife: pigs and rams, donkeys and camels, lions and eagles, and, of course, deer. Graceful and delicate, deer symbolise Georgian pride and independence, even as their eyes reveal human sadness. The makers of local Georgian pottery often made deer figurines.

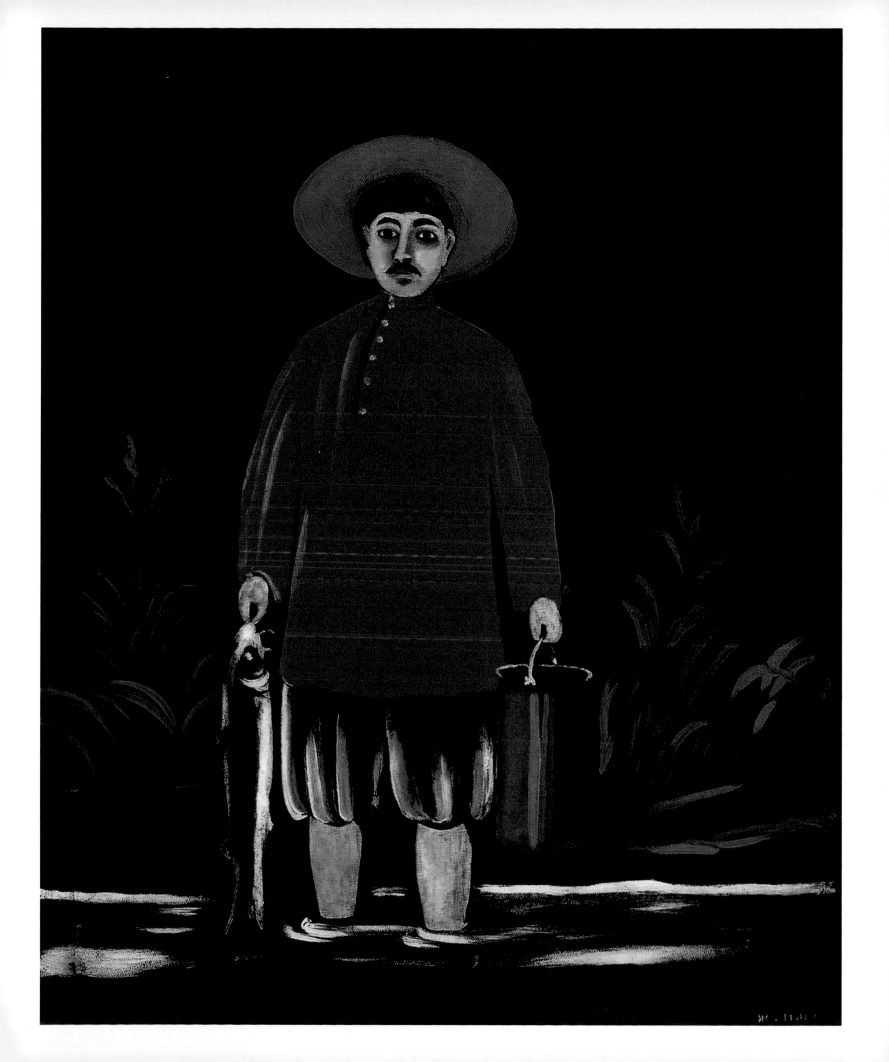

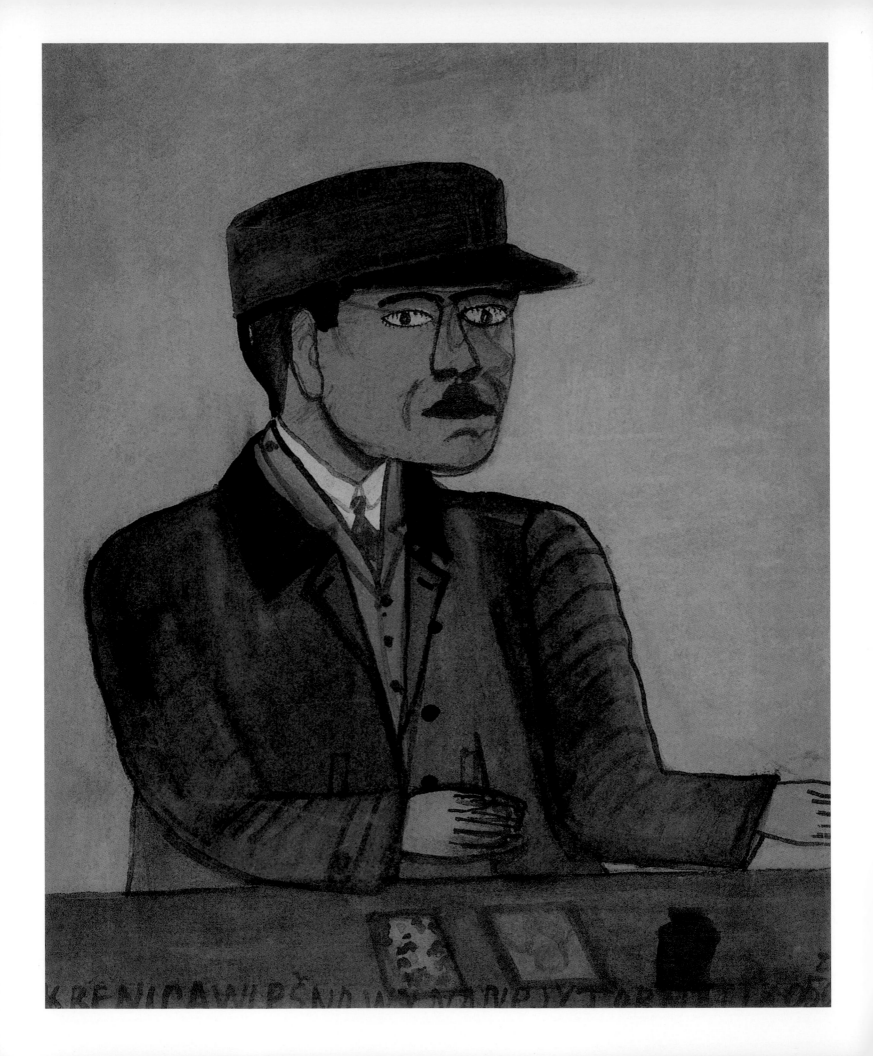

Poland

Nikifor Krylov

(Krynica Wiés, 1895 – 1968)

The life of this painter remains an enigma. Originally from Ukraine, it is thought that he lived in the city of Krakow. Poor and orphaned as a young boy, Nikifor (Epifan Drowniak) begged in the streets, he was thought to be deaf and mute because of his difficulty with language. Self taught, he started drawing from the age of thirteen on whatever material he could find: wrapping paper, wood, cardboard, cigarette packets, etc. His work shows a real desire to communicate with the outside world. One says he used to offer a drawing at the merest sign of kindness towards him. He would have painted a lot, more than a thousand works. Even after he became comfortably off, his works keep the same theme, famine.

His works are known for his evasive use of line, transforming landscapes, views of villages, etc. into fantastic landscapes. He drew principally churches, street scenes or stations, symbols of departure, taking off and also that of escape. A very religious man, a number of his paintings represent the Saints. To hide his illiteracy, he often inserted words or letters into his canvases, most of the words being badly spelt. He sometimes used the name 'Mitijko', as a homage to the Polish painter, showing his local culture and the fact that he considered himself as an artist, and therefore being aware of his own talent.

Nikifor Krylov,
Self-Portrait.
Watercolour on paper,
46 x 37.5 cm.
Galerie Charlotte, Munich.

Nikifor Krylov,
Triple Portrait.
70.5 x 59.5 cm.
Private collection.

Croatia

Ivan Generalić

(Hlebine, 1914 – Koprivnica, 1992)

Ivan Generalić was highly influenced, as were a number of others after him, by the Croatian artist Hegedušić. He founded the Zemjla School (the Earth) where he helped develop the progression and the interest of naive art in the region. "A particular social and aesthetics programme, explains Oto Bihalji-Mérin, mixed these artists who, at the time when the people had no access to art, attempted to implant it in the real world and make it understandable by the majority."[42] The meeting of the two great artists, Hegedušić and Generalić then gave birth to the School of Hlebine which was joined by other naive artists such as Mirko Virius. This place is now considered as the little Montmartre of the 1930s.

The evolution of Generalić is very clear, his paintings become more and more poetic and brighter and brighter. The fact he painted on glass is one major explanation. His effects of transparency immediately appeal to the spectator, the deftness of the artist shows in the remarkable absence of brush strokes, which is one of the difficulties of painting on glass. The brightness of paint on glass, and therefore its use, attracted Egyptian, Phoenician and Syrian artists. Present in Rome or in Byzantium, this art grew in the sixteenth century when the glass of Murano was discovered. Often used in the Hapsburg court and in France, this painting on glass developed in the peasant community, thanks mainly to Generalić.

Marcel Arland wrote about him: "He disarms us and convinces us because the little world he brings with him is really his and he has no need for other guides. Earth itself has given birth to him and he possesses its grace, wisdom and charm. In his paintings, one feels a friendly conversation between animals and people."

Ivan Generalić,
Nocturnal Landscape, 1964.
Private collection.

Ivan Generalić,
Crucified Rooster, 1964.
Oil on glass.
Private collection.

Ivan Generalić,
Fluvial Landscape, 1964.
Private collection.

Ivan Generalić,
On the Meadow.
Private collection.

Ivan Generalić,
The Deer Wedding, 1959.
Oil on glass, 43 x 68 cm.
Private collection.

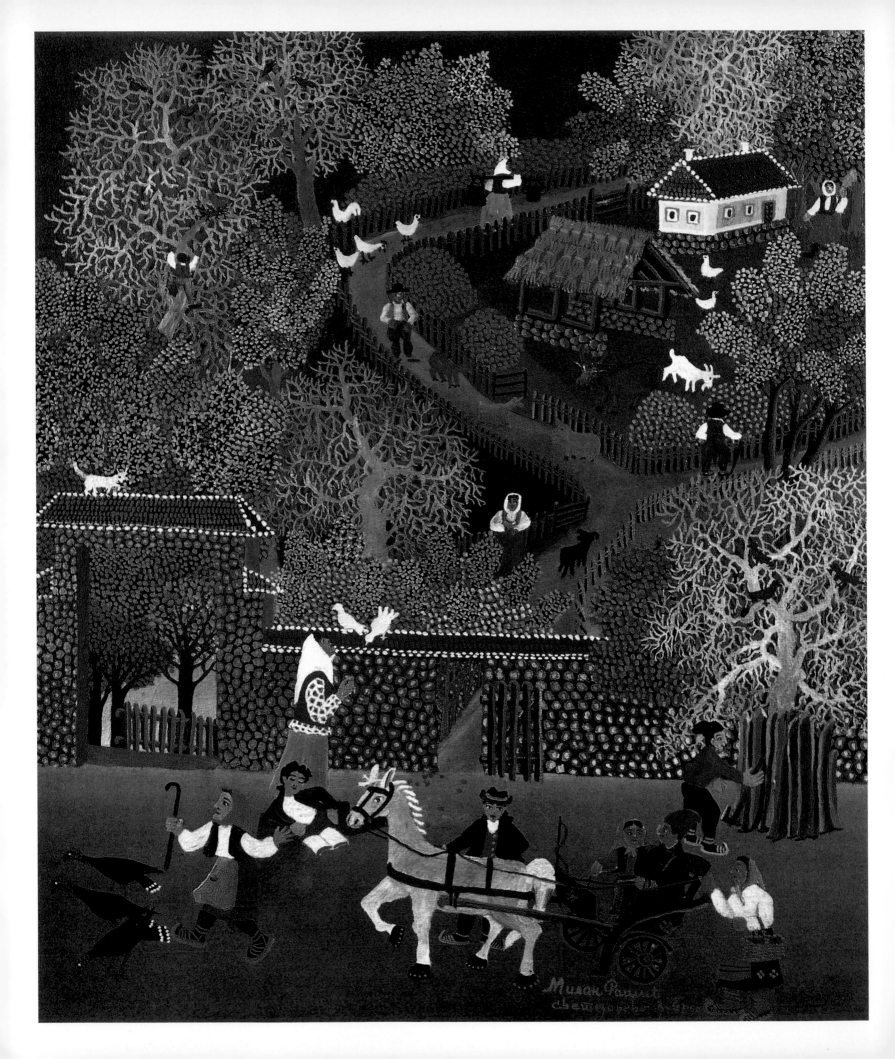

Serbia

Milan Rašić

(Donje Stiplje, 1931 –)

Milan Rašić was discovered in the 1960s and typically symbolises the characteristics of Serbian naive art. He situates his paintings in the country of his origin, Serbia. He always represents customs and traditions, while he surprisingly conserves a universal value. A taste for childhood, folklore, and nostalgia for paradise lost, etc., all these feelings make his painting a lyrical, sensitive and fragile work. He reveals sentiments indirectly rather than stating them in a striking way. He will say about himself: "I paint to give back to Nature, to liberate my soul and not to feel alone." His overloaded, detailed and very colourful paintings ostensibly show his love of nature and his trust in man. A contagious optimism radiates through his highly coloured work.

Milan Rašić,
My Village in Spring.
Private collection.

Milan Rašić,
Brandy-Making in my Village.
Private collection.

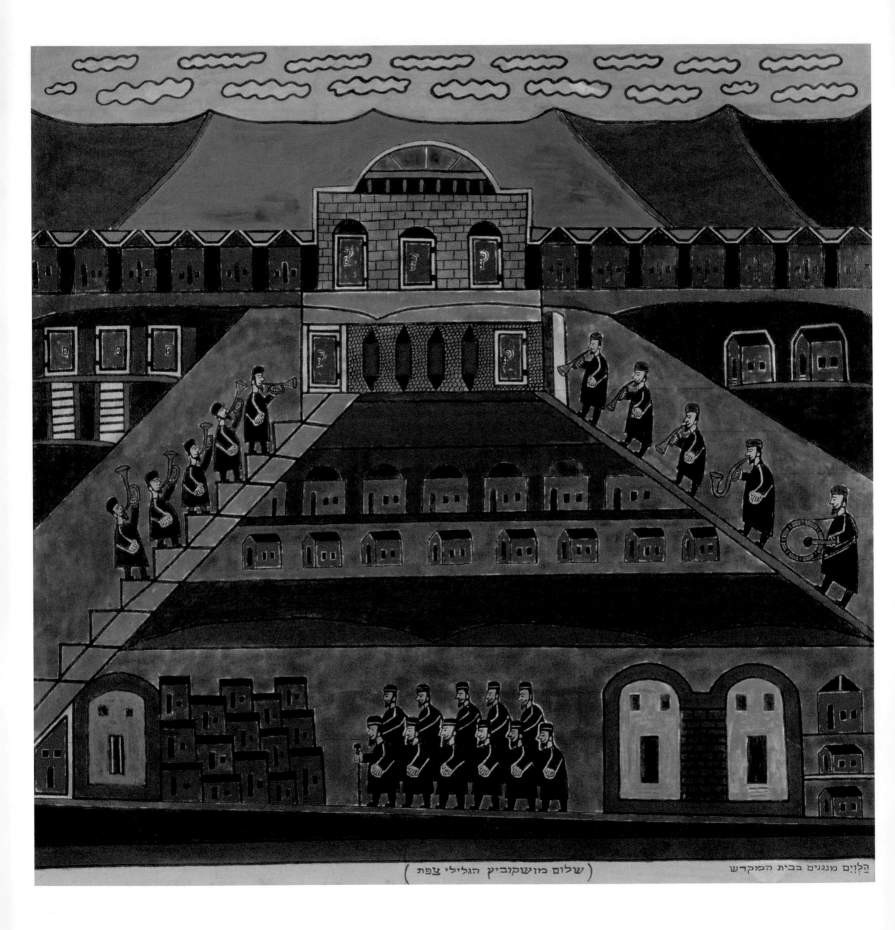

הַלְוִיִם מְנַגְּנִים בְּבֵית הַמִּקְדָּשׁ

(שלום מושקוביץ הגלילי צפת)

Israel

Shalom Moscovitz, also called

Shalom of Safed (Safed, 1887 – 1980)

Shalom of Safed is the best known Israelian naive artist. His humorous work finds its inspiration in the sacred texts and cultural folklore. Beginning as a simple clockmaker, his work represents popular art crafts and the different rites underline the traditions that are dear to him, although certain scenes are sometimes bordering on caricatures. The figures are easily recognised because they are very often bearded and wearing the kippah. His works, are generally composed of different scenes on the same canvas, and remind us of the horizontal sequences of gravestones of the past or in a more modern way of comic strips. They are a testimony to the Jewish culture and its secular transmission at a time when modernity triumphs. His numerous and varied works, in different media such as paintings, tapestries and lithographs have been exhibited in more than twenty museums across the world, some of which are in permanent collections including The Museum of Modern Art in New York and the Musée national d'art moderne, Centre Georges-Pompidou, Paris.

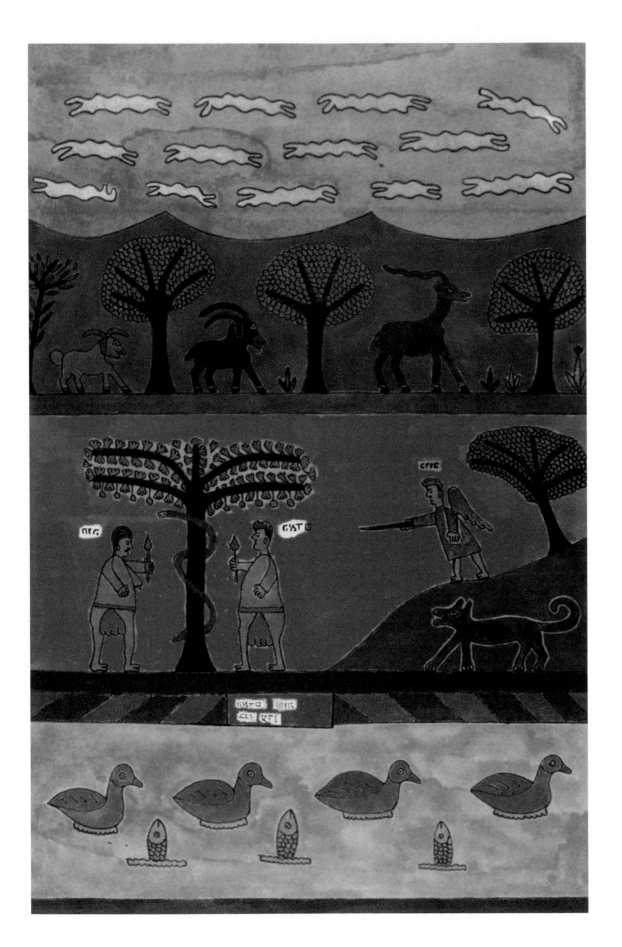

Shalom Moscovitz,
also called **Shalom of Safed**,
Levites Playing Music, 1972.
Acrylic on canvas.
The Jewish Museum, New York.

Shalom Moscovitz,
also called **Shalom of Safed**,
Noah's Ark, 1970.
Private collection.

Shalom Moscovitz,
also called **Shalom of Safed**,
The Garden of Eden.
Gouache on paper, 50 x 32 cm.
Musée International d'Art Naïf
Anatole Jakovsky, Nice.

Shalom Moscovitz,
also called **Shalom of Safed**,
Scenes from the Book of Ruth, 1960.
Tempera on paper, 67.5 x 47.5 cm.
The Jewish Museum, New York.

Bibliographical Notes

1. Charles Schaettel, *L'Art naïf*, PUF, Paris, 1994, p.58

2. Gert Claussnitzer, *Malerei der Naiven*, Seemann Verlag, Leipzig, 1977

3. M. Genevoix, *Vlaminck*, Paris, 1983, p.31

4. Quoted from: Agnès Humbert, *Les Nabis et leur époque*, P. Cailler, Geneva, 1954, p.137

5. Quoted by Jean Laude, *La Peinture française et l'art nègre*, Klincksieck, Paris, 1968, p.105

6. *Ibid.*, p.10

7. *Le Douanier Rousseau*, published by the Galeries nationales du Grand Palais, 1985, p.262

8. *Le Banquet du Douanier Rousseau*, Tokyo, 1985, p.10

9. A. Salmon, *Souvenirs sans fin, deuxième époque, 1908-1920*, Gallimard, Paris, 1956, p.49

10. G. Coquiot, *Les Indépendants, 1884-1920*, Librairie Publishing, p.130

11. *Ibid.*, p.132

12. M. Chile, *Miró, l'artiste et l'Œuvre*, Maeght Publishing, Paris, 1971, p.10

13. *Léonard de Vinci, œuvres choisies, Vol.2*, Moscow-Leningrad, 1935, p.112

14. Quoted from: E. Kojina, *Romantitcheskaïa bitva*, Iskousstvo, St Petersburg, 1969, p.250

15. Victor Hugo, *Notre-Dame de Paris*, Gallimard, Paris, 1966, p.190

16. *Ibid.*, p.186

17. *Ibid.*, p.187

18. *Ibid.*, p.159

19. *Ibid.*

20. *Ibid.*, p.156

21. A. Povelikhina, E. Kovtoun, *Russian Painted signs and the Avant-Garde artists*,

 Aurora-St Petersburg, 1991, p.186

22. *Ibid.*, p157

23. *Ibid.*

24. Walter Benjamin, *Journal de Moscou*, L'Arche Editeur, Paris, 1983, p.28

25. *Ibid.*, p.26-27

26. R. Wildhaber, *Das Naive Bild der Welt*, Baden-Baden, Frankfurt am Main, Hanover, 1961, p.87

27. A. Povelikhina, E. Kovtoun, *op. cit.*, p.72

28. K. M. Zdanevitch, *Niko Pirosmanashvili*, Iskousstvo, Moscow, 1964, p.80

29. *Ibid.*

30. *Ibid.*, p.10

31. *Ibid.*, p.25

32. Victor Ernst Masek, *L'Art naïf*, Les Editions Méridiane, 'Courants et Synthèse' Collection, 1989

33. *Le Douanier Rousseau*, published by the Galeries Nationales du Grand Palais, Paris, 1985, p.37

34. Wilhelm Uhde, *Cinq Maîtres primitifs*, 1949

35. *Les Maîtres populaires de la réalité*, catalogue of the exhibition organised by the Museum
 of Grenoble; text and notes by Maximilien Gauthier, preface by Raymond Escholier, Paris, 1937

36. Wilhelm Uhde, *Cinq Maîtres primitifs*, 1949

37. E. Benezit, *Dictionnaire des peintres sculpteurs, dessinateurs et graveurs*, Grund, 1976

38. Oto Bihalji-Mérin, *Les Peintres naïfs*, Delpire, Paris, p.16

39. Wilhelm Uhde, *Rousseau*, Figuière, Paris, 1911

40. K.M. Zdanevitch, *op. cit.*, pp.10-11

41. *Ibid.*, p.13

42. Oto Bihalji-Merin, *Naive art in Yugoslavia*, Belgrade, Yogoslovenska Revija, 1963

Index